REVOLUTION ON PAPER

Mexican Prints 1910–1960

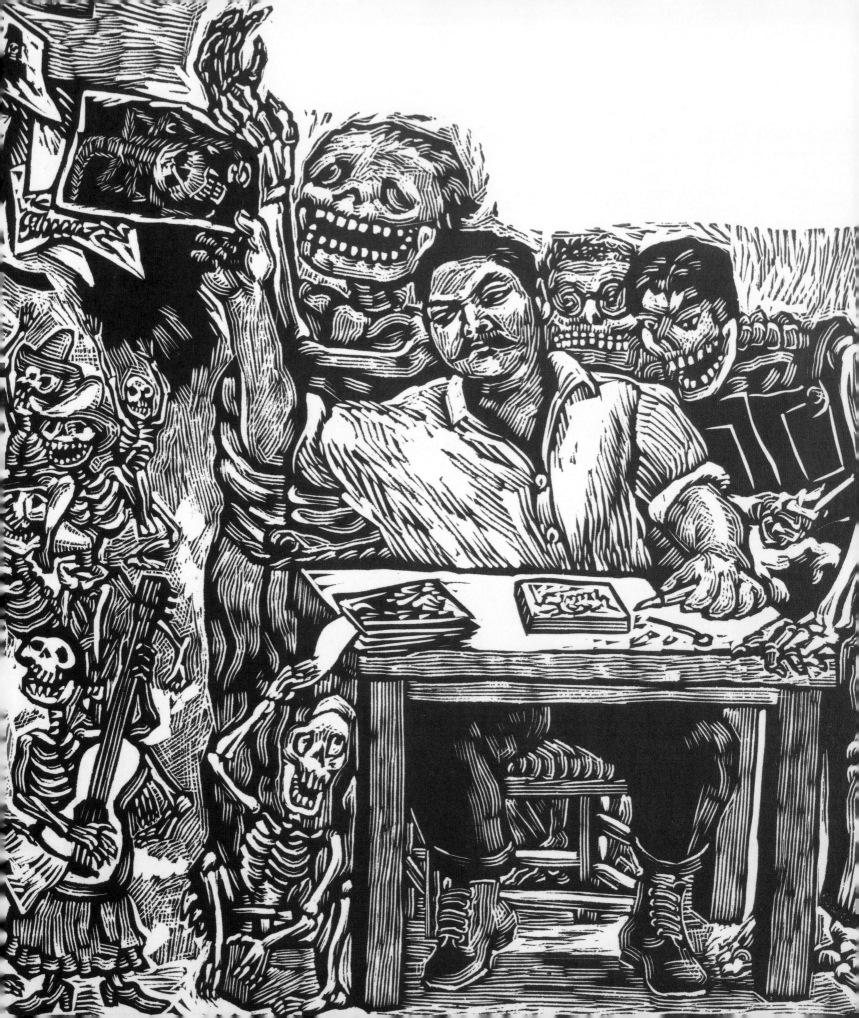

REVOLUTION ON PAPER

Mexican Prints 1910–1960

Dawn Adès and Alison McClean
with the assistance of Laura Campbell

edited by Mark McDonald

THE BRITISH MUSEUM PRESS

Published to accompany the exhibition 'Revolution on Paper: Mexican Prints 1910–1960'
at the British Museum from 22 October 2009 to 28 February 2010

The exhibition is supported by

THE · MONUMENT · TRUST

Additional support has been provided by

www.visitmexico.com

Frontispiece: Alfredo Zalce, *José Guadalupe Posada and calaveras*
(cat. 12, detail)

First published in 2009 by The British Museum Press
A division of The British Museum Company Ltd
38 Russell Square, London WC1B 3QQ

www.britishmuseum.org

A catalogue record for this book is available from the British Library

ISBN 978-0-7141-2670-8

Designed and typeset in Quadraat and Solex by Andrew Shoolbred

Printed in China
by C&C Offset Printing Co.

CONTENTS

Diego Rivera, *Communicating vessels* (*Vasos comunicantes*), linocut, 1938 (private collection)

PREFACE

The title of this exhibition, 'Revolution on Paper', emphasizes the close engagement that Mexican printmaking of the first half of the past century had with the events of the time, and particularly with the Revolution of 1910 to 1920 that dominated the history of the country throughout the period. Apart from Russia, Mexico was the only country in which a left-wing revolution succeeded in gaining power during this period. The subsequent developments were watched with fascination by liberals and intellectuals in America and Europe. Artists were seen as vital support in forming public opinion, and the most famous results were the vast mural projects commissioned for public buildings throughout the country. Three great painters emerged who gained international reputations: Diego Rivera, David Alfaro Siqueiros and José Clemente Orozco. But just as significant as these huge projects, although overshadowed by them today, was a parallel propagandist effort in printmaking, especially in the 'popular' media of woodcut and linocut. This came to be centred on the Taller de Gráfica Popular (People's Graphic Workshop) in Mexico City, whose influence continues to this day. Perhaps surprisingly, many of the earlier prints were made in the United States, where there was a strong market for works by the great painters who were lionized by sections of American society.

Mexican twentieth-century art and printmaking is little known and rarely seen in Britain. The landmark exhibition 'Art in Latin America', organized by Dawn Adès at the Hayward Gallery in 1989, had a wide geographical and chronological range and only a small part could be devoted to these prints. The Frida Kahlo exhibition at Tate Modern in 2005 suggested that there is a growing public interest in modern Mexican art in this country, and we are delighted to be able to mount the first British exhibition with catalogue on the prints of the period. As many other recent exhibitions in the British Museum have striven to do, it introduces the concerns and recent history of a country that is unfamiliar to many; the Museum combines the present with the past by presenting at the same time an exhibition devoted to the Aztec emperor Moctezuma. Within the Department of Prints and Drawings, the present show is the latest in a series of surveys of the schools of twentieth-century printmaking, the first of which was in 1980.

The most recent exhibitions in the series were of Italian and American prints; as with them, we are able to show works almost entirely drawn from our own collection in the present exhibition. This has been possible only with great help from donors and sponsors. We were able to purchase from our own funds a group of works by José Guadalupe Posada in the early 1990s, but almost every Mexican print acquired since has been a gift. The first of our donors were Dave and Reba Williams, themselves pioneering explorers of this area in recent times, who built up an important collection that formed the basis for a travelling exhibition in 1998; their catalogue for this was the first to open modern eyes to the interest and quality of the field. They gave us thirty-four prints from their collection in 2002 and fifty-four more in 2008 to the American Friends of the British Museum. The decisive step that turned this essential core into an exhibition came from the urging and support of James and Clare Kirkman, who know and love Mexico and its people. With enormous enthusiasm they gave us what they had collected, found prints that we needed, effected introductions, and most generously filled gaps to create the collection that we present here. We are greatly indebted to them. James and Laura Duncan continued their generosity by giving us the funds to acquire some important works, and the ever-generous Art Fund (formerly the National Art-Collections Fund) presented to us the famous print by Diego Rivera of Emiliano Zapata (front cover).

The Monument Trust has given us very generous support to enable us to publish the catalogue and provide an associated educational programme. Additional support has been given by the Mexico Tourism Board. Professor Dawn Adès, the doyenne of British art historians of South America, has helped us throughout, and has written the background essay. Dr Alison McClean has written the second essay on the prints. For the biographies and catalogue entries we were fortunate to be able to call on Laura Campbell, who is working on a thesis on Mexican architectural photography of the period, and Dave and Reba Williams helped greatly with the gift of their working library and notes. We would also want to mention here John Ittmann, whose great catalogue of the exhibition of 'Mexico and Modern Printmaking' that he organized in Philadelphia in 2006 has underpinned much of what is said in these pages.

Any project of this kind, which has involved constant traffic across the Atlantic, incurs numerous debts which must be acknowledged here. In the acquisition of the prints we are indebted to Deborah Kiley, the granddaughter of Erhard Weyhe, who allowed us to select eighteen prints from the gallery's historic stock and kindly presented three further prints in her grandfather's memory. Peter Schneider, an expert in the field, also helped us, as did Mary Ryan and other dealers in the United States and Mexico.

In Mexico we thank in the first place Magda Carranza de Akle, who made numerous introductions and went to enormous trouble to research information and to help in every way she could. Without her assistance we would never have been able to get as far as we have. We also extend our thanks to Daniel Akle, Mariana Pérez Amor, Mercurio López Casillas, Rogelio Flores of *Proceso* magazine, Enrique Fuentes Castilla, Dafne Cruz, Hector Fanghanel, Laura Baylon Moreno, Victor Rodrigues, Jorge Sanabria, Patricia Zapata, the art critic Mrs Raquel Tibol, and Mariana Arenas from the Sub-dirección de Curaduría at the Museo Nacional de Arte. In Europe we thank Mr and Mrs George Loudon and Helga Prignitz, and in the United States Marianne Martin and Robert Littman. We are grateful for the interest shown by the Mexican Ambassador to the UK, Juan José Bremer, and Ignacio Durán-Loera, Minister for Cultural Affairs, Mexican Embassy to the UK, and also Richard Maudslay of the British Mexican Society. Margarita Luna helped at an early stage with listing the prints and with the biographies of Mexican printmakers; photographs for the catalogue were taken by Ivor Kerslake and Kevin Lovelock, British Museum Department of Photography and Imaging. Helen Thomas helped to check the proofs. Our thanks also go to Teresa Francis, Managing Editor at the British Museum Company, Andrew Shoolbred, designer, and Johanna Stephenson, external editor, for their care and attention with the production of this catalogue.

Neil MacGregor
Director, The British Museum

CHRONOLOGY

Artistic and cultural events are in italic type

1852 *José Guadalupe Posada born in Aguascalientes, Mexico.*

1876 General Porfirio Díaz becomes President of Mexico; dictatorship lasts for seven terms, until 1911.

1900 Ricardo Flores Magón and his brother publish the anti-Díaz magazine *Regeneración* in Mexico City, signifying the beginning of political and social unrest.

1904 *Construction of the Palacio de Bellas Artes (Fine Arts Palace) in Mexico City begins but stopped in 1911 because of the Revolution.*

1909 Francisco Madero, a landowner from Coahuila in Northern Mexico, begins a campaign against Díaz's re-election as President.

1910 Celebrations marking the centenary of the beginning of the struggle for Mexican independence from Spain.

Díaz again re-elected as Mexican President while Madero is in prison.

Madero is released from prison; from the US he plans to launch an armed attack against Díaz on 20 November, now known as Revolution Day in the Mexican Civic Calendar; plans are delayed due to lack of troops until 1911, when Madero finally enters Mexico from the US and attacks.

Mexican Revolution begins.

National University of Mexico founded (from 1920s, the National Autonomous University of Mexico).

1911 Díaz is forced into exile and Madero takes office, initially supported by Pascual Orozco, Pancho Villa and Emiliano Zapata (who led various factions against Díaz); however, Madero gives them no responsibility in his government.

Weeks after Madero's victory, Emiliano Zapata signs the Plan de Ayala in the state of Morelos, south of Mexico City, opposing Madero's government for its similarity to the Díaz regime.

1912 Pascual Orozco attempts to overthrow Madero.

1913 February: the *decena trágica*, ten days of violence in Mexico City.

Madero and his deputy, José María Pino Suárez, are murdered.

General Victoriano de la Huerta claims the Mexican presidency.

Death of José Guadalupe Posada.

1913 Venustiano Carranza and his forces, in favour of a new Mexican constitution, wage war against Huerta.

1914 Huerta is overthrown; one of Carranza's generals, Pancho Villa, joins forces with Emiliano Zapata to conduct a Civil War against Carranza, the highlight of which is their entry in to Mexico City where they make speeches about the Revolution.

1915 Another of Carranza's generals, Alvaro Obregón, defeats the troops of Villa and Zapata.

1917 Signing of the Mexican Constitution (still in place today), offering a new, more stable political framework for the Mexican Republic.

Carranza becomes President.

1919 Emiliano Zapata assassinated by Carranza's forces.

Mexican Communist Party founded.

1920 **Mexican Revolution ends.**

Álvaro Obregón becomes President.

Rural schools and other social reform programmes; first murals painted in national buildings such as the Escuela Nacional Preparatoria (National Preparatory School).

1921 *Launch of El Estridentismo (the avant-garde Stridentist movement) and publication of its fourteen-point manifesto.*

1922 *Manifesto of the Sindicato de Obreros Técnicos, Pintores, y Escultores (Union of Painters, Sculptors and Technical Workers).*

1923 Pancho Villa assassinated in the state of Chihuahua.

1924 Plutarco Elías Calles elected President.

1926–9 Cristero Rebellion: Catholic uprising against the imposition of state rules on religion in the public sphere.

1928 Obregón elected President for a second term but assassinated shortly afterwards by a Catholic fanatic who shoots him in the head.

Establishment of ¡30-30! Protest of Independent Artists for artists, writers and intellectuals, named after a type of gun used in the Revolution, with the aim of restructuring Mexico's education programmes and art institutions; lasted until 1930.

Beginning of the *Maximato*, a six-year period which saw various 'puppet' presidents in office whilst Calles controlled them behind the scenes.

1934 Lázaro Cárdenas elected President and begins redistributing to peasants land previously held by landowners.

Liga de Escritores y Artistas Revolucionarios (League of Revolutionary Writers and Artists or LEAR) founded by a group of artists and intellectuals; group publishes its magazine, Frente a Frente.

Fine Arts Palace in Mexico City completed.

1935 *Works Progress Administration (WPA) Federal Art Project established.*

1936 Cárdenas sends Calles into exile.

Railway strikes.

Beginning of the Spanish Civil War.

Confederation of Mexican Workers (CTM) and Worker's University (Universidad Obrera) established.

Talleres Gráficos de la Nación (National Print Workshop) established by President Lázaro Cárdenas to provide printmaking facilities and classes to the public.

1937 Leon Trotsky is exiled to Mexico.

Taller Editorial de Gráfica Popular founded by Luis Arenal, Leopoldo Méndez and Pablo O'Higgins and quickly becomes the TGP (Taller de Gráfica Popular or People's Graphic Workshop), an association of young printmakers closely associated with the Mexican Communist Party.

1938 Nationalization of the petrol companies.

Formation of the Mexican Revolutionary Party (PRM).

1939 Tram strikes in Mexico City.

1940 Manuel Avila Camacho elected President in a tightly fought battle against General Juan Almazán, leader of the Partido Revolucionario Unificación Nacional (PRUN).

Attempted assassination of Trotsky at Diego Rivera's home in Coyoacán, Mexico City.

'Twenty Centuries of Mexican Art' exhibition at the Museum of Modern Art, New York.

1942 Mexico enters Second World War.

1946 Miguel Alemán elected President.

1947 Founding of the new, left-wing Partido Popular (PP) whose members from the TGP included Alberto Beltrán, Ángel Bracho and Leopoldo Méndez.

1948 *Sociedad Mexicana de Grabadores (Mexican Society of Printmakers) founded by Raúl Anguiano, Francisco Dosamantes and Amador Lugo.*

1952 Adolfo Ruiz Cortines elected President.

1953 Teatro de los Insurgentes (Theatre of the Insurgents) built in Mexico City and decorated with a mural by Diego Rivera, *La historia del teatro.*

1957 Earthquake in Mexico City.

Twentieth anniversary of the TGP celebrated by exhibition at the Fine Arts Palace in Mexico City.

1958 Adolfo López Mateos takes office as President.

1959 Movement of National Liberation (MLN) founded by Lázaro Cárdenas.

National Conference of Negro Artists (NCN) founded in the USA.

1960 *Many of the original members leave the TGP, including Leopoldo Méndez and Pablo O'Higgins, due to irreconcilable political differences.*

Celebration to mark the fiftieth anniversary of the beginning of the Mexican Revolution.

PRESIDENTIAL CHRONOLOGY

	
1876–1911	General Porfirio Díaz
1911–13	Francisco Madero
1913–14	General Victoriano de la Huerta
1914–20	General Venustiano Carranza
1920–24	General Álvaro Obregón
1924–8	Plutarco Elías Calles
1928–34	*Maximato*
1934–40	Lázaro Cárdenas
1940–46	Manuel Ávila Camacho
1946–52	Miguel Alemán
1952–8	Adolfo Ruiz Cortines
1958–64	Adolfo López Mateos

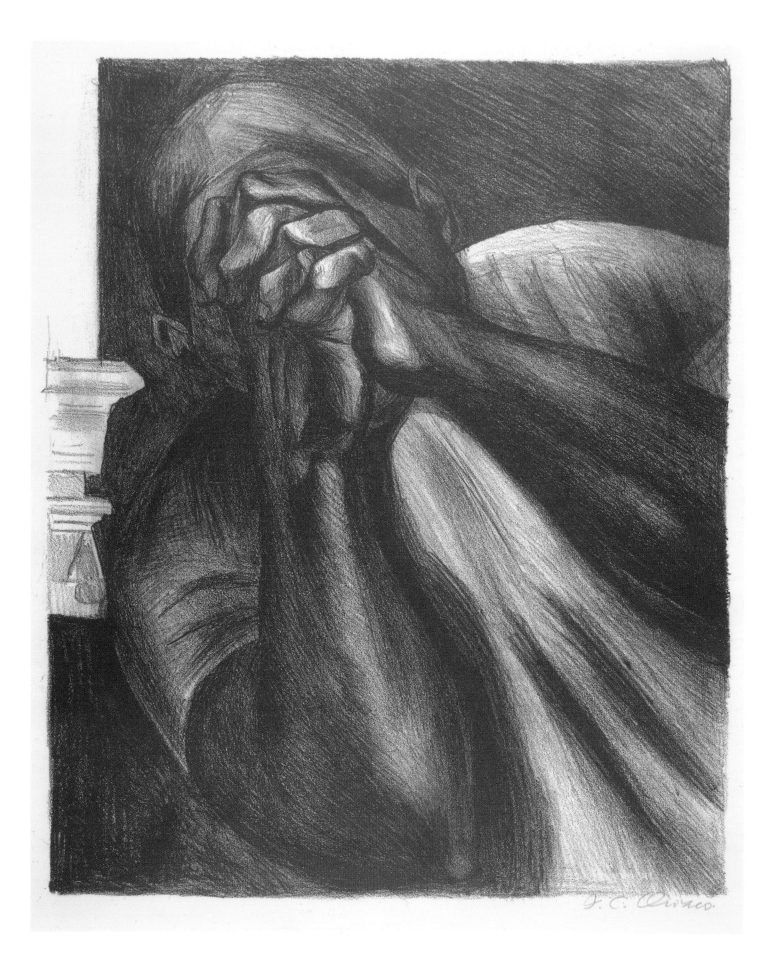

THE MEXICAN PRINTMAKING TRADITION *c.*1900–1930

Dawn Adès

There are few countries where art has taken its place so boldly in the front line of social and political events and ideologies as it did in Mexico following the Revolution that began in 1910. Printmaking in particular was remarkably vital during this period. It emerged as a favoured medium, alongside government-sponsored mural painting, among artists ready to do battle for a new aesthetic as well as a new political order.

POLITICAL CONTEXT

The Mexican Revolution was the event that defined modern Mexico. It brought change, if not the transformations in land ownership, political representation and the justice system that its most powerful voices, like that of revolutionary leader Emiliano Zapata (1879–1919), had called for. The Revolution erupted in November 1910, shortly after the lavish celebrations marking the centenary of the start of the Wars of Independence against Spain. The old dictator Porfirio Díaz (1830–1915) was coming to the end of his seventh term in office, having ruled the country since 1876. During over thirty years in power Díaz had overseen modernization and the exploitation of the country's resources, largely on behalf of foreign capital; for the majority of the population there were few benefits and great economic hardship. Despite declaring that he would not seek re-election yet again, when faced with a serious political rival, the liberal landowner Francisco Madero (1873–1913), Díaz determined to serve an eighth term as President, arrested Madero and fixed the election as usual. He had, however, seriously misjudged the mood of the country. There was discontent not just among intellectuals and idealists like Madero and among those who had probably suffered most under Díaz – rural workers, Indians and villages whose lands, held for centuries in a system of communal ownership stretching back before the Conquest, were now being enclosed by the gigantic sugar and henequen (agave) haciendas – but also among the petite bourgeoisie, artisans and factory workers. Madero's call for armed rebellion ignited the whole country. One of Díaz's most determined opponents, Ricardo Flores Magón, published his influential article 'Tierra y Libertad' ('Land and Liberty'), in the opposition journal *Regeneración* on 19 November 1910, the day before revolution broke out. Magón's article was both a call to arms and a warning to the peasants that the anti-re-electionists – in other words Madero – would do no more than change governments: 'Take, then, the land! The law tells you that you must not take it, since it is private property; but the law which so instructs you was a law written by those who are holding you in slavery'.[1]

The most enduring agrarian rebellion, Zapata's, from Morelos in the south, was to adopt Magón's slogan, 'Land and Liberty', as its own. Madero was confirmed as President in June 1911 amid general rejoicing. But the reactionary General Victoriano Huerta (1854–1916) engineered a counter-revolution; Madero was murdered in February 1913 and a long, bloody struggle ensued, with many different leaders and a bewildering clash of interests. 1917 is usually agreed as the end date of the violent phase of the Revolution, with the revised Constitution overseen by the then President Carranza (1859–1920), but it was only in 1920, when another former revolutionary general, Alvaro Obregón (1880–1928), was elected President, that a real phase of reconstruction stretching to every section of society began.

A fundamental change was the visibility of a Mexico long suppressed, or rather of multiple Mexicos, of traditions and cultures that challenged the centralizing, elite powers of Mexico City. In 1916 Obregón himself had published an important text, *Forjando Patria*, which had recognized the reality of a Mexico and of a history in which there were deep cultural differences, of language, custom and law. How to forge a nation, let alone a modern nation, was an urgent and continuing issue, and one in which the visual arts were involved to a striking degree.

Since Independence, artists had been conditioned to value the aesthetic traditions of Europe and in recent years the innovations of the modern movements – Cubism, Futurism, Expressionism – and ideally go to study there, in Rome or Paris. Now their eyes were turned towards their own country, tuning in to a different situation in which the dominant question was how the idea of the Mexican nation was to be understood and represented. How to square the demands of modern art with those of cultural nationalism was suggested in the 1921 manifesto by David Alfaro Siqueiros, 'Three Appeals for a Modern Direction: To the New Generation of American Painters and Sculptors'. Calling for artists to 'live our marvellous dynamic age!', Siqueiros proposed the restoration of 'old values', simultaneously endowed with 'new values'.[2] To this end he proposed a different way of looking at pre-Columbian art informed by a modern, constructive attitude to pure form, avoiding the 'lamentable archaeological reconstructions' of fashionable 'Indianism' or 'Primitivism': 'Let us go back to the work of the ancient inhabitants of our valleys, the Indian painters and sculptors (Maya, Aztecs, Incas, etc.). Our climatic proximity to them will help us assimilate the constructive vitality of their work.'

The following year, in the manifesto of the newly formed Sindicato de Obreros Técnicos, Pintores, y Escultores (Union of Painters, Sculptors and Technical Workers), there was a dramatic shift in emphasis from formal to political and didactic values. The manifesto, which coincided with the first flowering of the mural movement, was again written by Siqueiros but also signed by Diego Rivera, Xavier Guerrero, Fermin Revueltas, José Clemente Orozco and others. 'Indians' are still at the forefront: 'The art of the Mexican people is the most important and vital spiritual manifestation in the world today, and its Indian traditions lie at its very heart', but the focus is now on the 'people', on the collective rather than on individual expression.[3] Easel painting is brutally condemned as 'individualist masturbation' and artists are called on to 'turn their work into clear ideological propaganda for the people'. Monumental art – mural painting – is accessible to all, something 'of beauty, education and purpose' and an essential weapon while society is 'in a transitional stage between the destruction of an old order and the introduction of a new order'.

Following a retraction in the mural programme, after the elections in 1924, Siqueiros promoted a more direct and cheaper, if ephemeral, form of street art:

José Clemente Orozco, *Grief* (cat. 35)

the newspaper *El Machete*.[4] 'We will exchange the walls of public buildings for the columns of this revolutionary newspaper', he wrote in a handbill published by *El Machete*, urging its supporters to stick it up on walls.[5] *El Machete* was launched in March 1924, financed by the Union, and 'includes work by over thirty draughtsmen and engravers, all Mexico's revolutionary writers...'.[6] The gigantic format, bold red and black woodcuts by Guerrero and Siqueiros, satirical drawings by Orozco, *corridos* (popular narrative poems) and slogans of the first year are very striking. The lines on the title page, like the refrain from a popular revolutionary song, read:

> The Machete is used to cut cane
> To open up paths in shady woods,
> To decapitate snakes, to cut down all tares
> And to bring low the arrogance of the impious rich.[7]

The Union artists who produced *El Machete* did everything themselves and received no official support: as Guerrero said, 'We wrote the articles, drew the illustrations, carved the blocks; we printed and folded the paper, delivered it and paid all costs. The government was against us and we worked in secret...'.[8] To quote the August edition,

> Only because they wanted to put across a message did the muralists
> turn engravers. They were awkward at their new craft. The desire to
> enunciate clearly, the strong mural style regardless of scale, the authentic
> primitivism of engravings carved with a pocket knife, rich in art and short
> on skill, the unequal pressure on inked blocks hardly level with the type
> and the resulting coarse printing, even the tone blocks that smudge
> with red the design – all combine to make an effective impact.[9]

The image of twentieth-century Mexican art, and especially printmaking, as highly political and socially committed has been extremely powerful, and its self-proclaimed revolutionary imperative has dominated the way it has been perceived, as this conversation with the Abstract Expressionist Franz Kline illustrates:

> Visiting galleries with Franz Kline around 1955, I asked him how he felt
> about making prints, perhaps lithographs, thinking that his vivid white
> and black image could be perfectly suited to the velvety inks and papers
> of the medium.
> 'No,' he said, 'printmaking concerns social attitudes, you know – politics
> and a public...'
> 'Politics?'
> 'Yes, like the Mexicans in the 1930s; printing, multiplying, educating;
> I can't think about it; I'm involved in the private image...'[10]

Pervasive as this perception of Mexican art, and especially printmaking, has been, it is by no means the whole story. There were many strands to the rich cultural life that blossomed in Mexico City during the 1920s, and the visual arts were not exclusively dedicated to political and educational ends. Dominant, nonetheless, was the question of the 'Mexican nation', and how this abstraction was to be understood and represented socially, culturally and politically. Indicative of the intellectual debates, if not of the interests of the various peoples in question, were two essays published together in 1926, José

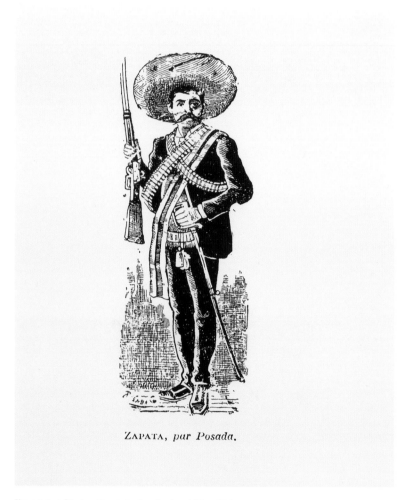

Figure 1 André Breton, *Zapata by Posada*, zinc etching, 1914, printed in *Minotaure*, vol. 12/13, 1939, p. 52

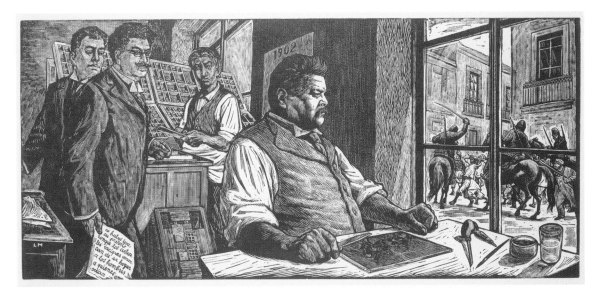

Figure 2 Leopoldo Méndez, *Homage to Posada* (*Homenaje a Posada*), linocut, 1953
(British Museum, P&D 2009,7058.1)

Vasconcelos's *European Aspects of Mexican Civilization* and Manuel Gamio's *Indigenous Aspects of Mexican Civilization*.

El *Machete* was at the extreme left of the engagement with printmaking, and other groups, such as the Open Air Schools, as well as individuals, explored the medium with gusto. More broadly, there was tension between a desire for a modern, progressive outlook and a belief in the need to return to or revive the past or the indigenous values in which many saw this past enshrined. A mighty effort was made by the Estridentistas (Stridentists; see p. 22) to impose an avant-garde aesthetic on the Mexican vanguard, which provides an interesting contrast to Siqueiros's argument that the modern constructive forms could be found in the sculpture of the ancient Mexicans. Recurrent in these disputes was the question of the popular arts. In post-revolutionary Mexico the rhetoric about the new freedom and the rights of the Mexican 'people' was accompanied by the idea of an art of and for the people. Views about what such an art might be also differed widely. José Clemente Orozco, always going against the mainstream, remarked that there was no need to make an art for the people: 'Why paint for the people? The people make their own art.'[11] It was in this context that printmaking came to occupy such a prominent place in post-revolutionary art and that José Guadalupe Posada became the iconic figure he remains today. Interestingly, in the Mexican art magazines of the 1920s sculpture and direct carving occupy a place equal to printmaking in the argument for a modern Mexican art, the former privileged because of its connection to pre-Columbian practices. It is not surprising, however, that printmaking won out both on practical and aesthetic grounds, as an ideal medium for direct expression and mass dissemination.

Although, as we shall see, there were many artists involved in printmaking beside the muralists and the socially committed artists of the Taller de Gráfica Popular (TGP), the claim of the latter to access a genuinely popular tradition through Posada has dominated the history of Mexican printmaking. There is good reason for this, as Posada is quite rightly celebrated as a unique and original artist and the iconography he created has spread widely through later prints and paintings. However, the direct line that Rivera and others claimed to trace back to Posada, as guarantee of the genuinely popular base of their own work, was forged more in retrospect than in actuality.

FORGING A TRADITION

In 1939 the Surrealist leader André Breton closed his celebration of revolutionary Mexico in the journal *Minotaure* with a print entitled *Zapata by Posada* (fig. 1). The image and its title, yoking the names Zapata and Posada, encapsulated the Mexican Revolution as the post-revolutionary artists saw it. Zapata the agrarian leader, murdered in 1919 and identified with radical land reform, and Posada, 'printmaker to the people', stood for the complete social and political transformation of Mexico.

A woodcut by Alfredo Zalce of 1948 (cat. 12) depicts Posada seated at his work table flourishing his latest *calavera* (skeleton image), with a stream of other *calavera* prints darkening the sky above a crowd of fashionably dressed citizens fleeing in terror; in the foreground a woman in a smart ballgown covers her eyes in horror. Massed round Posada himself are Mexicans with sombreros, guitar and shabby trousers, while behind him Los Tres Grandes (the Three Greats), Rivera, Orozco and Siqueiros, bare their teeth in huge skeletal smiles. The contrast is clear: the rich with their foreign styles are driven away, leaving the field clear for the real Mexicans, the poor and previously downtrodden.

A famous linocut by Leopoldo Méndez, *Homage to Posada* of 1953 (fig. 2), similarly emphasizes Posada's political engagement. Knife in hand, his massive figure gazes on a scene of violent confrontation between mounted, armed

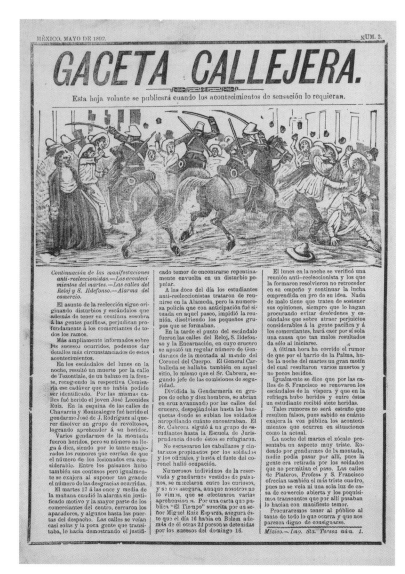

Figure 3 José Guadalupe Posada, *Continuation of Anti-re-election Riots*, from *Gaceta Callejera*, no. 2, May 1892. Wood engraving (Metropolitan Museum of Art, New York)

and helmeted troops and unarmed Indian peasants. Posada is imagined here not just as the witness to a scene that by implication radicalized the printmaker, but as the mediator between past and present and harbinger of the active role of the artisan-artist in the Revolution. Behind him are the Flores Magón brothers, apparently waiting for the cut plate before printing the anti-government text. Ricardo Flores Magón founded the journal *Regeneración* in 1900, which outspokenly criticized President Díaz. The anti-re-election riots that regularly took place were among the political events recorded by Posada in a period that saw an acceleration of the effects of social and economic change in the capital.

By 1903 Flores Magón had been forced into exile in the USA. He was a fervent supporter of the international anarchist movement, believed that property was theft and advocated self-reliant, socialist communities rather than governments. Méndez's image was intended as a homage, not as an historical record, though it has sometimes been taken as such: 'Rather than the real Posada, the linocut portrays Méndez's idealization of the revolutionary artist. For the engraver the image of the militant artisan, who gets involved in popular causes and gets angry in the face of injustice is a model to follow, a life project and an artistic programme.'[12] The scene Posada apparently witnesses from his studio relates to his image of the anti-re-election riots against President Díaz in 1892, which was published in *Gaceta Callejera* in May of that year (fig. 3). The Federal Soldiers on horseback brutally attacking the unarmed peasant crowd are transformed by Méndez into sinister hooded thugs of Fascist appearance. The date 1902 refers not to the date of the scene Posada witnesses, but to the date of Méndez's birth. Méndez refers to only one of the satirical prints Posada made of the riots, which implies a clear anti-Díaz stance, but in fact it would be hard to determine Posada's politics from his work: like all great satirical artists, his targets were hypocrisy, corruption, abuse of power and pretension.

In the search for an alternative visual tradition it was natural for the post-revolutionary artists to recognize in Posada a worthy forebear, though this recognition was not as immediate or instinctive as they claimed: he died in relative obscurity in January 1913. The story of his rediscovery throws an interesting light on the emergence of 'los artes populares'. After his death the publishing house of Vanegas Arroyo, for which Posada had done most of his work, continued to print from his plates, on occasion sawing and trimming them just as had frequently been done during his lifetime. Posada was not wholly forgotten, though, and he was, unusually, mentioned by name in a context where most producers are by definition anonymous, in the catalogue for the exhibition 'Los Artes Populares en México' organized by Dr Atl in 1922. This wide-ranging celebration of Mexican popular arts included not just textiles and pottery but also furniture, architecture and music.

> The popular arts in Mexico are important:
> because they satisfy vital social needs
> for the variety of their productions
> because all bear, either in their forms, or in their decorative spirit, or in their colours, the stamp of an innate, of a deep, innate aesthetic sense...
> Moreover, the artistic or industrial manifestations of the pure indigenous races and of the mixed or intermediate races present – contrary to those of groups that are ethnically similar to europeans – strongly marked characteristics of homogeneity, method, perseverance, and really constitute a true, national culture.[13]

A chapter in the catalogue was devoted to 'Literatura-Poesia-Estampería' ('Literature-Poetry-Printmaking'), with *corridos* and moral tales interspersed with popular prints: many of the *corridos* are, as Atl notes, completely modern, dating from 1921, and are dedicated to Zapata and his tragic death, or to Pancho Villa and other heroes of the Revolution. A special section with more prints ended with a text on 'Las casas editoras de Vanegas Arroyo y Guerrero' ('the publishing houses of Vanegas Arroyo and Guerrero'). A few of the prints reproduced on the preceding pages are from the Guerrero publishing house, but the vast majority were from Vanegas Arroyo's, 'la más importante en su género en todo el país' ('the most important of its kind in the whole country'). Two of Vanegas Arroyo's writers are mentioned: Manuel Romero and Constancio S. Suárez, author of the comic-fantastic macabre *capricho* *Fandango of the Dead*. Of the prints reproduced, only a handful are visibly signed by Posada, though most are assumed to be by him, and he is the only artist named: '... Guadalupe Posadas [sic], printmaker unique of his kind, for nobody has caught the absurd character of the capital's lower classes so clearly'.[14]

In 1924 *El Machete* used one of Posada's prints without naming him, drawing a topical message from an incident from the early days of the Revolution:

[Title:] Government hired guards are not the Invincibles. Since 1910, the People have defeated them many times.
[Caption:] The engraving here published dates from the early days of the Revolution and represents revolutionary 'hordes' destroying the unbeatable Federal troops whose officers were trained in European military academies. May the military men of today never renege on their revolutionary origins to become in their turn bodyguards to the present government, or they will suffer the same fate.[15]

The author of the image was irrelevant; all that mattered was the message.

More influential in the discovery of Posada was the article by the French painter Jean Charlot published in *Revista de Revistas* in 1925, 'Un precursor del movimiento de Arte Mexicano: el grabador Posadas [sic]'. In 1930 Posada was honoured with a monograph published by the magazine *Mexican Folkways* for the Talleres Gráficos de la Nación (National Print Workshop), with an introduction by Diego Rivera. Rivera describes a negative and a positive tendency in Mexican art: on the one hand the 'imitative and colonial', on the other 'the work of the people ... popular art ... of these artists, the greatest is the genial engraver José Guadalupe Posada'.[16] Posada, 'as great as Goya or Callot', produced, Rivera claims, more than fifteen thousand engravings. Rivera devises an ingenious argument connecting the urban caricaturist to the pre-Columbian art that was now appealed to as the basis of a genuine Mexican tradition. He admits that Posada's prints may be extremely dynamic, but they still maintain 'the greatest equilibrium of chiaroscuro in relation to the dimension of the engraving', equilibrium being 'the greatest quality of classical Mexican art, that is, of Pre-Conquest art'. The 'terrible and droll use of death', too, was a trait of ancient Mexican art, and Posada was the greatest exponent of the satirical *calavera*: 'Surely no bourgeoisie has had such bad luck as the Mexican in having had so just a portrayer of their customs, actions and doings as the genial and incomparable Guadalupe Posada.' Particularly interesting is Rivera's attempt to reconcile the incompatible demands of the anonymity of the popular and the naming of the artist:

Who will raise the monument to Posada? Those who one day will make the true Revolution, – the workers and peasants of Mexico.
Posada was so great that perhaps someday his name will be forgotten! He is so integrated with the popular soul of Mexico that perhaps his identity will become completely lost ...'[17]

Reversing what had, in fact, already happened – the forgetting of the name of this gifted jobbing artisan – Rivera puts the seal on Posada's rehabilitation as the ideal revolutionary artist. Recognizing the unique quality of Posada's work, however, did not stop almost the entire production of popular prints now being ascribed to him. Among the victims of Posada's posthumous fame was Manuel Manilla, many of whose prints are still misidentified, despite the best efforts of Jean Charlot who did so much to rescue the names of these artists from oblivion. As he put it in his early essay on Manilla in *Forma* in 1926:

So the trick of 'popular art' was invented, whereby homage could be paid to the works of art and the artist who created them could continue to be despised. He was kept out of sight, supposedly for his own good, for if his work ceased to be anonymous, it would cease to be 'popular' and no longer interest the 'elite'.[18]

Charlot had no truck with the romantic notion of the anonymous people's artist; though fully signed up to the often repeated admiration for the natural aesthetic sense and love of beauty in everyday things – pots, *rebozos* (shawls), altarpieces – regularly attributed to Mexicans, he was determined to dignify wherever possible their makers, especially of the popular prints produced in their thousands by publishing houses like Vanegas Arroyo's. 'I believe that, with a little good will, we could "de-popularize" a large part of Mexican visual art and finally render its creators the praise and respect they deserve.'[19] If, as Charlot says, Posada shook up and revolutionized an existing tradition, this tradition was well represented by Manilla.

MANILLA, POSADA AND THE PUBLISHING HOUSE OF ARROYO
According to the biography quoted in *Las Artes Populares en México*, Vanegas Arroyo was from Puebla. He learned about printing from his father, moved to Mexico City in 1868 at the age of sixteen, married in 1875 and the following year set up his own publishing house with capital of ten *pesos*. Thanks to his huge energy and enthusiasm he prospered, and kept up a flow of cheap prints, broadsides, songbooks and so on of an unrivalled quality. He died in 1917, four years after Posada. In 1922, when Dr Atl published his monograph on popular art in Mexico, the house was still going strong, run by Arroyo's widow and his son Blas, the prints as popular as ever. The seasonal rhythm continued, with the *calaveras* for the Day of the Dead and the images of the Virgin of Guadalupe on her holy day, 12 December. Posada's line blocks were reused again and again, and fifty years later the firm was still productive:

One late evening in the 1940s in the inner recesses of his shop I watched Don Blas, son of Don Antonio and by then head of the firm, apportioning by the light of a single candle his brittle wares to a flock of papaleros [newspaper boys] as crumbs to sparrows. With nimble fingers he sorted the frail sheets with astonishing speed. 'For you one hundred Guadalupes. And for you fifty Santo Niños...'[20]

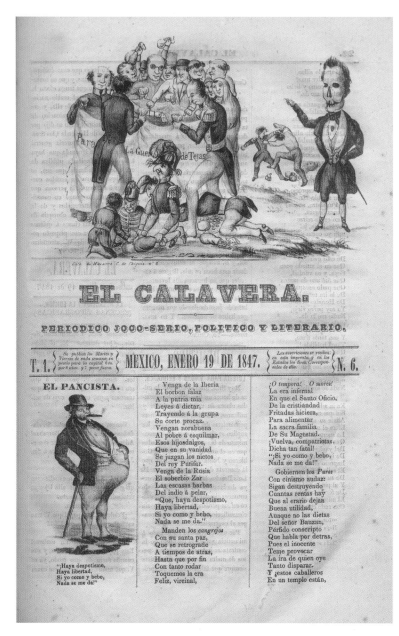

Figure 4 Front cover of *El Calavera*, 19 January 1847. Lithograph (Beinecke Rare Book and Manuscript Library, Yale University)

Manuel Manilla was a native of Mexico City; born in 1830, he started to work for Vanegas Arroyo in 1882. It is said that his retirement in 1892 was at least in part caused by the arrival of the younger Posada, against whose energy and visual ingenuity he was no match. He died in 1895, but the Manilla workshop continued until about 1902.

> Manuel Manilla and Son. This firm, specializing in engravings, is located in the third booth at No 12, Pulquería de Palacio. We cut all kinds of designs in wood and metal, mother-of-pearl and tortoise shell [and] paint commercial signboards. We also electrotype stereotypes with utmost perfection, specializing in elevations and views of buildings. We carve seals in both rubber and metal, design stamps and monograms.[21]

Manilla's prints lack the dynamism of Posada, the sharp eye for the detail that brings limb or gesture to life and the acute satirical edge. However, they have a constructive solidity that conforms with his specialization in architectural views. His prints often include city streets, with a greater emphasis on detail of the building than one finds in Posada, or carefully plotted interiors with meticulous perspective. As well as street and simple family scenes, Manilla produced a ran.ge of entertaining characters from the circus: bandits, demons carrying away unruly boys, and picturesque types like the waterseller. In *Epitaphs at the old cemetery* (cat. 8), both the architectural detail and the rather stolid types being directed to their last resting places by a seated *calavera* suggest that the print could be by Manilla. Each of the types, male or female (soldier, bull-fighter, tenor, doctor, professor, lawyer, etc.), has an appropriate epitaph in the accompanying *corrido*. In *A skeleton from Guadalajara* (cat. 5), printed by Vanegas Arroyo long after Manilla died, the man is seated at a table seen in depth, with the objects carefully disposed as if in a still life.

Manilla was one of the first to specialize in the *calavera*, which has a long history in Mexico. One of the first satirical reviews in Mexico was El *Calavera* ('comic-serious political and literary periodical'). On 19 January 1847 it carried on its front page a skull-headed, well-dressed figure observing a military fiasco in which officers profited from the war with the USA (fig. 4). Manilla established the *calavera*, the animated figure of death, as a genre in the popular print.

Calaveras were produced for the Day of the Dead festivities on 1 November; some would have been sold individually from the shop at the front of the Vanegas Arroyo publishing house, others parcelled out for distribution on the streets and into the country by hawkers and peddlers. In Posada's *The graveyard where all the skeletons are piled high* (cat. 3), rich and poor come, as is still the custom on All Souls' Day, to the cemetery to share food with their deceased relatives. Families clean and decorate the graves with flowers and spread out the picnic. This was evidently a particularly popular print and was used several times with variations and additional elements, most probably put together by Don Antonio Vanegas Arroyo himself. The central element of the image is the same in these prints which also drop in elements from other blocks, so that there is a variety of techniques including photo-relief etching (the main picture) and engraving. Not only did the publisher here combine sections from various plates, but these were also probably by different artists, the single skulls to right and left of the main picture closely resembling those on Manilla's *The horrifying skeleton of the Guanajuato flood*. Identical skulls also occur in the latter and in Posada's *Artistic Purgatory*.

From estimates of up to twenty thousand prints, Posada's oeuvre is now

reckoned at about fifteen hundred, although of course this remains complicated by the combinations and re-cuttings, which play havoc with the very idea of the 'oeuvre'. Posada had been apprenticed in 1868, as a teenager, to a lithographer, José Trinidad Pedroza, in his native town of Aguascalientes. After moving to León he not only produced lithographs for the illustrated press and for books, but taught practical lithography at a technical school in León. He was therefore an expert in a relatively refined technique. After moving permanently to Mexico City in 1888 he began to work for Vanegas Arroyo and other popular publishers; his technical procedures and style changed as a result, from a sophisticated to a cruder and simpler manner. The illustrations for the broadsides, produced in large quantities, had to be set with type and quickly and cheaply produced, requirements for which lithography was not suitable. Posada seems quite soon to have adopted a process known as photo-relief etching, which was quicker and cheaper than more traditional forms of engraving and etching.[22]

Posada himself frequently recycled his prints, adapting them for new circumstances, events and characters. He made two versions in 1907 of *The skeletons of the people's editor Antonio Vanegas Arroyo* (cat. 1), of which this is probably the second. At the publisher's feet his broadsheets and books are strewn over the ground, together with the symbols of their chief subjects: gun and sword for the tales of violence and military exploits on one side, a diamond ring and a cross on the other, weddings and funerals, perhaps. Above the latter, on the right, is a *calavera* of a priest; on the other side, a soldier. The resemblance of the cross, on a religious pamphlet, to crossbones is wickedly picked up on the two broadsheets with their skulls and crossbones being peddled by the street salesman just under Vanegas Arroyo's arm.

> Founded in the year 1880 of the nineteenth century, this ancient firm stocks a wide choice: Collections of Greetings, Tricks, Puzzles, Games, Cookbooks, Recipes for making Candies and Pastries, Models of Speeches, Scripts for Clowns, Patriotic Exhortations, Playlets meant for Children or Puppets, Pleasant Tales. Also: the Novel Oracle, Rules for Telling the Cards, a New Set of Mexican Prognostications, Books of Magic, Both Brown and White, Handbook for Witches.[23]

Don Antonio Vanegas Arroyo stands with his books behind him on the right, and the typographic trays on the left. Keeping to this division, the two wings of his house's production spread on each side: on the right the writers at a table with inkpot and paper, music sheets behind them, and on the left the printing press operated by a hunched skeleton. In the first version the images extend up each side of the *corrido*, continuing the theme. On the left there is an artist-*calavera*, seated in front of an easel, and on the right a photographer-*calavera* ducked under the black hood of his plate camera. Quite what the implications of this particular paired opposition are is not clear – perhaps it is between documentation and invention. Posada had begun to base some of his actual images on photographs, often from the Casasola agency in Mexico City, which transmitted news photographs worldwide. But more likely it refers, as Thomas Gretton has argued, to the production processes:

> Vanegas Arroyo never used half-tone photo-engraved blocks, made from photographs; so, in the picture, the camera is surely being used to produce line blocks and the artist is tracing drawings for this process;

the ironic, self-referential tone of the rest of the picture, and of the texts, tells us that we should add: 'this too.'[24]

In any case, fate and chance haunt the scene as much in the cards and dice scattered about as in the skulls and skeletons themselves.

One of Posada's most famous *calavera* prints was the *Great electric calavera*, c.1905 which reappears as the *Centenary festival* in 1910 (cat. 6). In *Great electric calavera* he creates an animated scene in which the electric skeleton, rays darting from its eyes like the magic invisible sources of energy that power the street car, addresses a crowd of skulls that have tumbled from the cemetery, its sombre trees visible behind its walls. Electric trams were introduced to Mexico City during the regime of Porfirio Díaz as part of the extensive modernization programme that included electric street lighting and railways and transformed the capital from a provincial city to a prosperous metropolis. Díaz's thirty-four years of rule saw peace, economic prosperity for the few and worsening conditions for the vast majority of Mexicans who lived on the land. Posada was not interested in agrarian problems or in the questions of Indian land rights, but in so far as they visibly inflamed the growing unrest in the country he responded with satirical prints such as *It looks like a drink of chía, but it's the soft drink horchata*, which was reproduced in El Diablito Rojo in October 1910. Also sometimes given the title *Project for a monument to the people*, this is an extraordinary print that strays outside his regular reference both in depicting the 'raza indigena', the indigenous people, on one side and the proletariat on the other, and in using a European classical source, the sculpture of the Laocoon, to express the conflict within the notion of the 'people'.

The skeleton of Pascual Orozco (cat. 9) of 1912 reworks the *Ordinary skeletons* of 1910, accompanied by a new *corrido*. The wildly grinning figure with bloody machete and huge sombrero running rampant over the crowds could well be seen as the harbinger of revolution. From the black holes of the huge skull's eyes rays shoot out, like those from the *Electric calavera*, as though they were the shining black obsidian mirror-eyes of Tezcatlipoca, one of the principal pre-Conquest Aztec deities. Few as Posada's references are to the Aztec, this *calavera* with its typically Mexican attributes does seem uncannily to prefigure the double appeal of the post-revolutionary artists to the Aztec past and to the popular arts. The *calaveras* are like memento mori crossed with a macabre carnival. The first version of this *corrido*, *Ordinary skeletons*, mentions both the former president and Francisco Madero, so presumably was made after Díaz had fled ('Aqui esta la calavera/ del que ha sido presidente': 'Here is the *calavera* of the person who was president'). Perhaps it is Díaz and his top-hatted advisors who are being scared away at the left. Two years later, Posada reuses the plate, now to make the *Skeleton of Pascual Orozco*. This time, the hugely grinning skull with wide-brimmed, richly decorated sombrero and brandishing a machete represents not the people but one of the leaders of the Northern rebellion, 'militar famoso/ temeraro [sic] y poderoso' ('famous soldier, bold and powerful') as lines from the *corrido* describe him. Pascual Orozco was one of the three chief leaders of the regionally based revolutionary movements that swept through Mexico. The other two were Pancho Villa and Emiliano Zapata, later to become far more celebrated than Orozco.

THE MEXICAN REVOLUTION

Following the collapse of the Díaz dictatorship and the election of Francisco Madero as President in November 1911, Orozco, formerly a muleskinner, and

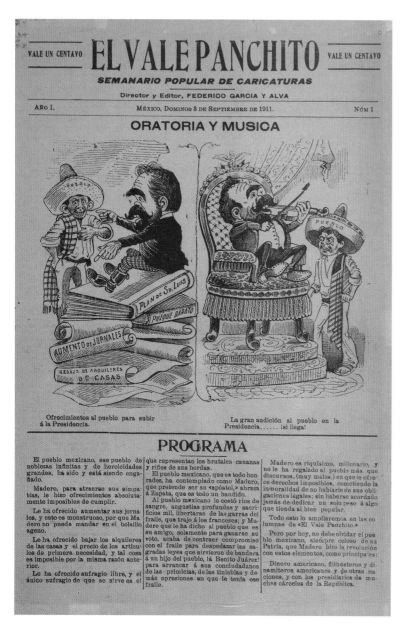

Figure 5 José Guadalupe Posada, *Oratorio and music (Oratoria y música)*, from *El Vale Panchito*, 3 September 1911. Zinc etching

Villa, rural worker and occasional bandit, 'openly declared their allegiance to Madero's revolution. Madero's promises and successful armed struggle encouraged the formation of the mass-based agrarian working class and urban and industrial labor movements of the revolution.'[25] Madero was quite unable to contain or satisfy the forces for change that had been unleashed. While his power base was the provincial elites, local landowners and the relatively small middle class, who resented the extensive foreign influence courted by Díaz through his long reign and the stranglehold of US and European capitalists on Mexican land and resources – vast haciendas, mines and industries owned by absentee landlords – Orozco and Villa were working men who led a mixture of peasants, industrial workers, artisans as well as Yaqui Indians from Sonora and Mayo Indians in Sinaloa. The nationalism of Madero and his supporters was very different from that of peasant, working-class and Indian revolutionaries, and his failure to appoint either Orozco or Villa to his cabinet and his refusal to recognize their demands for full-scale land reform, minimum wages and nationalization of the railways were strategic blunders – although in line with his political thinking and the interests of the provincial elite who backed him.

Violence was to continue throughout the country; while historians agree on the date of the start of the Revolution in 1910, its end date is less clear. Some give 1917, the date of the nationalist constitution and the presidency of Carranza. Others give 1920, the date of Alvaro Obregón's *coup d'état* against Carranza and the start of his process of consolidating the Revolution and restructuring the political framework; or even 1924, when this was tested and proved strong enough to ensure the relatively peaceful election of his successor. However, in her 1943 history of the Revolution, *The Wind That Swept Mexico*, Anita Brenner suggests that it was still not laid to rest: 'It is the past, and it is a set of beliefs.'[26] How those beliefs survived, challenged the reality of postrevolutionary Mexico and were enshrined in the work of the artists who 'gave a face' to the Revolution has been a major factor in the history of modern Mexico.

In *The skeleton of Pascual Orozco* (cat. 9) Posada injects his usual dynamism and vitality into the figures, especially that of the triumphant fighter. However, were it not for the title, he would more naturally be identified as Zapata, usually depicted wearing the wide-brimmed hat, while Orozco himself wore a high-crowned felt hat.[27] The Revolution was only a couple of years into its long, violent and complex unfurling when Posada died, in January 1913, and to describe him as a 'revolutionary artist' begs many questions. Even by this date it was clear that there were different interests and ambitions among the different forces at war, though with the election of Madero as President in November 1911 it might have looked as if his revolution had succeeded. The fact that this was not what Zapata had expected and for which he had supported Madero through the first months of the Revolution was becoming evident.

Madero, from a wealthy landed family, a progressive and a liberal, dissolved the Anti-re-electionist Party and founded a new Progressive Constitutional Party in July 1911, in preparation for the elections that would undoubtedly bring him to the presidency. He had needed Zapata, as well as Orozco and Villa, to establish a broad base to his revolution, but when the time came was not prepared to honour the promises of local land reforms for which Zapata was working. The planters and hacienda owners agitated against Zapata, and a campaign in the Mexico City press ran scaremongering headlines: 'Zapata is the modern Attila'. The Zapatistas' very specific, distinct revolt in Morelos found echoes and many local bands of supporters all over Mexico, but it was unlike the Northern Revolt and unlike the nationalist revolutionaries led by Madero, who

were concerned more with legal government than with implementing radical agrarian reforms which looked to them dangerously like Communism. Zapata had a definite and limited goal, which was to restore to the villages and *ranchos*, the small farms, the rights to land, water and timber that had been drastically eroded by the expansion of the haciendas and the great sugar plantations under Díaz. In the absence of confirmation from Madero that these reforms would be forthcoming, and eventually an official repudiation ('Inform him that his rebellious attitude is damaging my government greatly...'),[28] Zapata, aided by Ottilio Montaño, drew up the Plan de Ayala, to which he remained committed.

This was the situation that Posada satirized in his cartoon 'Oratoria y música' in the popular weekly *El Vale Panchito* (fig. 5). Madero's promises to the 'people' and the reality of his actions as President – though still to come, this was a foregone conclusion – are quite different. Madero is shown, on the left, gesturing to 'the People' from the top of a pile of the published pronouncements that had led Zapata to trust him; the Plan of San Luis Potosi had contained a crucial clause in the Third Article that said:

> Through unfair advantage taken of the Law of Untitled Lands, numerous proprietors of small holdings, in their majority Indians, have been dispossessed of their lands... It being full justice to restore to the former owners the lands of which they were dispossessed so arbitrarily, such dispositions and decisions are declared subject to review. And those who acquitted [the lands] in such an immoral way, or their heirs, will be required to return them to the original owners...[29]

In the cartoon, to the right, Madero is shown fiddling from a throne, trying, perhaps, to fool the people with lyrical, empty promises, having 'reverted to his patrician upbringing'. Posada's political angle is not evident – as a satire on Madero it could have been seen as coming from right or left, from the old Díaz supporters, landowners and the elite, or from the 'people' being wooed, not just with the Plan of San Luis Potosi, but with cheap *pulque* (agave beer). Madero is clearly the target, but the 'pueblo' is also a caricature, the 'Indian' and the peon, as Madero, it is implied, saw them. For Posada the city man, skilled artisan, witness to the modernization and electrification of the city, rural issues – despite the fact that over 80 per cent of the Mexican population was employed on the land – were not central. The strikes that affected the city in the summer of 1911, such as the tram strike, were of greater interest. Nonetheless, he had earlier published broadsides (fig. 6) attacking the system of kidnapping workers and transporting defeated opponents of the regime like the Yaqui Indians to work on the henequen plantations of Yucatan.

EMILIANO ZAPATA

Emiliano Zapata was already notorious when Posada produced his portrait, based on a photograph from the Casasola agency, showing the agrarian leader full-face in dark clothes, tight black trousers, crossed bandoleers, gun and sword. Already he was 'no longer a man, he is a symbol. He could turn himself in tomorrow ... but the rabble [following him] ... would not surrender'.[30] The fundamental difference between the social and the political ideas of revolution, the divorce between the agrarian demands of the Zapatistas and the national, political concerns of the city or landowner classes, continued to furrow deep divisions throughout Mexico. The aim of Zapata's opponents was not just to get rid of him physically, but to root out his very memory. After his

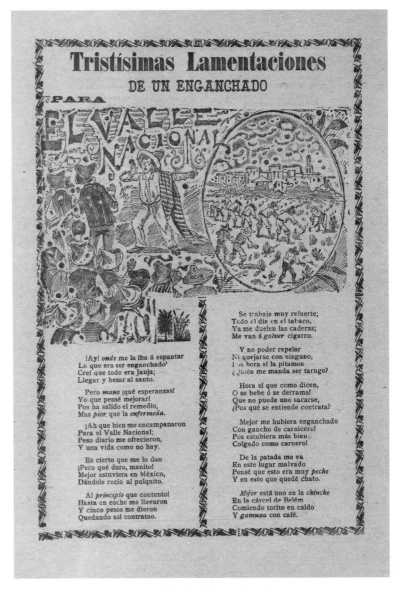

Figure 6 José Guadalupe Posada, *Kidnaps* (*Tristísimas lamentaciones de un Enganchado*), zinc etching, 1904 (Yale University Art Gallery)

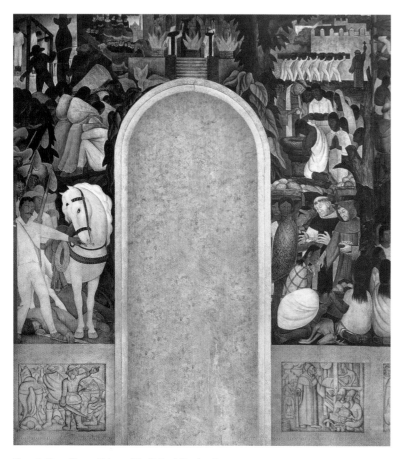

Figure 7 Diego Rivera, *History of the State of Morelos, Conquest and Revolution*, mural, Palace of Cortés, Cuernavaca, 1929–31

murder in April 1919 a triumphalist manifesto from the military governor of Morelos declared: 'Zapata having disappeared, Zapatismo has died.'[31] The Carranza newspapers trumpeted the death of 'the famous Attila', but the more moderate El Demócrata recognized that his myth was based in the reality of what he stood for among the natives of Morelos, to whom he gave 'a formula of vindication against old offences ... which already existed latently and which his cry of insurrection did no more than condense in tempestuous storm clouds'.[32] The myth of Zapata could only be destroyed with the destruction of the injustices that generated him – a prophetic comment.

Seven years after Zapata's murder, Rivera depicted him in the chapel of the Agricultural School at Chapingo, in one of the five scenes in the sequence in the nave, *Canción de la terra (Song of the Earth)*. The bodies of Zapata and his old colleague Ottilio Montaño (executed for treason by Zapatistas in May 1917) are shown in shrouds under the ground beneath sprouting fields of maize: 'The blood of the martyrs fertilizes the earth.' The symbolism came naturally to Rivera.

Rivera's 1932 lithograph *Emiliano Zapata and his horse* (cat. 22) was based on one of the panels Rivera painted for the Palace of Cortés in Cuernavaca, *History of the State of Morelos, Conquest and Revolution* (1929–31; fig. 7). Cuernavaca is the state capital of Morelos, Zapata's home ground. Rivera included Zapata twice in the Cuernavaca murals: standing isolated in an inner arch dividing the long chamber, facing the Independence hero Morales, in the pose made famous by Posada's print, and then in a scene from the history of Morelos. Rivera's panels, reading from right to left along the wall in the manner of the pre-Conquest codices, start with the Spanish invasions of the sixteenth century and end with 'Revuelta'. This is the scene on which the lithograph, and a free-standing fresco panel now in the collection of the Museum of Modern Art in New York, are based. Unlike the Posada-based portrait, here Rivera shows him wearing the white shirt, trousers and sandals of the native peasants who formed the great bulk of his army and would return at planting and harvesting times to work their fields. This was Zapata's ultimate aim, to return to his farm, as he said in an interview in June 1911: 'I've got some land and a stable ... that I earned through long years of honest work and not through political campaigns ... Now I'm going to work at discharging the men who helped me so I can retire to private life and go back to farming my fields.'[33] During one of the many attempts to forge alliances between the different revolutionary factions in 1914, while there was a power vacuum in Mexico City, representatives of General Carranza – the ambitious, wily ex-Díaz supporter, member of the high ruling circles of the revolutionary coalition after the fall of Díaz and First Chief of the Constitutionalists who eventually took power in 1917 – arrived in Cuernavaca for talks with Zapata:

> ... their surprise at what they saw immediately betrayed how slight were the chances for an understanding ... Cuernavaca had become a town that Morelos's common country people had taken over, camped in and turned into their own ... To their discomfort, the Constitutionalists could not tell who was a chief and who was not: except for stray *charros* [horsemen], Zapatista leaders dressed like their followers in the sandals and white work clothes all Morelos farmers wore.[34]

Rivera shows precisely this modest indifference to hierarchy and the decorum of power: Zapata is one among many, but he is also exceptional. The clear whites of horse and clothes stand out against the thick, dark mass of foliage

and the softer, greyish white of those behind him. Zapata carries a sickle (one half of the icon of the Russian Revolution), and those behind him carry hoes. Under his foot is the sword of a dead soldier or bandit, and the message is clear: for peace, beat swords into ploughshares.

Rivera captures something of the qualities that have made Zapata such an enduring symbol of the fight for land rights and justice. He was neither personally ambitious nor greedy, and was regarded by his followers with *cariño*, affection, not fear. A gifted horseman, he had been employed in the stables of Díaz's son-in-law before the Revolution, and could have stayed; he was offered a hacienda by one new president after another if he would promise to disarm and stop harassing them. Deliberately, Rivera shows Zapata on the ground, not mounted. It is not therefore an equestrian portrait in the grand tradition of Rubens and Van Dyck, though it certainly has echoes of these, in the elegant curve of the horse's neck and flowing mane. The white horse, with its braided and silver-studded bridle, is more flamboyant than Zapata himself. Rivera may be referring here to the legend that quickly gained strength in Morelos after his murder. Zapata was killed while riding a beautiful new sorrel given him by the man who betrayed him, a young army officer who pretended to defect with his troop to the rebels. It was said, after the murder, that the horse was seen galloping, riderless, in the hills; those who saw it said it was white now, white as a star.

So far from being erased with his death, Zapata's image continued to be instantly recognizable, whether wearing the peasant white, as in Ignacio Aguirre's linocut (cat. 20), or sombrero and neckerchief, as in Angel Zamarripa's woodcut (cat. 21), with banners bearing the name of his village in Morelos, Anenecuilco, and the slogan of the anarchists, 'Tierra y Libertad', Land and Liberty, first coined by Ricardo Flores Magón (see p. 11). An early TGP poster of 1938, *All land for the peasants* (cat. 23), invokes Zapata in its claim that land redistribution has not moved as fast nor been as complete as it should have been: '... the country people must continue to struggle to get back the 70,000,000 hectares still in the control of the big landowners and thus realize the ideals of Zapata.' Woodcuts of the post-revolutionary printmakers, of which Aguirre's *Zapata* is a striking example, emphasize the direct, laborious business of cutting into the wood. The harsh, angular strokes for the maize plants, the varied but simple marks for the corn in its husks on the ground and the repeated gouges that construct the earth beneath his feet mimic the labour of the farmer. They impress on the viewer the union between the artist's social commitment and the actual job of tilling, sowing and harvesting.

JOSÉ CLEMENTE OROZCO

Both Rivera and Siqueiros responded to the new idea of the nation, whose complex rural, indigenous and proletarian components as blown apart by the Revolution were analysed in texts such as Manuel Gamio's *Forjando Patria* of 1916, with works, including many prints, that were either of a polemical, historical and political character, or sentimental and romantic views of peasant or Indian subjects. However, the third member of Los Tres Grandes, José Clemente Orozco, took a much bleaker view of the Revolution and of the idea of 'the people'. His early career was as a satirist and in some respects he is closer to Posada than any of the other post-revolutionary artists. But if he shared Posada's satirical vision, it was not as an artist of the people but as an individualist with a visual intelligence that made the most of his particular means.

During the early years of the Revolution Orozco had made caricatures for anti-Madero newspapers, *El Imparcial* and *El Hijo del Ahuizote*, and in 1915 for the pro-Carranza *La Vanguardia*, which often use the *calavera*. Violent, radically anti-clerical and often sexual, these cartoons look back to Posada but also herald an attitude to modern life, to Mexico and to the Revolution that is very different from that of Rivera and Siqueiros. Orozco rejected picturesque 'Mexicanism' and the sentimental 'painting of sandals and dirty cotton pants'. 'The people' were the subject of two bitter lithographs in the mid-1930s (cats 37a, b), one showing virtually mechanized proletarian marchers dwarfed by their banners, the other a mass of mouths on stick legs under a few presumably anarchist flags, a terrifying vision of mindless demand. Orozco was resistant to the glorification of the Revolution, and determined, as an artist, to find another way, independent of both the realist Mexicanism of the sombrero and the peasant mother and of the modernist styles of Europe. His work remained figurative but has a freedom related both to Expressionism and to his earlier caricatures.

In 1928 Orozco started to make lithographs, as he wrote to Jean Charlot from New York: 'LITHOGRAPHY: I am going to do it, it's easy, it doesn't have to be done on stone, there are some special plates, I already have two of them.'[35] Orozco's first New York lithograph is a scene in the theatre (cat. 33), a brilliant exercise in the contrast between dark mass and the light, sketchy, dynamic stage performance. Other lithographs from his stay in New York, however, which lasted from 1927 to 1934, relate to the murals he had painted at the National Preparatory School in Mexico City in 1923–4, and in 1926.[36] The 1930 lithograph of the figure with clasped hands (cat. 35) is based on the left-hand figure of the mural *Revolutionary Trinity*, of 1926, a devastating indictment of blind violence. A gunman shrouded with a red liberty cap forces his way between two workers, one blind and handless, the other – the origin of this lithograph – with hands clasped, desperately shielding his face. In his lithograph Orozco shows this figure from the mural as if he is seeing it in its architectural setting, with the column framing it at the left side. It is a memory rather than a copy of the fresco, however. Whereas in the original the full figure is seen kneeling, in the lithograph Orozco has closed in his focus and cut it off at the elbow, so that all the attention is concentrated on the straining arms and knotted fingers. While the figure in *The Revolutionary Trinity* is undoubtedly male (an earlier drawing identifies the two victims as engineer and architect, both men), the lithograph is more ambiguous, the smooth, velvety mass of the arms less muscular and the clothes less gender-specific.

The lithographs produced by Rivera and Orozco in the late 1920s and 1930s were for exhibition and sale; Orozco showed in both group and solo shows all over the USA and also in Vienna and Paris.[37] Rivera produced highly marketable images like the *Boy with chihuahua* (cat. 27), a consummate orchestration of the interplay of hard contour and soft, shaded masses characteristic of lithography.

CULTURAL NATIONALISM AND THE AVANT-GARDE

Post-revolutionary energies drew artists into the nationalist surge to create a new culture; how this was to be understood, however, differed widely according to the political and aesthetic ideas of the various individuals and groups. Unlike revolutionary Russia, the underlying motivation was on the whole national rather than international. But like the Russian revolutionary artists, the aim was to reach the widest possible audience with means appropriate to the message. The contrasts with debates and practices in Russia during and after the October Revolution are very interesting. Whereas in the USSR, at least in the first years after the Revolution, the drive was towards technologically modern forms of expression, such as photography and photomontage, in line with grand

Figure 8 Manuel Maples Arce, Stridentist manifesto poster, *Actual*, December 1921

modernization projects and utopian social schemes, in Mexico it was prints, together with the gigantic mural programmes, that gave a face to the Revolution. Although occasionally there was recourse to photographs, and less frequently photomontage, artists turned to what were seen as more popular forms, especially woodcuts and linocuts. Though often short-lived, new magazines burgeoned in the welcoming cultural climate fostered by José Vasconcelos while Minister of Education and Head of the National Preparatory School from 1920 to 1924. There were several different groups in Mexico in the 1920s that sought to lay the aesthetic basis for a modern Mexican art; in all cases printmaking was promoted as a major means of expression.

El Estridentismo (Stridentism) was, as its name indicates, a raucous avant-garde movement built along the lines of Italian Futurism and dedicated to dragging Mexico away from its obsession with the past. 'Death to the Curate Hidalgo!' it shockingly declared, blithely wiping out the most revered of Mexico's heroes of Independence. Stridentism was launched in Mexico City, by the young law student and poet Manuel Maples Arce (1898–1981) with a manifesto-poster published in the first issue of his review *Actual*, in December 1921 (fig. 8). The fourteen points of the manifesto pick smartly from among the European '-isms', with a huge range of reference to poets, philosophers and artists, from Nietzsche and Pierre-Albert Birot to Marinetti's 1909 *Founding and Manifesto of Futurism*, one of whose most famous lines is quoted: 'A racing car is more beautiful than the Victory of Samothrace.'

Celebrating the machine and attacking logic in a combined Futurist-Dada manner, Maples Arce's idea is for a frankly eclectic avant-gardism, without rigid aesthetic rules.

No more creationism, dadaism, paroxysm, expressionism, synthetism, imagism, suprematism, cubism, orphism, etcetera etcetera, more or less theorized and efficient 'isms'. Let's make a quintessential and purifying synthesis of all the tendencies that have flourished at the maximal level of our modern, enlightened, elation.[38]

The manifesto ends triumphantly with a Directory of the Vanguard, listing well over 150 names, including Alfonso Reyes, Rivera, Siqueiros, Duchamp, Picasso, Tatlin, Breton and de Chirico. Among the artist-affiliates were Ramón Alva de la Canal, Fermín Revueltas, Fernando Leal, Jean Charlot and Leopoldo Méndez. Stridentist publications were illustrated, usually with woodcuts and linocuts, the most striking of which were by Alva de la Canal and Charlot, who draw on generalized elements of a modernist vocabulary, sometimes using the red and black colours of Russian constructivism. Charlot, in his illustrations for Maples Arce's *Urbe: Bolshevik Super Poem in 5 Parts* (cat. 101), published in 1924, uses contrasts of scale to increase the impact of the large, simple shapes of viaduct, skyscraper, ocean liner. The character of woodcut, with shapes gouged and scraped into the block, and the emphasis on directness and simplicity of outline, is evident in the strong black masses with thinly sketched white figures. In *Viaduct* the train's speed is cunningly indicated by the white dashes along the line of the bridge's parapet, which could be lights or sparks, and its great height above the elongated arches is reinforced by the tiny figure below, waving a handkerchief. This woodcut anticipates Kertesz's 1928 photograph of the viaduct at Meudon, on the outskirts of Paris, and it is possible that Charlot knew the Rodchenko photomontages for Mayakovsky's poem 'Pro Eto' ('About This') of 1923.

Jean Charlot had arrived in Mexico early in 1921 and immediately joined the Open Air School at Coyoacán, where he shared the studio of another young painter, Fernando Leal. Charlot was an ambitious young fresco painter seeking, as he put it, walls to paint, and had heard of the new mural programme in Mexico. Although he grew up and trained as an artist in Paris, he had strong connections with Mexico. His great grandfather had moved there in the early nineteenth century and married a Mexican; his grandfather was born in Mexico City and also married there, but returned to Paris where Charlot remembers his apartment crammed with mementoes, landscapes by Velasco and wax figures of popular Mexican types. Charlot's uncle, Eugène Goupil, was the distinguished collector of pre-Hispanic antiquities and codices, including the Boturini, an Aztec manuscript describing the migrations of the Mexíca before they settled in the Valley of Mexico in the fourteenth century. Goupil gave his collection to the nation and Charlot recalls visiting the Bibliothèque nationale, where the Goupil manuscripts form the core of the great collection of Mexican and Maya codices, when he was a child, to copy them.

No doubt Charlot intensified the Mexican atmosphere of his Paris upbringing in his later memoirs, but nonetheless he was in a privileged position, arriving in Mexico in 1921 as, on the one hand, a young artist familiar with the latest trends in European contemporary art, and on the other, not a complete outsider. He did have romantic expectations of tropical colours, magnificently clad charros and exotic creatures, and was bowled over by what he saw, which was its opposite – silent people clad in earth-coloured rebozos (cat. 14). Charlot was instrumental not only in recovering and researching the popular printmakers of Mexico, but also in disseminating in Mexico some of the modernist ideas he had absorbed in Paris. He was familiar with Cubism (as of course was Rivera, who had spent the previous decade in Paris and consorted with Picasso) and also with German Expressionism, which offered particularly apposite examples of modern printmaking. Charlot's studio companion, Leal, recalled the hostility with which their experiments were greeted by the other students at the Open Air School, which was devoted to impressionism and the study of nature:

> The climax was reached when we began to make woodcuts, a technique which Charlot had learned in his country and used with skill. The scandal became boundless. We painted without models and proclaimed composition as uppermost in a picture. We engraved on wood, which was tantamount to bringing art from its height to the level of the corridos of Vanegas Arroyo. Worse still we courted culture by reading all sorts of books when the proper course of an artist is to be genuinely ignorant and to paint only from nature.[39]

The woodcuts produced by the artists associated with the Stridentists are eclectic in style, and the movement, which effectively came to an end in 1927, had more impact as a literary than an artistic vanguard. Nonetheless, the combination of image and lettering on the covers of Stridentist publications is often very powerful, as in Charlot/Maples Arce's Urbe, where the flat geometric façades of the buildings contrast with the blocky typeface punctuated with black circles. Roberto Montenegro's design for the cover of Kyn Taniya's Radio (1924; cat. 102), probably an ink drawing transferred photographically to the line block, is equally effective but in an entirely different mode, harking back to the delicate symbolist style of his mural for the church of San Pedro and San Pablo,

The Dance of the Hours (1922). The white letters RADIO float against the solid, black ground and recede to create a sensation of great depth. Disembodied mouth and ear float in a cosmic space where the mysteries of radio waves are conveyed by pearly dotted white lines, black lightning zigzags and other linear decorations. Kyn Taniya's 'Wireless poem in thirteen messages' plays on the terrestrial and cosmic interpenetration of music and voices:

> Tonight
> To the negro rhythm of the New York jazz bands
> The moon will dance a fox-trot.[40]

The artists associated with the Stridentists were not a unified group and most of them were involved at least in the early 1920s in the new mural movement. It was a time of open debate about the future of Mexican art, with strong views on several fronts against the background of a conservative National Academy of Fine Art (San Carlos) and the anachronistic impressionism of some of the Open Air Schools. Although the most vocal, the Stridentists were only one of the groups seeking a new route. To begin with, alternative or 'countercurrent' voices were heard both within and outside official circles, as is clear from the literary and artistic reviews that proliferated in the 1920s. One of the most important, Forma: Revista de Artes Plasticas (1926–8), was produced by the Secretaria de Educación Pública and the Universidad Nacional de Mexico, and assured its readers that it would include views with which the editors did not always agree. There was a strong didactic side to Forma, with articles on art training and especially on the successes of the Open Air Schools and the Centros Populares de Pintura in reaching out to children and working-class students, often Indian. Each issue of Forma carried a section on woodcuts by contemporary artists; the first showed work by children, the second a sequence of book illustrations by Francisco Díaz de León. The accompanying text explains that the best wood for engraving is from box, orange, pear and coffee trees, and also chides Díaz de León for betraying too much foreign influence, especially French:

> Some of these engravings, technically irreproachable, suffer from a European influence, especially French. Nonetheless, the activity of this young artist gives us the welcome hope that in a very short time he will find definitively an expression more suited to our medium.[41]

Díaz de León's neatly framed illustrations do recall Raoul Dufy's woodcuts for Apollinaire's Bestiaire ou Cortège d'Orphée of 1911. Fernando Leal's woodcuts in the next issue were evidently closer to what was regarded as 'proper to our medium': the subjects drawn from native dances, masks and rituals, the surfaces animated with an extraordinary variety of hatchings, cross-cuts and pocked textures (cat. 105).

Leal had been one of the first, with Charlot, to complete a mural, on the staircase of the Escuela Nacional Preparatoria (National Preparatory School; 1922–3). The subject symbolized the new consciousness of native aspects of Mexican civilization buried under centuries of colonial rule: The Feast at Chalma showed an incident in a church in the hills above Puebla, when an earthquake dislodged a devotional image of the Virgin to reveal behind it an ancient stone statue of the Aztec water goddess. Anita Brenner based the title of her 1929 study of Mexico, Idols Behind Altars, on this story. Gabriel Fernández Ledesma,

Figure 9 ¡30-30! manifesto poster, woodcut and letterpress

editor of *Forma*, published a group of woodcuts for posters in the sixth issue. The poster advertising direct carving, for the new Free School, an Escuela de Escultura y Talla Directa (School of Sculpture and Direct Carving) that he founded in Michoacán, vividly makes the connection between the printer's tool and the sculptor's hammer and chisel.

Following on from *Forma* but with a more specific and polemical agenda, the group ¡30-30! (named after a machine gun popular in the Revolution) waged a campaign against the Academy of Fine Art through a series of large, brightly coloured posters bearing manifestos and woodcuts pasted up on the city walls (fig. 9). In 1929 an exhibition organized by ¡30-30! of a decade's worth of graphic work revalued printmaking as an artistic practice. Including work by Charlot and Siqueiros, it was held far away from the smart centre of the metropolis, in a circus tent in a popular neighbourhood. Fernando Leal in particular loved the circus, a frequent theme in his and other Mexican artists' work at the time: 'palpitating with life and popular tragedies'.[42] By then the artists involved were experienced at printmaking, publishing and propaganda: Fermín Revueltas had published *Irradiador*, another Stridentist publication, earlier in the 1920s, and Alva de la Canal and Méndez had produced the short-lived but punchy *Horizonte* in 1926. ¡30-30! was not a tendency in art, but rather a campaigning group of young artists fighting for new conditions; they were angry at the conservatism, laziness and corruption of the Academy, but also recognized the need for a market so that they could be independent of the government and official policies. Although there were exhibitions in temporary spaces in Mexico, there was no commercial gallery until Inés Amor founded the Galería de Arte Mexicano in 1935. As early as 1921 Maples Arce was already suspicious of the marriage of art and government:

> I incite all young poets, painters and sculptors of Mexico, those who have not yet been corrupted by the easy gold from government sinecures, those who have not yet been perverted by the paltry praise of offical critics and the plaudits of an obscene and lustful public...[43]

The more cosmopolitan groups, like Los Contemporáneos, whose eponymous magazine ran from 1928 to 1931 (cat. 108), increasingly found themselves sidelined as the political agenda of the muralists hardened. As Maples Arce put it in his memoirs, 'A mafioso spirit gave them preponderance. Sometimes they would truly persecute those who resisted their attempts at intellectual hegemony...'.[44] The Contemporáneos were a loose group of poets, artists and critics who were no less dedicated to Mexico and to cultural nationalism than the officially supported muralists, but they maintained a more open attitude to foreign art, recognized long-standing European connections that did not have to be dismissed as 'colonial', and above all believed in the artist as an individual rather than a political voice for the nation. As the Mexican critic Cardoza y Aragon put it,

> They loved a Mexico without provincialisms, but they loved it with the provincialism of a fascination for Europe. As such, they were revolutionaries in the face of parochial nationalist themes. Socio-politically, they stood out not so much as sceptics as for being anachronistic. In the arts and literature, they dedicated themselves to the cultural renovation and enrichment of Mexico. That is no small achievement.[45]

The cover of *Los Contemporáneos* (cat. 108) reflected the eclectic vanguard/indigenist orientation of the magazine: cubist-inspired semi-abstract forms, in which vase, book, building and radio tower are visible while a Mexican mask, possibly from Teotihuacan, dominates the lower panel. The review included not only the work of independent easel painters like Julio Castellanos, but any artist, European, Mexican or American who was deemed authentic, and not *cursi*, affected or pretentious. Their aesthetic was broad-based and not governed by political considerations.

> The pretentious is the middle class of taste.
> What is authentically popular or truly aristocratic – the limits of native purity – leave no room for the adjective *cursi*
> The nouveau riche, the bourgeois, the provincial are social types defined by the pretentious...[46]

It is easy to see why Cardoza y Aragon should describe them as socio-politically behind the times, but their literary and visual tastes were right up to date. The range of the material in the review, national and international, was extraordinary. In one issue from 1929 they included Zapotec legends retold by Henestrosa, recent drawings, 'Dibujos de la Revolución Mexicana', by José Clemente Orozco, and Rayographs by the Surrealist Man Ray. Another included recent paintings by Salvador Dalí and Joan Miró, and lithographs by Roberto Montenegro. *Los Contemporáneos* was subsequently sidelined in the history of Mexican art and has only relatively recently been given the attention it deserves.

The 1920s were a decade of rebuilding and experiment for artists in Mexico. In the works of the printmakers, the conflicts that became more sharply etched in the 1930s between politically committed work and free experiment, between the idea of popular art and the new impulses of modernism, between public and private and between national and international were already evident. In Mexican printmaking more clearly than in any other area, original modes of expression developed, neither socialist realist nor purely modernist, whose origins can be traced in the post-revolutionary debates and practices of the 1920s.

1 Flores Magón 'Tierra y Libertad', *Regeneración* (19 November 1910); Joseph and Henderson 2002, p. 335. Flores Magón died in prison in Kansas in 1922.
2 'Three Appeals for a Modern Direction: To the New Generation of American Painters and Sculptors', *Vida Americana*, Barcelona, 1921.
3 Manifesto of the Union of Mexican Workers, Technicians, Painters and Sculptors.
4 The slide to a more reactionary government gathered pace through the 1920s and was reversed only with the election of Cardenas in 1936.
5 Siqueiros, 'Appeal to the Proletariat', *El Machete* (10 August 1924); Adès 1989, p. 325.
6 In November 1924 *El Machete* became the official organ of the Communist Party, of which Siqueiros remained a member throughout his life.
7 'El Machete sirve para cortar la caña / Para abrir las veredas en los bosques umbrios, / Decapitar culebras, tronchar toda cizaña / Y humillar la soberbia de los ricos impíos.'
8 Charlot 1963, p. 248.
9 Ibid., p. 250.
10 Thomas Hess, 'Prints: Where History, Style and Money Meet', *Art News* (January 1972), quoted in Keller 1985.
11 Jean Charlot, 'José Guadalupe Posada: Printmaker to the Mexican People', in Rothenstein 1989, p. 175.
12 'Mas que al Posada real, el linóleo retrata la idealización que hace Méndez del artista-revolucionario. Para el grabador, la imágen del artesano-militante que se compromete con las causas populares y se indigna ante la injusticia es un modelo a seguir, un proyecto de vida y un programa artístico.' Monsiváis 2002, p. 55.
13 'Las Artes Populares en México son importantes: / porque ellas satisfacen vitales necesidades sociales – / por la variedad de sus productos – / porque todos tienen, o en sus formas, o en su espíritu decorativo, o en sus coloraciones, el sello de un innato y hondo sentimiento estético... /

Además, las manifestaciones artísticas o industriales de las razas indígenas puras y de las razas mezcladas o intermedias, presentan – al contrario de lo que acontece en los grupos étnicamente semejantes a los europeos - caracteres muy mercados de homogeneidad, de método, de perseverencia, y constituyen realmente una verdadera cultura nacional.' Atl 1922, p. 15.
14 '... Guadalupe Posadas [sic], grabador único en su genero, pues nadie como él ha tenido la percepción de lo caricaturesco del pueblo bajo de la capital.' Atl 1922, p. 364.
15 *El Machete* (August 1924), quoted by Jean Charlot, 'José Guadalupe Posada and his successors', in Tyler 1979, p. 51.
16 Posada 1930, n.p.
17 Ibid.
18 Jean Charlot, 'Manuel Manilla, Grabador Mexicano,' *Forma*, no. 2 (November 1926), p. 18, trans. in López Casillas 2005, p. 6.
19 Ibid., p. 6.
20 Jean Charlot, 'José Guadalupe Posada and his successors', in Tyler 1979, p. 35.
21 Ibid., p. 31.
22 Miliotes 2006, p. 11. For a fuller account of Posada and the photomechanical process see Gretton 1992 and Rachel Freeman's Technical Note in Miliotes 2006, pp. 37–40.
23 Jean Charlot, 'Posada's Dance of Death, 1964', in Rothenstein 1989, p. 179.
24 'Vanegas Arroyo nunca empleó bloques de impresión de fotograbados de medio tono, realizados a partir de fotografias, por lo que, en la imagen, la cámara seguramente esta siendo usada para producir fotograbados de línea y el artista esta trazando dibujos para este proceso; el tono irónico y de autoreferencia del resto de la imagen, y de los textos, nos dice que debemos añadir: "incluido este"'. Thomas Gretton, 'De cómo fueron hechos los grabados de Posada', in Soler and Avila 1996, p. 142.
25 Mason Hart 1987, p. 241.
26 Brenner 1943, p. 5.
27 Both right and left rebelled against Madero, who was betrayed and murdered in February 1913, a month after Posada's death. Orozco sided with his successor, 'a tough and ambitious old Indian killer' (and himself an Indian), Victoriano Huerta, which cost him the loyalty of the revolutionary peasants and workers in the north, who henceforth followed Pancho Villa. After Villa defeated Huerta at the Battle of Zacatecas in June 1914, Orozco and Huerta fled to New Mexico and planned a new revolt; Orozco was shot by Texas Rangers in August 1915.
28 Womack 1972, p. 156.
29 Francisco I. Madero, Plan of San Luis Potosí, quoted in Womack 1972, p. 108.
30 Womack 1972, p. 172. Posada's print, based on a Casasola photograph, was reused by Vanegas Arroyo on more than one occasion; here, in 1914, in response to false rumours of Zapata's death (*El Entierro de Zapata*, Zapata's Burial).
31 Womack 1972, p. 445.
32 Ibid., p. 444.
33 Ibid., p. 177.
34 Ibid., p. 284.
35 José Clemente Orozco, letter to Jean Charlot from New York, 23 February 1928, in *¡Orozco!*, 1980, p. 42.
36 The National Preparatory School was an elite institution preparing students for university; Orozco's 1923–4 mural cycle was damaged by students and he repainted several walls in 1926.
37 See Innis Howe Shoemaker, 'Crossing Borders: The Weyhe Gallery and the Vogue for Mexican Art in the United States 1926–1940', in Ittmann 2006, pp. 23–54, for an account of the print market in the USA.
38 'Ya nada de creacionismo, dadaismo, paroxismo, expresionismo, sintetismo, imaginismo, suprematismo, cubismo, orfismo, etcetera, etcetera, de "ismos" más o menos teorizados y eficientes. Hagamos una síntesis quinta-esencial y depuradora de todas las tendencias florecidas en el plano máximo de nuestra moderna exaltación iluminada ...'. First Stridentist Manifesto, *Actual*, no. 1, 'Compromido Estridentista de Manuel Maples Arce'. See appendices in Bardach 2008.
39 'Reminiscences: Fernando Leal', 1946, in Charlot 1963, p. 166.
40 'Esta noche / Al ritmo negro de los jazz-bands de Nueva York / La luna bailera un fox-trot.'
41 'Algunos de estos grabados, tecnicamente irreprochables, se resienten aun de cierta influencia europea, francesa sobre todo. Sin embargo, la actividad de este joven artista nos da la grata esperanza de que dentro de muy poco tiempo sabrá encontrar en definitiva una expresión mas propia a nuestro medio', *Forma*, no. 2 (November 1926), p. 36. Díaz de León later championed lithography, and published a short text, 'Mexican Lithographic Tradition', in *Prints*, vol. VI, no. 1 (October 1935), which described the first 'timid and vague' attempts of Charlot and Emilio Amero, c.1923, to revive the process: '... they were unable to raise lithography to the same high place to which they had brought wood engraving.'
42 'palpitantes de vida y tragedias populares.' Quoted in Laura González Matute, Introduction to facsimile of ¡30-30! publications, Mexico City, 1993, p. 78.
43 'Excito a todos los poetas, pintores y escultores jóvenes de Mexico, a los que aun no ha sido maleados por el oro prebendario de los sinecurismos gobernistas, a los que aun no se han corrompido con los mezquinos elogios de la critica oficial y con los aplausos de un publico soez y concupiscente...', Article XIV of the first Stridentist manifesto, quoted in Bardach 2008, p. 28.
44 Maples Arce, quoted in Bardach 2008, p. 28.
45 Luis Cardoza y Aragon, El Río, in Bardach 2008, p. 26.
46 'Lo cursí es la clasa media del gusto. / Lo que es auténticamente popular o aristocracia verdadera – limites de nativa pureza – no admite el adjetivo: cursi. /...El nuevo rico, el burgués, el provinciano son los tipos sociales de lo cursi...', *Los Contemporáneos*, vol. 3 (1929).

¡VICTORIA!

Los artistas del Taller de Gráfica Popular nos unimos al júbilo de todos los trabajadores y hombres progresistas de México y del Mundo por el triunfo del glorioso Ejército Rojo y de las armas de todas las Naciones Unidas sobre la Alemania Nazi, como el paso más trascendente para la

DESTRUCCION TOTAL DEL FASCISMO

COMMITTED TO PRINT:
PRINTMAKING AND POLITICS IN MEXICO AND BEYOND, 1934–1960

Alison McClean

The popular, revolutionary optimism that had inspired Mexico's printmakers in the early decades of the twentieth century gave way in the early 1930s to a more critical approach to domestic politics. Disillusioned with the many failings of the revolutionary government and the increasingly repressive rule of its leader, General Elias Plutarco Calles (1877–1945), a new generation of printmakers working for the Liga de Escritores y Artistas Revolucionarios (League of Revolutionary Artists and Writers, LEAR) waged a campaign of dissent through the pages of left-wing journals such as El Machete and Frente a Frente. Disappointed with the progress of their own revolution, many of the printmakers working for the LEAR looked towards the USSR for inspiration, becoming enthusiastic activists in support of Stalin's international Popular Front against Fascism.

The removal from power and deportation of Calles by his successor, General Lázaro Cárdenas (1895–1970), in 1935 led to a period of renewed optimism in domestic politics and coincided with the emergence of a new printmaking collective, the Taller de Gráfica Popular (People's Graphic Workshop or TGP), an organization made up of young printmakers with close associations to the Mexican Communist Party and the left-wing Partido Popular (People's Party or PP). As well as producing posters, portfolios and pamphlets in support of the international anti-Fascist cause, and working on behalf of the numerous groups of Spanish and German exiles now based in Mexico City, the TGP was also active in support of Cárdenas's own domestic Popular Front, aimed at uniting Mexico's disparate political organizations as well as its various labour and peasants' groups (see p. 29).

Domestic and international concerns converged as Mexico entered the Second World War in support of the Allies in 1942. As well as producing war propaganda attacking Nazi atrocities, the printmakers of the TGP also began producing images in support of Mexico's new allies in the United States. The 'Good Neighbour' policy of friendship and cultural exchange between the USA and Mexico during the war years provided opportunities for members of the TGP to exhibit and sell their work in the United States and to extend their influence among young printmakers north of the border. The 1940s thus began an era of growing international prominence for Mexican printmaking, as well as greater commercial success for the TGP.

Although its radical leftist tendencies had not acted as a barrier to the TGP's success in the USA during the war years, the onset of the Cold War and the deepening fear of Communism in the USA forced the TGP to redirect its activities towards Europe and Latin America. Throughout the 1950s the group pursued an ambitious international exhibitions programme, taking in most of Western and Eastern Europe, all of South and Central America, as well as China, North Africa and Australasia. Despite growing and, ultimately, irreconcilable political differences between the membership, as well as its waning influence on the domestic scene in Mexico, the TGP had, by the end of its active life in 1960, provided an enduring legacy for those seeking to use the medium of printmaking as a weapon for political action.

Ángel Bracho, Victory (cat. 74)

MURALISM AND THE EMERGENCE OF PRINTMAKING

For the younger generation of socially committed artists in Mexico, the dominance of Los Tres Grandes (the Three Greats: Rivera, Siqueiros and Orozco) in the immediate post-revolutionary decades was something of a mixed blessing. On the one hand, large-scale public mural projects required numerous assistants, providing many young artists with valuable apprenticeships. On the other, the virtual monopolization of such projects in Mexico in the 1920s by Los Tres Grandes (Rivera in particular) meant that aspiring muralists struggled to obtain commissions in their own right, leading many younger artists to seek an alternative means of expression. The medium of printmaking was an obvious choice; the work of José Guadalupe Posada had already been appropriated into the canon of popular revolutionary art established by the Sindicato de Obreros Técnicos, Pintores, y Escultores (Union of Painters, Sculptors and Technical Workers), and black-and-white woodcuts had become a stock feature within the pages of their broadsheet, El Machete. The earlier work of the Estridentistas (Stridentists; see p. 22) would also prove pivotal to the emergence of a new generation of printmakers, many of whom trained at the San Carlos Academy in Mexico City under leading Stridentist artists such as Gabriel Fernández Ledesma, Emilio Amero and Ramón Alva de Canal. The printmaking endeavours of the muralists, particularly Jean Charlot and José Clemente Orozco, had also done much to advance the profile of the medium, both in Mexico and the USA. Inspired by these examples, young artists such as Leopoldo Méndez, Pablo O'Higgins and Francisco Dosamantes abandoned their mural scaffolds and began experimenting with lithography, wood and linocuts.

An early manifestation of the emergence of printmaking as the preferred medium for the post-muralist generation appeared in 1928 with the formation of the ¡30-30! Protest of Independent Artists. Aimed at restructuring Mexico's art institutions and education programmes, the ¡30-30! manifesto, produced as a poster illustrated with a woodcut by Ledesma, is notable for the absence of any explicit reference to mural painting in its programme for revolutionary art in Mexico.[1] Among ¡30-30!'s members were a number of artists who would later become key figures in the development of printmaking in the 1930s and 1940s, including Méndez, Dosamantes and Gonzalo de la Paz Pérez.

By the early 1930s the appeal of muralism among the younger generation of artists in Mexico had also dwindled as a result of its association with a political force that had deteriorated into a repressive dictatorship. General Calles, whose candidacy for President in 1923 had been endorsed by the Union of Painters, Sculptors and Technical Workers, continued to hold an iron grip on Mexican politics, ruling through a succession of puppet presidents and deploying Fascist-style Sinarquistas or 'Goldshirts' to intimidate and suppress any opposition. Fearful of the consequences of delving too deeply into domestic affairs, many artists on the Left were compelled to look towards the international sphere and, in particular, the emergence of Fascism in Europe and the growing conflict between the Soviet Comintern and Trotsky's Fourth International – a conflict which in Mexico was mirrored in the ongoing and increasingly bitter political and artistic rivalry between David Alfaro Siqueiros and Diego Rivera.

THE LIGA DE ESCRITORES Y ARTISTAS REVOLUCIONARIOS (LEAR)

Responding to these concerns (and taking advantage of the absence of Los Tres Grandes on various mural commissions in the USA),[2] a group of artists and intellectuals joined together to form the League of Revolutionary Artists and Writers. Officially launched in Mexico City in 1934, the LEAR encompassed all spheres of creative endeavour, including music, theatre, photography, architecture and, most importantly, graphic art. In this respect it marked a significant departure from previous artistic-political initiatives in Mexico which, as in the case of the Union of Painters, Sculptors and Technical Workers and the Stridentists in the 1920s, had often been confined to the disciplines of painting, sculpture and literature. The inclusive approach of the LEAR was evident in its journal *Frente a Frente*, which combined domestic talent with political art from all over the world, including the photomontages of John Heartfield in Germany and Gustav Klutsis's agitprop posters from the USSR. Alongside this, *Frente a Frente* also acted as a showcase for the developing talents of the LEAR's own Graphic Arts Division, led by Leopoldo Méndez, Luis Arenal and Pablo O'Higgins (fig. 10). For its first issue, in 1934, Méndez produced a woodcut, *Calaveras' symphony concert* (cat. 15), ridiculing the revolutionary pretensions of both the Mexican government and the Trotskyist Fourth International. In this image the two *calaveras* (skeletons), one representing each party, sit side by side to view a performance of a 'proletarian' *corrido* (ballad) for which, as a carefully placed handbill indicates, the admission charge is $25. As the two central figures enjoy the performance from the comfort of their box, seated in chairs carved with the signs of the dollar and the swastika, an armed and jackbooted soldier repels a protesting proletarian couple. In a roughly hewn style reminiscent of *El Machete*, Mendez's print appropriates the popular medium of the woodcut and the satirical *calavera* style (made famous by Posada) to make an explicitly iconoclastic statement about the condition of revolutionary politics in Mexico at this time. There is also in this image a demonstration of the artist's disillusionment with the muralists: the *calavera* depicted as representing the Trotskyists is an obvious caricature of Diego Rivera.

Whatever enmity might have existed between the Graphic Arts Division of the LEAR and the muralist maestros, such differences were set aside at the American Artists Congress in New York in 1936 when Arenal and fellow printmaker Antonio Pujol joined Siqueiros and Orozco to make up the Mexican delegation. The Congress also hosted an exhibition of LEAR prints including works by Méndez, Arenal, Pujol and Alfredo Zalce. At the Congress itself, both Siqueiros and Orozco enthused about the work of the LEAR and the contribution of its young printmakers. Siqueiros even went so far as to advocate the medium of print as a much more powerful tool for revolutionary propaganda than mural painting had ever been:

> A new movement has grown out of all the past experiences and has appeared already in Mexico. The new movement is impelled and organised by the section of plastic art of the League of Revolutionary Artists and Writers ... The League has adopted the principle that revolutionary art is inseparable from forms of art which can reach the greatest number of people.... It has adopted the principle of self-criticism as an instrument of advance. It has also adopted the principle of teamwork as distinguished from isolated individual work. Instead of painting in the official buildings far from the masses, the League wants to help the Mexican workers find a form suitable to a graphic art of revolutionary propaganda.[3]

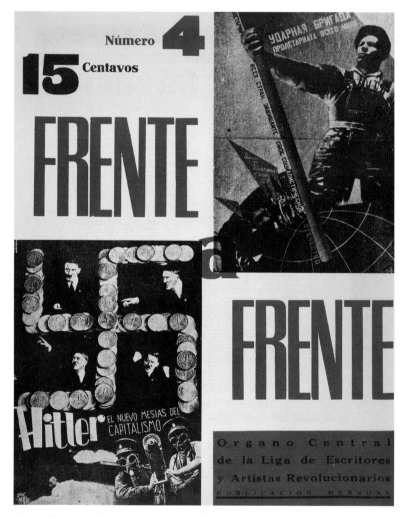

Figure 10 Front cover of *Frente a Frente*, no. 4, 1934 (facsimile)

Although the LEAR embraced artists and intellectuals from a variety of stylistic persuasions, its political position was much less accommodating. In its earliest days its battle-cry had been 'neither Calles nor Cárdenas', a reference to General Cárdenas who had been hand-picked by Calles as the official candidate for the 1934 presidential election. The LEAR's suspicions regarding the new candidate were understandable: Calles had selected each of the three previous incumbents in order to ensure their compliance in his continued domination of the government. Thus it was not unreasonable for the LEAR to assume that Cárdenas would be equally submissive, and that the repression of recent years would continue. But Cárdenas proved to be no political stooge, exiling Calles to the USA in 1935 and launching an ambitious programme of industrial and agrarian reform. This created something of a dilemma within the membership of the LEAR, with opinion divided as to whether to support the new President or to continue to agitate against the Mexican government as a whole. Matters were polarized still further in 1936 when Cárdenas offered safe haven to Leon Trotsky, a move that incensed the Mexican Communist Party and a number of its supporters in the LEAR, most notably Siqueiros (see pp. 31–2).

FROM THE LEAR TO THE TALLER DE GRÁFICA POPULAR (TGP)

Although Siqueiros's endorsement of the Graphic Arts Division of the LEAR at the American Artists Congress in 1936 provided a welcome boost to the emerging generation of Mexican printmakers, his desire to dictate the group's political agenda proved hugely divisive. Cárdenas had done much to prove his popular credentials during the first two years of his presidency and in 1936 extended an olive branch to the printmakers of the LEAR by founding the Talleres Gráficos de la Nación (National Print Workshop) in Mexico City. Providing public access to presses and equipment, as well as instruction in basic print techniques, the Talleres Gráficos was aimed at encouraging the production of graphic materials for use by the newly formed peasants' and workers' organizations soon to be incorporated into the reconstructed ruling Partido de la Revolución Mexicana (Mexican Revolutionary Party, or PRM).[4] This strategy echoed that of José Vasconcelos in the 1920s, promoting accessibility in the arts as a means of harnessing popular support for the now reconstituted revolutionary state. Méndez's 1936 woodcut *Political piñata* (cat. 52) celebrated Cárdenas's new political order by caricaturing the destruction of Calles's Partido Constitucional Revolucionario (Constitutional Revolutionary Party) and the subsequent expulsion of corrupt government officials and trades union leaders such as Luis Morones.[5]

The establishment of Talleres Gráficos marked the official endorsement both of the print medium and of the artists of the Graphics Arts Division of the LEAR, several of whom were invited to paint murals for the new Talleres Gráficos building. Despite strenuous resistance from Siqueiros (then in New York), who denounced 'graphic expressions which correspond with official demagogy',[6] the LEAR drew even closer to the Cárdenas administration by accepting financial support from the Ministry of Education to facilitate a 10,000-copy edition of *Frente a Frente* in March 1937, and an exhibition in Paris. Under fierce pressure from Siqueiros in New York and the Communist Party in Mexico, the Graphic Arts Division, comprising Méndez, O'Higgins, Arenal, Ángel Bracho and Alfredo Zalce, resigned from the LEAR en masse to form a new printmaking collective, the Taller de Gráfica Popular (TGP). Following a series of informal meetings and correspondence which saw the addition to their ranks of Xavier Guerrero, Fernando Castro Pacheco and José Chávez Morado,

the new group finally issued a formal manifesto in its Declaration of Principles, published in Mexico City in 1938. A relatively brief statement compared with that of their predecessors in the Union of Painters, Sculptors and Technical Workers, the TGP's manifesto pledged itself to a collective effort to 'help the Mexican people defend and enrich their national culture' by producing art which 'reflect(s) the social reality of the times'. Although not endorsing Cárdenas by name, point four of the Declaration asserted the TGP's intention to 'co-operate professionally' with external organizations, including 'other cultural workshops and institutions, workers' organizations, and progressive movements and institutions in general'.[7] Focusing initially on lithography and woodcuts, the workshop also sought to tap into the broadsheet tradition established by Posada and *El Machete*; prints and posters, including numerous *calaveras*, were mass-produced on cheap paper and posted around the streets of Mexico City, or sold for a few *pesos* each on market stalls or from street vendors.

Dedicating itself to 'professional co-operation' with the Cardenista programme, in its early years the TGP was involved in a succession of campaigns and propaganda in support of trades union rights, education and agrarian reform. One of its most vigorous domestic campaigns was its promotion of socialist education. This policy, an essential element of Cardenismo, had its origins in the early years of the Calles administration in the 1920s, where attempts to implement secular state education in the provinces had provoked violent resistance from the Catholic Church, contributing to the outbreak of the Cristero rebellions in 1926. Although Calles had abandoned the project in 1931, Cárdenas was committed to reviving it, believing literacy among the peasantry to be essential to the success of his plans for agrarian reform and development. This policy struck a particular chord with a number of TGP members, including Méndez, Zalce and Bracho, who had been among the young recruits to Calles's original programme in the 1920s. All three had participated in cultural missions to the provinces on behalf of the Ministry of Education, or had assisted directly with the establishment of rural schools. They may even have had bitter experience of the brutality of Cristero resistance as depicted in Méndez's 1939 portfolio *In the name of Christ*, which documents the murders of seven of the more than two hundred teachers believed to have been killed during the Cristero rebellions. An earlier image by Méndez, dating from 1931, also demonstrates the horror of Cristero violence with the image of a deranged, fanatical priest wielding a crucifix to attack the peasants beneath him (cat. 51).

The early years of the TGP thus saw the production of numerous posters in support of socialist education. Aside from work aimed at gaining popular support for the programme, the TGP also produced posters to appeal directly to the teaching profession itself, encouraging members to unionize, as in José Chávez Morado's *United in your line* (1938), and reminding them of their obligations to their fellow citizens with Francisco Dosamantes' *Teachers, there is a means to appeal to the nation: Work! Work! Work!* (1938). The TGP was also involved in producing textbooks and other materials for teachers to use as visual propaganda in schools.

The TGP was also at the forefront of support for Cárdenas through the oil expropriation crisis of 1938. Under trades union legislation introduced by Cárdenas through his 'Fourteen Points For Capital and Labour' in 1936, the Mexican government had declared itself the final arbiter in labour disputes and threatened state expropriation of any industry which failed to comply with its judgements. In the numerous strikes that followed this decree, the government almost always sided with the workers, as in the case of the rail strikes of 1936

Figure 11 Leopoldo Méndez, *Run because the ball is coming* (*Corran que ahí viene la bola*), from the Workers University Calendar, lithograph, 1938 (British Museum, P&D 1990,1109.139)

(which led, eventually, to the nationalization of the Mexican railway), and in numerous other disputes involving the electricity, mining and telecommunications industries. In this context the declaration of strike action by the Petroleum Workers Trade Union (STPRM) in 1937 was almost inevitable, given the ongoing tensions between the workers and the oil companies' foreign owners, mostly from the USA and Great Britain, over pay and benefits. Anxious to avoid the practical and economic catastrophes any interruption to Mexico's fuel supply would cause, the government was quick to intervene in the workers' favour. Despite a Supreme Court ruling, however, the oil companies refused to yield to the STPRM's demands and, citing this as an unacceptable defiance of Mexican law, Cárdenas took the bold step of re-nationalizing the oil industry on 18 March 1938. The response from the disgruntled foreign investors was swift, with the US oil barons in particular urging their government to take stern, even military, action to protect their interests. President Roosevelt, however, was reluctant to undermine his 'Good Neighbour' policy towards Latin America and refused to intervene with force, instead supporting the oil companies' claims for compensation with a series of economic sanctions. Although Roosevelt's actions may appear moderate in comparison with the demands of the oil barons, the artists of the TGP rallied against what they and many other Mexicans regarded as yet another imperialist intervention in domestic affairs by the USA. In an almost immediate offensive strike the TGP issued a pamphlet endorsing Cárdenas's action and protesting against the hypocrisy of their 'Good Neighbour' in the north.

THE TGP AND THE POPULAR FRONT IN MEXICO

Just as the TGP's participation in Cárdenas's literacy campaigns had its roots in the artists' earlier involvement with the socialist education programme under Calles, its unqualified support for the President's sequestration of foreign oil interests was similarly informed by its members' previous activities in support of labour groups and trades unions. Indeed, one of the TGP's earliest projects, begun under the auspices of the LEAR, had been a commission to produce the 1938 calendar for the Universidad Obrera (Worker's University) in Mexico City (fig. 11)[8] and a portfolio of eight lithographs, *Homage to the Revolution*, for the electricians' union STERM. These activities developed further in the context of Cardenismo to include posters and pamphlets advertising the activities and meetings of the Confederation of Mexican Workers (CTM), the teaching union SUTESC and the Mexico-based trades union congress for Latin America, CTAL. The 1948 poster by Pablo O'Higgins and Alberto Beltrán, produced on behalf of CTAL and STPRM on the occasion of the tenth anniversary of the oil expropriation crisis, indicates both the depth and longevity of the links forged between the TGP and the trades union movements during the Cárdenas era (cat. 82a).

In addition to its commitment to Cardenismo in Mexico, the TGP was also engaged in numerous campaigns in support of the International Popular Front against Fascism. Working alongside the growing number of European exiles living in Mexico City and with the full approval of both the Mexican government and the Mexican Communist Party (not to mention the Soviet Comintern), the TGP began producing posters to advertise the activities of anti-Fascist groups such as the Pro-Republican Sociedad Francisco Javier Mina and the anti-Nazi Liga Pro-Cultura Alemana. Among these were a series of posters for conferences on the Fascist threat organized by the Liga Pro-Cultura Alemana (fig. 12), including Isidoro Ocampo's *The Japanese Fascist*, 1939 (cat. 81). The Republican

Figure 12 Jesús Escobedo, *How to combat Fascism* (*El Fascismo, como combatir el fascismo*), Liga Pro-Cultura Alemana poster, lithograph in black and red, 1939 (British Museum, P&D 2008,7073.9)

cause in the Spanish Civil War was also of particular interest to the TGP; two of its founding members, Antonio Pujol and José Chávez Morado, had served with the International Brigades in 1936, while Josep Renau, the Spanish photomontage artist (best known for commissioning Picasso's *Guernica* for the Paris World's Fair in 1937), became a regular collaborator in anti-Fascist causes following his exile to Mexico in 1939. Among the many works produced in support of the Spanish Republic are Francisco Dosamantes's *Bombardment Spain 1937* (cat. 46) and the 1938 portfolio of fifteen lithographs entitled *Franco's Spain*, including works by Leopoldo Méndez, Luis Arenal, Xavier Guerrero and Raúl Anguiano.

The TGP also worked to oppose the emerging Fascist threat in Mexico itself. Cárdenas's left-wing policies had led conservative elements within the country to rally round General Juan Almazán's Partido Revolucionario Unificación Nacional (PRUN). Almazán, an admirer of Benito Mussolini, stood for election as President in 1940 against the PRM's Manuel Avila Camacho (due to the clause in Mexico's constitution forbidding re-election, Cárdenas was unable to stand for a second term). During a violent and divisive campaign, during which Fascist Sinarquistas appeared once more on the streets of Mexico City, the TGP produced several posters attacking Almazán and the PRUN, including Jesús Escobedo's *The General's triumphant entrance*, 1940 (cat. 77), depicting Almazán riding on the back of a ragged peasant, bedecked in swastikas and dollar signs and giving a Nazi salute.

Although happy to support the many groups of exiles living in Mexico City, the TGP's relationship with one particular exile proved highly problematic. Whilst President Cárdenas had won widespread acclaim for receiving 20,000 Republican exiles from Spain following Franco's victory in 1939, the presence of Leon Trotsky in Mexico continued to cause outrage within the Mexican Communist Party, whose members included a number of artists working at the TGP. Although riddled by internal strife and factionalism, the Mexican Communist Party was anxious to assert its Stalinist credentials by its rigorous endorsement of the Soviet Comintern's call for an international Popular Front against Fascism. Trotsky's arrival in 1936 was, therefore, a source of great embarrassment to the Party and a considerable barrier to its attempts to unite the Mexican Left under the banner of the Popular Front. A vigorous and vicious propaganda campaign emerged from both sides, the Communists denouncing Trotsky as a pro-Fascist provocateur and the Trotskyists (led by Diego Rivera) establishing a Mexican branch of Trotsky's Fourth International, with its own journal, *Clave*, publishing articles attacking both the USSR and the Mexican Communist Party.

Among the most vocal opponents to Trotsky's presence was Siqueiros, then working as a guest member of the TGP. Although the exact circumstances surrounding the incident remain unclear,[9] Siqueiros led an unsuccessful attempt on Trotsky's life in May 1940, using the TGP as a rendezvous point. Among his fellow conspirators were workshop members Antonio Pujol and Luis Arenal. As a result, the entire membership fell under suspicion and a

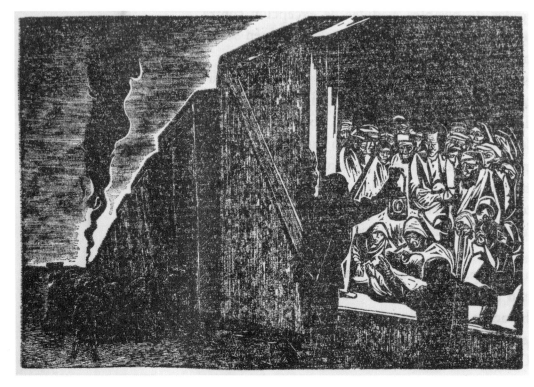

Figure 13 Leopoldo Méndez, *Train of death* (*Tren de la muerte*), linocut, 1943, from
The Black Book of Nazi Terror in Europe (*El libro negro del Nazi terror en Europa*)
(British Museum, P&D 2009,7029.7)

number, including Méndez, were arrested and detained. For his part, Pujol was later imprisoned, while Siqueiros and Arenal fled the country. The incident marked the beginning of what would be a prolonged and damaging struggle within the membership between those artists committed to the Communist cause and those who sought a more moderate line in the campaign for social justice. Alfredo Zalce, in particular, was outraged that Siqueiros's actions had compromised the reputation of the TGP, deliberately excluding him from his 1948 woodcut *José Guadalupe Posada and calaveras* (cat. 12), in which the popular print maestro is shown at his workbench under the admiring gaze of *calaveras* representing Dr Atl, Diego Rivera, José Clemente Orozco and (in place of Siqueiros) Leopoldo Méndez.

FROM BAUHAUS TO BARRIO: HANNES MEYER AND THE TGP DURING THE SECOND WORLD WAR

Such internal divisions were set aside, however, with the collapse of the Nazi-Soviet non-aggression pact in 1941 and Mexico's entry into the Second World War the following year. Throughout 1941 the TGP produced a series of prints and posters aimed at encouraging the Mexican government to join the Allied cause, including Alfredo Zalce's *The USSR is defending the freedom of the world – let's help!* (cat. 84a) and Francisco Dosamantes' *Dead soldier* (cat. 47). The TGP also began renewing acquaintances with German exile groups and producing illustrations for the anti-Nazi journals *La Voz de México* and *Alemania Libre*. In 1943

the Mexican government sponsored the publication of *The Little Black Book of Nazi Terror in Europe*, a collection of essays by Mexican and European commentators, including Thomas Mann, Anna Seghers and Leon Feuchtwanger, which provided graphic accounts of Nazi atrocities (often accompanied by harrowing photographs) and included twenty-two illustrations by the TGP. These include Leopoldo Méndez's *The people's vengeance* and *Train of death* (fig. 13), one of the earliest known images of the Holocaust produced by an artist outside Europe. The war years also saw the TGP resume its domestic campaigns on behalf of the Mexican government, producing Civil Defence posters and participating in a new National Campaign Against Illiteracy initiated by President Avila Camacho in 1944.

The Second World War also brought the TGP into contact with a man who was to be a seminal influence on the workshop's activities throughout the 1940s. Hannes Meyer, the Swiss-born architect, is best remembered for being forced to resign as Director of the Bauhaus at Dessau in 1930 amid allegations of his Communist sympathies. Having spent the following six years in the USSR, he travelled to Mexico City in 1938 to participate in an international conference on urban planning. Although his sojourn to Mexico was intended to be brief, Meyer chose to remain in order to take up a position as Director of the Town and National Planning Institute at Mexico's National Polytechnic Institute. During his first few years in Mexico, Meyer also became involved in the activities of numerous groups of exiles, including the anti-Fascist Alianza

Internazionale Giuseppe Garibaldi. He was also a member of the Liga Pro-Cultura Alemana and a founding member of El Libro Libre publishing house; these activities soon brought him into direct contact with Leopoldo Méndez who, after several years of informal collaboration, officially invited Meyer to join the TGP as Director of the workshop's publishing arm, La Estampa Mexicana, in 1942.[10]

Although Meyer dabbled in printmaking from time to time, his role at the TGP was largely administrative. Faced with one of the workshop's periodic financial crises (which subsequently led to the resignations of six members, including José Chávez Morado and Francisco Dosamantes), his first priority was to revive the fortunes of the TGP through an extensive international exhibitions and publications programme. Meyer was aided in his endeavours by the favourable attitude of the USA towards Mexican art and artists arising from the escalation of Roosevelt's 'Good Neighbour' policy during the Second World War.[11] Although the TGP had been among the first and most vociferous of opponents to 'Yankee imperialism' in the wake of the oil expropriation crisis in 1938, several of its members had been the recipients of the Good Neighbour policy, with both Leopoldo Méndez and Jesús Escobedo being awarded Guggenheim Fellowships. In addition, the Inter-American fund of the Museum of Modern Art also paid for the purchase of over sixty TGP prints in 1942.[12] Meyer sought to exploit this renewed interest in Mexican art among US patrons and institutions by publishing limited edition portfolios for sale on the lucrative US market. Images that had once been produced on cheap paper and sold on the streets of Mexico City for a few *pesos* each (or distributed for free as part of the Mexican government's literacy campaigns) now appeared in lavishly bound bilingual portfolios such as the *Album of 25 Prints by Leopoldo Méndez* in 1943 (cat. 55–9) and the *Mexican People* portfolio of 1946 (cat. 119), the latter generating royalties of around $8,000. Meyer also courted corporate as well as institutional sponsorship in the USA, with a number of prints being sold to the art collections of both IBM and General Motors.[13] The growing prosperity enjoyed by the TGP under Meyer's guidance, and the softening of attitudes towards the USA during the Second World War, can be seen in Ángel Bracho's poster *Victory* of 1945 (cat. 74) produced in celebration of the defeat of Fascism. Executed in black, white and red (perhaps in homage to the printmakers of the USSR), the poster pays tribute to the contributions of the USA and Britain to the Allied cause by including both nations' flags alongside that of the USSR.

Whilst Meyer seems to have had no qualms about the TGP participating in the capitalist exchange of goods and services within the US art market, there is compelling evidence that many of his early activities in Mexico corresponded with the tactics endorsed by the Soviet Comintern. The Comintern had been active in Mexico during the Popular Front and had resumed its work with European exile groups (including the Liga Pro-Cultura Alemana) in Mexico City following the collapse of the Nazi-Soviet non-aggression pact in 1941. As well as having lived in the USSR for several years, Meyer was also a known associate of the photographer Tina Modotti and her companion Vittorio Vidali, both Comintern agents working in Mexico in the early 1940s.[14] Indeed, it was following a dinner party at Meyer's home on 6 January 1942 (also attended by fellow TGP member Ignacio Aguirre) that Modotti met her sudden and, to some, highly suspicious death.[15] Meyer was also responsible for introducing the German journalist and Communist Party member Georg Stibi to the workshop in 1943, where he would remain as an Administrator until his return to East Berlin (and a cabinet post in the new Communist government) in 1946.

GOOD NEIGHBOURS AND FELLOW TRAVELLERS: THE INFLUENCE OF THE TGP ON US PRINTMAKING

Between 1940 and 1965 the TGP exhibited in the USA around seventy times. Such exhibitions ranged from small shows in regional or specialist print galleries, such as the Bonestell Gallery in New York (1940) and the Cincinnati Crafters in Ohio (1941), to blockbuster events including the 'Twenty Centuries of Mexican Art' exhibition at the Museum of Modern Art, New York (1940) and the 'Golden Gate Exposition' in San Francisco (1940). Alongside this the TGP also began working with other leftist artists' groups in the USA, including the Art Students League (for whom Raúl Anguiano later worked as a printmaking instructor), Associated Contemporary Artists and the Artists League of America, which in 1943 invited the TGP to participate in the exhibition 'Art, a Weapon for Total War' at the New School of Social Research in New York. The TGP also enjoyed a high academic profile in the USA, with more than a quarter of its exhibitions taking place at universities or art colleges, including several at the prestigious Chicago Art Institute. The Institute's Director, Carl Schneiwind, also purchased a number of prints by Leopoldo Méndez and wrote the prologue for Méndez's portfolio of woodcuts from Juan de la Cabada's *Incidentes Melódicos del Mundo Irracional*, published in 1945. Prior to that, the Chicago Art Institute was also the source for the TGP's first 'guest artists' from the USA, Max Kahn and Eleanor Coen who, along with David P. Levine and Marshall Goodman, arrived in Mexico City in the spring of 1940 in order to take part in a six-week printmaking course at the workshop.

The recruitment of 'guest' artists had always taken place on an informal basis since the TGP's inception (Siqueiros being among the most regular and troublesome of visitors). Under Meyer's stewardship, however, such arrangements became part of the TGP's wider fiscal policy. The courses attended by Kahn, Coen, Levine and Goodman (for a fee of $50 each) were aimed specifically at artists in the USA and advertised in the US press. Over the following years a number of young Americans would make the journey to the workshop on Calle de Quintana Roo, including Jules and Gloria Heller (who would later found their own Taller in San Francisco), Elizabeth Catlett, Charles White and Mariana Yampolsky.

Elizabeth Catlett had already studied lithography under Raúl Anguiano at the Art Students League in New York in 1941. Accompanying her then husband, the printmaker Charles White, she travelled to Mexico in 1946 where both she and White became guest members at the TGP. The work produced by the couple during their first year at the workshop provides a striking example of the way in which the methods of the TGP could be harnessed to advance the social and political aims of other interest groups. For Catlett and White, as African-Americans, their work focused on the historic struggle for freedom and equality. Catlett, in particular, drew inspiration from the TGP's images of revolutionary heroes to portray her own figures as dynamic, animated characters undertaking direct action on behalf of their people, as in her *In Harriet Tubman, I helped hundreds to freedom* from the 1946 series *I am the Negro woman* (fig. 14).[16]

For Charles White, his experience at the TGP inspired him to set up his own workshop in New York. Although open to artists of all races, the Workshop for Graphic Art was especially concerned with supporting the work of young African-American artists, including Jacob Lawrence, John Biggers and Robert Blackburn. Adopting both the TGP's collective organizational structure and its ethos of producing socially useful art, White acknowledged his debt to his

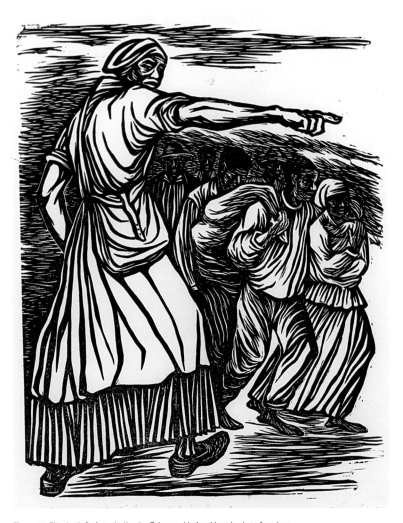

Figure 14 Elizabeth Catlett, *In Harriet Tubman, I helped hundreds to freedom*, woodcut, 1946

Mexican colleagues by contributing two of the many lithographs he made at the TGP to the first of a series of mass-produced portfolios entitled *Yes, the people*, published in 1948. He also began pursuing an active role in organized politics, producing illustrations for pro-Communist publications including the *Daily Worker*, *Freedom* and *New Masses*, as well as for African-American Journals such as *Opportunity*.

Accompanying her husband back to New York in 1947 purely to formalize their divorce, Catlett chose to return to Mexico as a permanent member of the TGP. Although heavily involved in a range of the workshop's domestic political activities, including the campaigns in support of the government's literacy programmes and for various trades unions, Catlett continued to produce prints documenting the African-American struggle in the USA, paying particular attention to the courage and tyranny emerging from the ongoing campaign for Civil Rights.

Mariana Yampolsky's journey to Mexico was inspired by the experiences of Eleanor Coen and Max Kahn. On their return to Chicago in 1943, Coen and Kahn had given a lecture on the TGP's work at the university where Yampolsky was a student. Determined to join the workshop after her graduation, she left for Mexico City the following year. As a young and inexperienced artist she began her printmaking career working on collaborative projects with TGP members such as Zalce, García Bustos and O'Higgins. Over the next fifteen years, however, she would become one of the workshop's most prolific members, undertaking more than sixty projects including contributions to the portfolios *Prints of the Mexican Revolution* (1947), *We Want to Live* (1950), *Mexican Life* (1953) and *Mexico is in Danger* (1958). She also collaborated with Méndez in the foundation of the Fondo Editorial de la Plástica Mexicana (Mexican Art Publishing Company) in 1958 and developed a parallel career in photography, a field in which she came to enjoy a distinguished international reputation.

Catlett and Yampolsky were also influential in opening up opportunities for other women artists to join the TGP. These included the Polish-born Fanny Rabel and María Luisa Martín from Spain. Among the home-grown talent joining the ranks were Sarah Jiminez, Mercedes Quevedo, Andrea Gomez and Elena Huerta. Most influential among the TGP's Mexican-born female artists, however, was Celia Calderón de la Barca. At the time when she joined the workshop, at the relatively late stage of 1952, Calderón was already an accomplished painter, muralist, teacher and printmaker. A former student of Alfredo Zalce and José Chávez Morado, she was the first woman to teach at the San Carlos Academy and, in 1947, a founder member of the Sociedad Mexicana de Grabadores (Mexican Society of Printmakers). Immediately prior to joining the TGP she had also been awarded a scholarship enabling her to travel extensively in Europe, visiting France, Italy and England, where she spent a year studying at the Slade School of Fine Art in London. The status accorded to Calderón by virtue of these experiences enabled her to establish a position of considerable seniority within the TGP in a very short space of time, and by 1953 she was already in charge of co-ordinating the workshop's extensive international exhibitions programme.

Aside from her administrative responsibilities, Calderón was also engaged on a number of high-profile assignments. She contributed a lithograph to the portfolio *Mexican Life* in 1953, and provided prints and illustrations for a number of publications, including Carlos Augusto Leon's *Coplas de la Muerte H y la Vida Popular* (1954), William Cameron Townsend's biography *Lázaro Cárdenas: Mexican Democrat* (1954), and the portfolio *Linocuts by the Taller de Gráfica Popular*

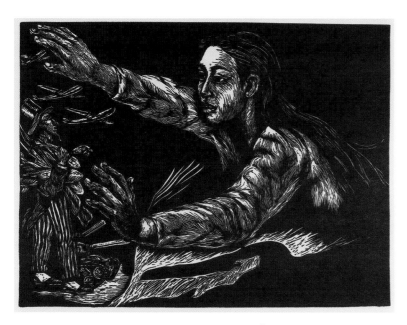

Figure 15 Celia Calderón, *The country will not accept foreign bases* (*La nación no acepta bases extranjeras*), woodcut, 1960, published in *450 años de lucha: Homenaje al pueblo Mexicano*, 1960 (British Museum, P&D 2008,7072.24.123)

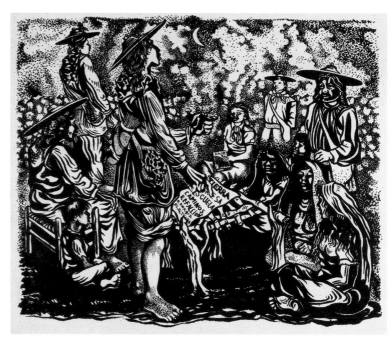

Figure 16 Ángel Bracho, *Huichol Indian meeting* (*Congreso Huichol*), from the portfolio *Ritual of the Huichol Indian Tribe* (*El ritual de la tribu huichol*), lithograph, 1942 (British Museum, P&D 2008,7069.4)

(1956). She also acted as the TGP's representative on visits to China in 1956 and the USSR in 1957, and was the only female member to execute a mural on behalf of the workshop at the Mexico-Cuba Cultural Institute in 1959.

The most significant aspect of Calderón's participation in advancing the profile of women in the workshop lay, however, in the content and imagery of her prints themselves. Although, like many of her colleagues – male and female – Calderón produced numerous images of Mexican women and girls, the iconography employed and the context in which such figures appeared provided a radical departure from the TGP's conventional representation of women as passive and vulnerable. Calderón's images ranged from those of the strong, industrious Indian matriarch in *Head of a woman* for *Mexican Life* to allegorical figures such as that presented in *The oil is ours*, an illustration for Townsend's biography of Lázaro Cárdenas in 1954. In this image the nationalization of the oil industry in 1938 is represented by a dark-haired woman, draped in the Mexican flag, clutching oil rigs to her bosom and gazing benevolently upon a mass of male workers. Calderón developed this iconography further in two prints for the 1960 album *450 Years of Struggle*, resisting Yankee imperialism in *The country will not accept foreign bases* (fig. 15), and defending Mexico's natural resources in *Mexico owns all of its resources*. She was also responsible for one of only thirteen colour prints in the portfolio, a portrait of the revolutionary hero Morelos.

The allegorical figures employed by Calderón were indicative of the interest shown by members of the TGP in the ethnographic concept of 'Mexicanidad' ('Mexicanness'). Eager to find out more about the lives of those peasants for whom they had been campaigning, a number of artists from the TGP left their cosmopolitan base in Mexico City to spend time in the Mexican countryside. In

1945 Alfredo Zalce travelled to Campeche, Quintana Roo and the Yucatan peninsula, producing a portfolio, *Prints of Yucatan*, on his return to the TGP in 1946. At the same time Ángel Bracho published a portfolio of lithographs entitled *Ritual of the Huichol Indian Tribe* (fig. 16). As the English title suggests, such images of rural Mexico were especially popular among US patrons and provided the basis for future publications, including *Mexican People* (cat. 119) and *Mexican Life*. As well as reproducing an image from Bracho's portfolio, *Mexican People* also included Francisco Mora's lithographs of mineworkers in Pachuca and Pablo O'Higgins's images of market traders and bricklayers in Cuautla and the Valley of Mexico. Similarly, *Mexican Life* included Francisco Dosamantes's *Three women* (based on sketches made of peasant girls during his work on cultural missions in Oaxaca, Michoacán and Guerrero, cat. 90), as well as *Cane mill workers* by Alberto Beltrán and Fanny Rabel's *Corn for the harvest*. Such picturesque images were a far cry from the studies of urban poverty shown in both Alfredo Zalce's *Mexico transforms itself into a great city*, 1947 (cat. 100) and Everardo Ramírez's 1948 portfolio *Life at My City's Edge* (fig. 17), which included images of tinkers, peddlers and itinerant musicians. The stark contrast between these images suggests that the romanticized ideal of rural Mexican life was as big an influence on some of the artists of the TGP as it was for their US patrons.

MCCARTHYISM, CIVIL RIGHTS AND REWRITING THE MEXICAN REVOLUTION

As membership of the TGP increased throughout the 1940s, so too did the scope and ambition of its projects. Foremost among these was the 1947 portfolio *Prints of the Mexican Revolution*. Originally conceived in the early 1940s as an

Figure 17 Everardo Ramírez, *The jar seller* (*Vendedor de Jarros*) from the portfolio *Life at My City's Edge,* linocut, 1948 (British Museum, P&D 2002,1027.27)

historic tribute to the Mexican Revolution, the completed portfolio contained eighty-five prints produced by eighteen artists. As well as documenting key events in the Revolution (with an emphasis on the simple heroism of revolutionary icons such as Zapata, Villa and Carranza, and the corruption, tyranny and betrayal of a succession of political leaders from Díaz to Huerta to Calles), the portfolio also includes a number of prints dedicated to the achievements of Cardenismo, to Mexico's contribution to the allied effort in World War Two and to the industrial reforms of the country's President, Miguel Alemán. Although many of the images of the Mexican Revolution are drawn from the famous Casasola photographs of the time, the prints depicting the person and policies of Cárdenas demonstrate the former President's ongoing appeal and influence. Cárdenas himself appears in only three images, yet the representation of specific events and initiatives occurring during his presidency act to enhance his role as a revolutionary saviour. Méndez and Zalce's image of the deportation of Calles, for example, which shows the wizened dictator cowering in his bed with a copy of Hitler's *Mein Kampf*, serves as a demonstration of Cárdenas's victory against reactionary influences in Mexico and a revindication of revolutionary values against tyranny and corruption (fig. 18). Similarly, Francisco Catlett's print *Contribution of the people during the oil expropriation* (fig. 19), depicting women donating sewing machines and children handing over the contents of their piggybanks to assuage the economic crisis precipitated by the oil expropriation in 1938, symbolizes Cárdenas's popular appeal. The TGP had hoped that its favourable representation of President Alemán's industrialization programme might result in government sponsorship for the portfolio. However, Alemán continually refused Méndez's repeated requests for funding, leading to considerable delays in publication. In the end, 550 copies of *Prints of the Mexican Revolution* were published in November 1947, with the entire portfolio later serialized by the newspaper El Nacional. This serialization, spanning three months, provided the TGP with the biggest ever audience for its work.

Having steered the TGP on to a sound financial course, Hannes Meyer returned to his native Switzerland in 1949, following completion of his commemorative album *The Taller de Gráfica Popular: Twelve Years of Collective Artistic Work*. Written in both Spanish and English (suggesting an eye towards the US market), Meyer's album provided a deeply partisan rendering of the workshop's history at a time when political divisions among the membership were rife and many of its most senior members, most notably Zalce, were becoming disillusioned with its new political and commercial direction. Indeed, Meyer makes no mention at all of the numerous political conflicts which had riddled the workshop almost from its inception, conveniently overlooking the assassination attempt on Trotsky in 1940 and the various resignations, expulsions and readmissions which had taken place since. Meyer's generally upbeat approach is perhaps due to the wider commercial aims of the album, demonstrated on the final page, in which he lists the publications of La Estampa Mexicana with details of price and availability, and with a contact address for further information. That Meyer's final undertaking on behalf of the TGP should be directed towards such commercial aims is indicative of his overall significance within the workshop; regardless of his wider political agenda, or his dubious ties to the Soviet Comintern, Meyer's primary function within the TGP was to secure its financial viability, a role that he executed with uncompromising vigour.

Despite Meyer's departure, the influx of foreign guest artists continued well into the 1950s. Although the TGP's popularity in the USA had waned considerably as a result of its defiant stand against McCarthyism and the Red Scares

Figure 18 Alfredo Zalce and Leopoldo Méndez, *The Government of General Cárdenas orders the Deportation of Plutarco Elías Calles* (*Plutarco Elías Calles es deportado por órdenes del gobierno del Gral. Cárdenas*), woodcut, 1947, published in *450 años de lucha: Homenaje al pueblo Mexicano*, 1960 (British Museum, P&D 2008,7072.24.107)

Figure 19 Elizabeth Catlett, *Contribution of the people during the oil expropriation* (*Contribución del pueblo en la expropiación petrolera*), woodcut, published in *450 años de lucha: Homenaje al pueblo Mexicano*, 1960 (British Museum, P&D 2008,7072.24.111)

(most ably demonstrated in Ángel Bracho's 1953 poster in support of the Rosenbergs, fig. 20), the workshop continued to attract left-leaning artists from north of the border. The anti-Communist witch-hunts taking place in the USA under the auspices of Senator Joe McCarthy's House Un-American Activities Committee had created a climate of fear among artists and intellectuals as increasing numbers found themselves under investigation for alleged Communist sympathies. Those working within education or in government-funded arts institutions were especially vulnerable; even those with the most casual links to left-wing organizations could find themselves blacklisted and out of work. By the time McCarthy was finally censured by the Senate in 1954, more than 25,000 Federal employees had lost their jobs, including 600 teachers.

Among those who sought refuge in Mexico during the McCarthy era were a number of African-American printmakers. In 1950 John Wilson, a member of Charles White's Graphic Art Workshop in New York, arrived in Mexico to study mural painting with Orozco. For Wilson, whose interest in the work of Orozco had been encouraged by Fernand Léger (with whom he had studied in Paris during the late 1940s), the Mexican example provided the means of reconciling his traditional artistic training with his desire to produce positive images of African-Americans:

> In art school I discovered José Clemente Orozco and other Mexican mural painters. I was strongly influenced by their philosophy of creating a public art that expressed communal realities. I was also steeped in the traditions of Western European art. However, all the great art and time-less images I saw and admired never included images of black people as universal metaphors for significant realities and truths ... The work of the Mexicans seemed to offer a form through which I could use my art skills to create convincing images of black people. Hopefully, others would identify with these images and sense a common universal humanity.[17]

Upon arriving in Mexico City, however, Wilson learned of Orozco's sudden death from a heart attack several months previously. His original plan thwarted, he enrolled in Elizabeth Catlett's class at the La Esmeralda art school. Although he continued to study mural techniques at both La Esmeralda and the San Carlos Academy, he soon began working at the TGP. His 1951 lithograph *Worker* provides an example of how he used printmaking to realize his aspirations; in this print the dignified representation of the black construction worker appears in an almost geometric composition, a clear demonstration of Wilson's aim to combine the social example of his Mexican colleagues with the formal qualities of abstraction he had studied in Paris under Léger.

In 1952 Wilson was joined at the TGP by another African-American artist, Margaret Taylor Goss Burroughs. An associate of both Elizabeth Catlett and Charles White, Burroughs was a fervent political campaigner and civil rights activist whose decision to take a sabbatical from her teaching post in Chicago was motivated as much by the repression of the McCarthy period in the USA as by her desire to learn more about socially committed art in Mexico. In the 1930s she had cut her radical teeth as a columnist for the *Chicago Defender*, a newspaper founded by the African-American entrepreneur and civil rights campaigner Robert S. Abbott. In 1940 she exhibited, alongside Charles White, at the American Negro Exposition in Chicago and helped gain sponsorship from Roosevelt's Federal Art Project for the foundation of the South Side Community Arts Centre in 1941. Throughout the 1940s Burroughs's Michigan Avenue

Figure 20 Ángel Bracho, *We won't forget Julius and Ethel Rosenberg* (¡*No olvidemos! A Julius y Ethel Rosenberg*), linocut, 1953 (British Museum, P&D 2008,7073.3)

home was the scene of regular meetings and soirées involving leading lights among the African-American Left, including the actor Paul Robeson, the poet Gwendolyn Brooks and, prior to her departure to Mexico, Elizabeth Catlett. By the end of the decade, however, and the onset of McCarthyism, Burroughs's radicalism had become a liability, her decision to invite Paul Robeson to speak at the South Side Community Arts Centre in 1952 being seen by the authorities as especially provocative. On arriving in Mexico she worked at La Esmeralda with Elizabeth Catlett before being invited to join the TGP. For Burroughs, the TGP's example of producing art with an explicitly social function not only acted as a creative stimulus, but also gave her renewed enthusiasm for the political struggle back home in the USA:

> I learned a lot and met a number of artists there … The year there strengthened me in more ways than one – not only artistically, but morally and intellectually – so that when I came back to Chicago I was in a fighting mood, and I decided to fight the reactionaries who were trying to run me out of my job as a teacher in the Chicago Public Schools. So I came back determined to fight anything like that and to continue in the way that I was doing before I left.[18]

Despite Burroughs's relatively brief tenure at the TGP (she returned to the USA in 1954, although her attempt to renew her membership of the South Side Community Arts Centre was politely declined), her Mexican experiences had a significant impact on her work with young African-American artists in the USA. Defying the constraints of McCarthyism and resuming her civil rights activities, Burroughs was an influential figure in the foundation of the National Conference of Negro Artists (NCA) in 1959, an organization which, like both the TGP and Charles White's Graphic Art Workshop, adopted the medium of the print to promote both its members' work and their social and political values. The NCA's portfolios, in tandem with an annual members' exhibition at Atlanta University, aimed at overcoming the institutional barriers that continued to make it difficult for African-American artists to exhibit their work.

THE INFLUENCE OF THE TGP IN CENTRAL AND LATIN AMERICA
The TGP also attracted artists from among its Hispanic and Latin American neighbours. Rafael Tufino was one of several Puerto Rican artists to travel to Mexico in the late 1940s, where he studied printmaking under Zalce and Chávez Morado at the San Carlos Academy. On his return to Puerto Rico in 1949 Tufino helped to establish the Centre for Puerto Rican Art (CAP), a printmaking collective strikingly similar in its aims and methodology to the TGP. In its manifesto, published alongside its first portfolio, *Puerto Rican Prints*, in 1950, the CAP pledged itself to the production of popular, collective and nationalist art through the medium of printmaking, stating that:

> This portfolio … is the fruit of the collective labour of a group of artists interested in the development of Puerto Rican art. They are of the view that the print permits the artist to reach a broader public [and] that in Puerto Rico art should spring from a complete identification of the artist with the people.[19]

Aside from the obvious similarities between the CAP's manifesto and the TGP's declaration of principles, the work produced by Tufino and his colleagues

provides further evidence of the influence of the Mexican workshop in Puerto Rico. The issue of collectively produced portfolios such as *Puerto Rican Prints* and *Prints of San Juan* (1953) owed much to the practices developed by the TGP under Hannes Meyer in the 1940s, as did the use of the medium of the black-and-white linocut. The CAP's debt to the technical and stylistic approach of the TGP can also be seen in individual works, such as Tufino's *Cane cutter* (1952), a powerful homage to rural life and labour executed using a style and technique similar to those of Leopoldo Méndez. The CAP's association with the TGP was developed still further with the arrival of Carlos Raquel Rivera in Mexico as a guest member in 1954. He returned again in 1958 to contribute to the TGP's anti-nuclear portfolio, *Mexico is in Danger*, and to participate in the first Inter-American Biennial where his 1955 linocut *Hurricane from the north* (which used the image of the *calavera* as an allegory for US imperialism) won third prize.

The Bolivian printmaker Roberto Berdecio also enjoyed an enduring association with the TGP. Having moved to Mexico in 1934 to study mural painting and become an associate member of the LEAR, Berdecio exhibited alongside Méndez, Zalce and Arenal at the exhibition of the Graphic Arts Division at the American Artists Congress in New York in 1936. Following several years in New York, where he worked alongside Jackson Pollock at Siqueiros's experimental art workshop, Berdecio returned to Mexico in 1947 and remained a guest artist at the TGP for the next eight years. Avoiding the more overtly political and propagandist aspects of the TGP's work, Berdecio's prints belong to the more romantic, ethnographic tradition within the workshop, with numerous studies of the rural landscape and delicate portraits of children, such as *Portrait of a Mexican girl*, 1947 (fig. 21).

Ecuador's Galo Galecio enjoyed a brief but highly influential spell at the TGP in the mid-1940s. Having been sent to Mexico to study mural painting by the revolutionary government of Ecuador in 1944, he joined the TGP as a guest member in 1946. During this time he became the first of only two overseas-born members to produce their own portfolios. Galecio's *Under the line of Ecuador*, 1946 (fig. 22), was moreover the first to utilize the medium of the linocut, a technique that would soon replace lithography as the TGP's preferred medium. It is unclear as to what extent Galecio himself influenced this change, but the publication by La Estampa Mexicana of a 100-edition portfolio by a guest member provides some clue as to the high regard in which Galecio was held by his Mexican colleagues.

Antonio Franco of Guatemala was also drawn to Mexico, like so many of the TGP's foreign guest members, by his interest in the muralists. A former student of Rivera, Orozco, Zalce, Frida Kahlo and María Izquierdo, he experienced the entire spectrum of the Mexican school during the early 1940s before joining the TGP in 1947. Although a member for only two years, he participated in a number of prestigious projects, including the portfolios *Prints of the Mexican Revolution* and *CTAL 1938–1948*. Returning to his native Guatemala in 1949, he also played a pivotal role in organizing the TGP's debut exhibition there in 1950.

INTERNATIONAL DIMENSIONS:
THE TGP IN EUROPE AND LATIN AMERICA
As Cold War tensions began to impinge on the TGP's activities in the USA (an exhibition planned at the Metropolitan Museum of Art in 1954 was cancelled – an act condemned by Siqueiros as a manifestation of McCarthyist tyranny), workshop members began to turn their attentions towards Eastern Europe.

Figure 21 Roberto Berdecio, *Portrait of a Mexican girl* (*Retrato de muchacha Mexicana*), lithograph, 1947 (British Museum, P&D 2002,1027.3)

Despite Stalin's support for Socialist Realism and the idealized representation of workers and peasants as a tool of revolutionary propaganda, the TGP had struggled to make an impact in the USSR, despite exhibiting there several times during the early 1940s. In 1948, however, it held a successful exhibition in Czechoslovakia, heralding the start of a ten-year programme of exhibitions in Europe that would include over seventy exhibitions in eighteen countries. Once again, Meyer and his former associate Stibi provided an important stimulus to the TGP's emerging European profile, publishing articles in *Bildende Kunst* and *Graphis* in 1948 and 1950 by way of an introduction to the workshop for a European audience.[20] Stibi was also responsible for organizing an exhibition of prints from the portfolio *Prints of the Mexican Revolution* in East Berlin in 1949, followed by a touring exhibition of prints and posters in eleven towns and cities throughout Poland. The particular enthusiasm for the TGP's work in Czechoslovakia resulted in several more successful exhibitions and tours, and the publication, in 1955, of a book, *Mexicka Grafika*, written by a former cultural attaché to Mexico, Norbert Fryd, and containing some two hundred reproductions.

Aside from the obvious political implications of the workshop's emphasis on countries within the Soviet Bloc, a number of the TGP's Eastern European activities had an explicit political purpose. Exhibitions in East Berlin in 1951, Romania in 1953 and Moscow in 1957 and 1958 all ran in conjunction with various Communist Party Youth and Peace Congresses. Although modest in scale and centred on small regional galleries, the significance of the TGP's presence in Europe should not be underestimated; at a time when the USA was aggressively promoting exhibitions of Abstract Expressionism in Europe as a symbol of liberal capitalist democracy, exhibitions by the TGP acted as a demonstration of a powerful counterpoint.

The 1950s also saw the workshop's exhibition programme develop into a global enterprise. In March 1956, Ignacio Aguirre and Celia Calderón de la Barca accompanied an exhibition of Mexican Graphic Art to China. Other exhibitions were held as far afield as Israel, Japan, Lebanon, and Egypt, as well as throughout Latin America, most notably in Chile, where members exhibited regularly throughout the 1950s. A pivotal influence in these activities was the Nobel prize-winning poet Pablo Neruda who, as an associate member of the LEAR, had close and long-standing ties to the TGP. In 1943 he had contributed a foreword to the book *Muerte al Invasor de Ilya Ehrenburg*, a tribute to the Communist author and activist commissioned by Hannes Meyer and illustrated by TGP members. The favour was returned in 1950, when the workshop provided illustrations for the Mexican edition of Neruda's epic poem against US intervention in Latin America, *Que Despierte el Leñador*. This publication also coincided with the TGP's debut exhibition in Santiago, an event co-sponsored by Mexico's ambassador in Chile, the former Stridentist leader Manuel Maples Arce.

As in the case of Chile, the vast majority of the TGP's Latin American exhibitions were made under the auspices of cultural diplomacy or for the purposes of international competition. Around a quarter of its exhibitions in Latin America were held at the Mexican embassy or on the initiatives of the Mexican government in co-operation with those of the host countries, as in the case of the exhibitions in Guatemala City in 1950, Santiago de Chile in 1953 and Buenos Aires in 1958. In addition to these the TGP also participated in numerous Inter-American art competitions, including the Biennials of Brazil, Chile and Cuba. That said, like many of their Eastern European ventures, a number of the TGP's

Figure 22 Galo Galecio, *Charcoal ovens* from the portfolio *Under the Line of Ecuador* (*Bojo la linea del Ecuador*), linocut, 1946 (British Museum, P&D 2008,7072.2)

Latin American excursions were politically motivated. In 1952, former guest artist Roberto Berdecio organized an exhibition of members' work in his native Bolivia to coincide with the rise to power of the Movimiento Nacionalista Revolucionario (MNR). The MNR's programme for agrarian reform and the nationalization of industry harked back to the glory days of Cardenismo in Mexico, and the TGP's exhibition in La Paz drew a staggering audience of 35,000, or 10 per cent of the population. Similarly, during the early 1950s the TGP undertook several visits to Guatemala under the presidency of the left-wing Jacobo Arbenz, and were swift to condemn the USA following the CIA-sponsored coup that deposed Arbenz in 1954. Several other exhibitions also appear strategically timed to coincide with critical points in the political climate of the nations visited: Panama in 1948 (an election year), Haiti in 1950 (which saw a right-wing coup against the elected government of Dumersais Estime), and the Dominican Republic in 1961, scene of a hard fought presidential election campaign between the novelist and Communist sympathizer Juan Bosch and Joaquin Balaguer, nephew of the assassinated dictator Rafael Trujillo.

THE END OF AN ERA

Such international successes were, however, overshadowed by a growing schism within the membership over domestic issues. Throughout the 1950s the TGP had continued to produce posters and pamphlets in support of the activities of both the Mexican Communist Party (PCM) and its rivals in the Partido Popular (PP, led by the trades unionist Vicente Lombardo Toledano), as well as continuing to accept commissions from an increasingly repressive Mexican government. The duality of the TGP's position was most clearly demonstrated during the miners' strikes in Cloete and Nueva Rosita between 1950 and 1952. With the PP and the PCM united in support of the workers, the TGP embarked on a vigorous campaign on behalf of the striking miners and attacked the Mexican government for its repressive tactics in imprisoning their union leaders. Despite such acts of dissension, however, the TGP continued to accept government commissions, appearing as part of the official Mexican delegation at the Venice Biennial in 1950 and 1952, and producing a portrait of President Adolfo Ruiz Cortines for distribution among Mexico's overseas embassies.

The TGP's impotence in domestic affairs reached its nadir in 1956 when the workshop failed to respond to the violent suppression of a students' strike or to protest against the Federal government's decision to ban it from posting members' work on the streets of Mexico City. The involvement of existing and former members in a number of rival organizations, such as the Frente Nacional de Artes Plasticas (founded by Xavier Guerrero and José Chávez Morado) and the Union of Painters, Sculptors and Printers (whose members included Roberto Berdecio, Raúl Anguiano and Francisco Dosamantes), also served to diminish the TGP's status and influence. The disintegration of the workshop became complete in 1960 when, following the dismal reception given to the portfolio 450 *Years of Struggle: Homage to the Mexican People*, Méndez and his supporters resigned en masse, leaving the Communist faction in sole control of the TGP.

Although the loss of the Méndez faction, and of course of Méndez himself, was a severe dent to the TGP's reputation, it did at least clarify the group's political position, leading to the return of several former members including Francisco Mora and Antonio Pujol. There was new impetus, too, from the Cuban Revolution and the return to Mexican politics of Lázaro Cárdenas who, through the Movement of National Liberation (MNL), aimed to unite the diverse

and often disparate left-wing groups in Mexico. Under the leadership of Cárdenas the MNL was to provide the inspiration for the TGP's return to the domestic political arena during 1961 and 1962. Becoming actively involved in the movement's campaigns for social justice and against imperialism, the workshop produced conference posters, *calaveras* and several small booklets. Despite this new sense of political purpose and unity, however, the economic problems of the TGP could not be overcome; surplus copies of *450 Years of Struggle* had flooded the market and, with membership now dominated by young unknowns, exhibiting opportunities became scarce, and new commissions even rarer.

The 1960s thus became a decade of marginalization and growing obscurity for the TGP. Although the workshop would continue to operate until the mid-1970s, campaigning for sexual equality, civil rights and nuclear disarmament, it was no longer considered a potent force in the propaganda war, to be courted by government and opposition alike. Indeed, the final exodus of its remaining senior members, Luis Arenal, Ángel Bracho and Adolfo Quinteros, coincided with the massacre of students by government forces in Mexico City in 1968, confirmation, as if any were needed, that the glory days of Cardenismo had long since passed.

AN ENDURING LEGACY

Although their collective ethos was ultimately undone by political strife, the printmakers of the TGP continued to exert a lasting influence on artists in Mexico and beyond. Leopoldo Méndez went on to found the Fondo Editorial de la Plástica Mexicana in 1958, publishing lavishly illustrated volumes on the Mexican mural movement, José Guadalupe Posada and Mexican folk art. Méndez also produced prints for the films *The White Rose* (1960) and *Pancho Villa's Gold* (1966). In 1968, along with his former Stridentist colleagues Manuel Maples Arce and Gabriel List Arzubide, he became a founding member of the Academy of Arts in Mexico (affiliated to the National Academy of Fine Arts and now the holder of a substantial archive of Mexican prints). Similarly, Alfredo Zalce founded a workers' art school in Michoacan, as well as the Museum of Contemporary Art in his native Morelia, while Francisco Dosamantes was a founder member of both the Society for the Advancement of the Visual Arts and the Frente Nacional de Artes Plásticas. Beyond Mexico, Margaret Taylor Goss Burroughs founded the DuSable Museum in Chicago, while Elizabeth Catlett continues to inspire new generations of artists, such as Samella Lewis, with her prints and sculptures.

1 *Protest of Independent Artists ¡30-30!*, Mexico City, 7 November 1928, reproduced and translated in Adès 1989.
2 Siqueiros was working in Los Angeles, Orozco at Dartmouth College, New Hampshire, while Rivera was working on his ill-fated *Man at the Crossroads* mural at the Rockefeller Centre in New York.
3 David Alfaro Siqueiros, 'The Mexican Experience in Art', address of the Mexican Delegation to the American Artists Congress, New York, 15 February 1936.
4 These included the Confederación de Trabajadores Mexicanas (CTM) led by the trade unionist Vicente Lombardo Toledano, and the Confederación de Campesinos Mexicanos (CCM).
5 The expulsion of Morones is also depicted in another Méndez woodcut from 1936, *The large obstacle* (cat. 53).
6 David Alfaro Siqueiros cited in Prignitz 1992, p. 33. According to Prignitz, the principal target for this attack was Siqueiros's old adversary, Diego Rivera. However, given the LEAR's growing support for the Cárdenas administration, there were also obvious implications for the Graphic Arts Division.
7 *Declaration of Principles of the Taller de Gráfica Popular*, reproduced and translated in Adès 1989, Appendix 8.1.
8 The 1938 Calendar for the Universidad Obrera is the only known work to display the imprint of both the LEAR and the TGP.
9 A detailed, but unsubstantiated, account of this event and its impact on the TGP is described by José Chávez Morado in Caplow 2007, pp. 155–6.
10 1942 is the date of Meyer's formal appointment. There is, however, considerable evidence to suggest that his work on behalf of the TGP began much earlier, probably around 1940.
11 Pablo (Paul) O'Higgins was born in Salt Lake City and grew up in San Francisco. He moved to Mexico in the 1920s to work as an assistant to Diego Rivera on his murals at the Ministry of Education.
12 The diplomatic imperatives informing this purchase are largely confirmed by the fact that, to date, none of these prints has ever been put on public display at the Museum.
13 The IBM Collection of Mexican Art, including prints by Anguiano, Bracho, Dosamantes, Zalce and Chávez Morado, was exhibited at Grand Central Galleries in San Francisco in May 1946. The General Motors Collection, which held prints by more than twenty members of the TGP dating from the 1940s to the mid-1950s, was exhibited at the University of Texas in 1969 and commemorated in two volumes entitled *Image of Mexico I and II* (1969).
14 Modotti's biographer, Margaret Hooks, suggests that Meyer's association with Modotti and Vidali began shortly before his dismissal as Director of the Bauhaus in 1930, and that Meyer was one of only a few people to know about the couple's covert entry into Mexico in 1939. Vidali has also been implicated in the failed assassination attempt on Leon Trotsky led by Siqueiros in 1940. See Hooks 1993.
15 The close relationship between Modotti, Meyer and the TGP is further evidenced by the fact Leopoldo Méndez carved the headstone for Modotti's grave in Mexico City.
16 *I am the Negro Woman* was a series of fifteen linocuts produced by Catlett at the TGP in 1946. As well as Harriet Tubman (who helped free over three hundred slaves in the nineteenth century and worked as a spy for Union forces during the American Civil War), the series included images of other African-American heroines such as Phyllis Wheatley and Sojourner Truth.
17 Papers of John Wilson (undated), Reel 4876, Archives of American Art, Smithsonian Institution, Washington DC.
18 Margaret Taylor Burroughs, interview with Anne Tyler, 5 December 1988, Archives of American Art, Smithsonian Institution, Washington DC.
19 CAP Manifesto from the portfolio *La Estampa Puertorriquena*, translated and reproduced in Benítez 1988, p. 83.
20 Stibi 1948; Meyer 1950.

CATALOGUE

1 POSADA AND HIS LEGACY

José Guadalupe Posada 1852–1913

José Guadalupe Posada was born in Aguascalientes, Mexico, where he began his career as a printmaker at the age of sixteen when he was apprenticed to José Trinidad Pedroza (1837–1920). His early work involved making lithographs for the satirical magazine *El Jicote*, which only ran for eleven issues. At the age of twenty Posada moved to León with Pedroza to open a print workshop. When Pedroza left León in 1876, Posada took over. After twelve years of making prints for calling cards, leaflets and other paraphernalia, he moved to Mexico City in 1888 where he established a print workshop on Santa Inés Street, in the heart of the city.

During his first few years in Mexico City Posada made prints mainly for the popular press, especially Antonio Vanegas Arroyo's publishing house that produced newspapers and weekly magazines, including *Gaceta Callejera* (*Street Gazette*). Posada's prints were mainly satirical or sensationalist, relying on caricature. They dramatized incidents such as floods, earthquakes, fires, suicides, derailments and other perils of modern life. He also illustrated rhyming ballads (*corridos*) and stories about love affairs printed on brightly coloured paper for the penny press, to be sold by street vendors in markets, on the street and at festivals for 1–5 *centavos*. They were designed as an effective vehicle for telling stories to the masses who were unable to read.

From the 1880s Posada made prints of *calaveras* (skeletons) which he circulated through broadsheets. These depict skeletons dancing, playing instruments and engaging in battles, as well as dressed up to represent well-known national figures such as politicians. Produced around the time of the Day of the Dead festival (1–2 November), at which Mexicans celebrate and commemorate the dead, these prints put death on display as a reminder of mortality. Each year on the Day of the Dead families make altars and leave offerings of food for their departed ancestors whose souls they believe return during the festival.

Throughout his life Posada was regarded as a draughtsman rather than as a 'fine artist'. Antonio Vanegas Arroyo was partly responsible for consolidating his legacy: after Posada's death Vanegas Arroyo made copies of his prints that he used in *corridos* on current affairs. But it was Jean Charlot who in 1921 rediscovered Posada's work, publishing an important article on him in 1925 in the Mexican illustrated magazine *Revista de revistas*. The three leading muralists, Diego Rivera, José Clemente Orozco and David Alfaro Siqueiros (Los Tres Grandes), and other Mexican artists were inspired by Posada's prints, noting in particular his ability to tap into popular culture as a vehicle for bringing news to the masses. Whereas artists in the nineteenth century followed European artistic conventions, Posada used Mexican subjects as the impetus for his work. It is for this reason that he is now hailed as the father of Mexican printmaking and has had a profound influence on Mexican art.

BIBLIOGRAPHY
Dawn Adès, 'Posada and the Popular Graphic Tradition', in Adès 1989; Jean Charlot, 'José Guadalupe Posada: Printmaker to the Mexican People', in Rothenstein 1989.

1 JOSÉ GUADALUPE POSADA
The skeleton of the people's editor
(*La calavera del editor popular*)
1907
Photorelief, letterpress on buff paper
355 x 267 mm
1992,0404.90

The bearded skeleton wearing a top hat and glasses represents Antonio Vanegas Arroyo, who published many of Posada's prints. The verses around the image reflect the diversity of his work by listing his range of publications. His success as a publisher is further reinforced by the thousand-dollar note that he clutches in his right hand.

Two different scenes appear behind Vanegas Arroyo, reflecting the aspects of his profession. In the upper section is a shop, representing the commercial nature of broadsheet production. At his feet the skeletons in a workshop are engaged in the practical tasks of proof-reading and working the press. Standing in this workspace Vanegas Arroyo demonstrates how firmly rooted he was in the world of publishing and how he controlled its many facets.

Through depicting Vanegas Arroyo on a broadsheet, Posada credits his profession while at the same time transforming him from a publisher to a popular hero. But showing him as a skeleton, Posada also suggests that no matter how much of a people's hero an individual becomes, death is inescapable. Vanegas Arroyo died in 1917 but his son and grandson continued to print images.

LA CALAVERA
⇒ DEL EDITOR POPULAR ⇐
ANTONIO VANEGAS ARROYO

Esta sí es la calavera
del Editor popular,
más fachosa y salamera
como otra nunca han de hallar.

El fué quien nos publicaba
mil primores de poesía,
que nuestra vida endulzaba
y llenaba de alegría.

Tenía preciosas historias
que al más triste hacían gozar,
y dejaba en las memorias
un recuerdo singular.

Los alegres sin medida,
leyendo sus oraciones
sentían tan corta la vida
que prendían sus corazones....

Las muchachas que alocadas
por el novio ni dormir
pueden las....enamoradas
y no lo saben decir.

Que le quieren, que le adoran;
no se saben expresar....
y las desdichadas lloran....
el Editor Popular.

Da colecciones preciosas
para poder escoger
de mil cartas amorosas,
la que guste á la mujer.

Y los tratos arreglados
los novios pronto tenían
y prometen que abogados
de Don Antonio serían....

Los niños agradecidos
sus cuentos leyeron ya,
que son tan entretenidos
que los lee hasta su papá....

Y millares de folletos
y bibliotecas enteras,
que llevó á los esqueletos
y á todas las calaveras.

Lo que es de hoy en adelante
el cementerio será
la invitación más galante
que cualquier mortal hará.

Allá encontraréis gustosos
mil lecturas agradables,
mil cuentos maravillosos
y versitos admirables.

Historias estravagantes,
oraciones fervorosas;
sucesos espeluznantes
y comedias muy hermosas.

Allá Don Toncho Vanegas,
como en el mundo hizo igual;
sigue llenando talegas
y aumentando su caudal.

Aquí dejó á su hijo Blas,
que entre los vivos rezumba,
pero que remite más
para el país de Ultratumba.

Allá compra hasta el demonio
para escribirle á su diabla,
las cartas que Don Antonio,
de puros amores habla,

Y también vende á la muerte
"reglas pa echar la baraja"
que ella aplica diligente
y á los médicos desgaja....

Y todo aquello es ganar,
allí cualquiera trabaja,
y el Editor Popular,
ni muerto jamás se raja.

Y sigue siempre vendiendo
sus ediciones modernas
y todos siguen leyendo
esas lecturas eternas....
Si tú gustas, valedor,
la dirección te daré,
cuando vayas al panteón
al despacho te enviaré.

Y compras tus calaveras
y cuadernos de canciones,
y jotas y peteneras
que alegran los corazones.
Todo se vuelve gozar,
ni quien recuerde la vida.....
y el quien no sepa cantar
no más un cuaderno pida.

Y aprenderá mil cantares
y olvidará con razón
la soledad, los pesares
y tristezas del panteón.
Si este año no quieres ir,
Te esperaré el año entrante
Que cuando vuelva á venir.....
¡Tú que estés pata tirante!

2 JOSÉ GUADALUPE POSADA

The thundering skeleton of the modern bells

(*La tronante calavera de las campanas modernas*)
1905
Photorelief, letterpress on orange paper
358 x 262 mm
1994,0410.4

At the left a skeleton pulls a bell cord while holding aloft an hourglass. The bell is clearly from a church as the skeleton wears a Catholic cardinal's hat, and the words in the title – 'las campanas modernas' ('modern bells') – indicate that the bell relates to contemporary life. The title and the image probably refer to the bells and clock installed in the tower of the Metropolitan Cathedral in Mexico City in June 1905, the same year as the print was made.

The Metropolitan Cathedral is located in the Zócalo, the main plaza of Mexico City, and symbolically at the heart of the nation. President Benito Juárez had separated Church and State in the nineteenth century in order to reduce the power of the Church and to make the president sovereign. In 1905 President Porfirio Díaz re-established the relationship between Church and State.

The three columns at the right side of the sheet contain nineteen verses relating the misdemeanours of people of different occupations, including Don Angel the pawnbroker, Rosita the shoemaker, Joaquín the butcher and Aurelia the tortilla maker. One interpretation of the print is that the skeleton in his cleric's garb is calling these people to account for their behaviour; they in turn would have seen Posada's broadsheets. Thus the print may be seen to provide moral education for the working classes in an accessible and engaging format.

3 JOSÉ GUADALUPE POSADA

The graveyard where all the skeletons are piled high

(*El panteón de todas las calaveras que se encuentran en montón*)
1905
Photorelief, letterpress on orange paper
355 x 247 mm
1998,1004.20

Posada's representation of the popular Day of the Dead festival appears on the front of this double-sided broadsheet. The orange paper evokes marigolds traditionally made into wreaths to decorate tombstones for the festival. The print shows skeletons gathered together in a graveyard to share food and to spend time with the souls of their departed ancestors as is customary on this day.

While the print shows the Day of the Dead festivities, it also highlights the distinction in Mexico between marked tombstones for the wealthy and unmarked graves for the poor; Posada himself was buried in an unmarked grave. The verses beneath the print entitled 'Sepulcros sin inscripciones' ('Tombstones without inscriptions') emphasize this social divide. Another verse, 'Los de las aguas del Peñon' ('Those who go to the springs at the Peñon spa'), points to the fact that the rich took the waters at Peñon in order to maintain their health.

Posada's print shows all classes meeting in a graveyard for a picnic. Accompanied by an elegantly dressed woman, a man in a top hat sips his drink from a tall glass – a sign of bourgeois decadence – while the peasants (*campesinos*) drink from beakers. They feast on *mole* (chocolate and chilli sauce poured over food such as meat or tortillas) from a large casserole dish in the foreground. They also eat *pan de muertos*, a sweet bread sprinkled with sugar, made especially for the Day of the Dead. The print demonstrates that everybody dies and ends in the cemetery, where there is no distinction between rich and poor.

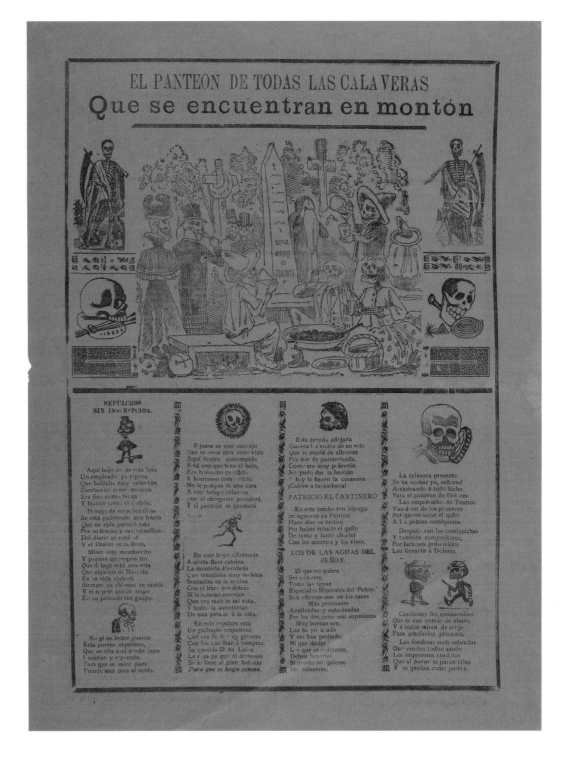

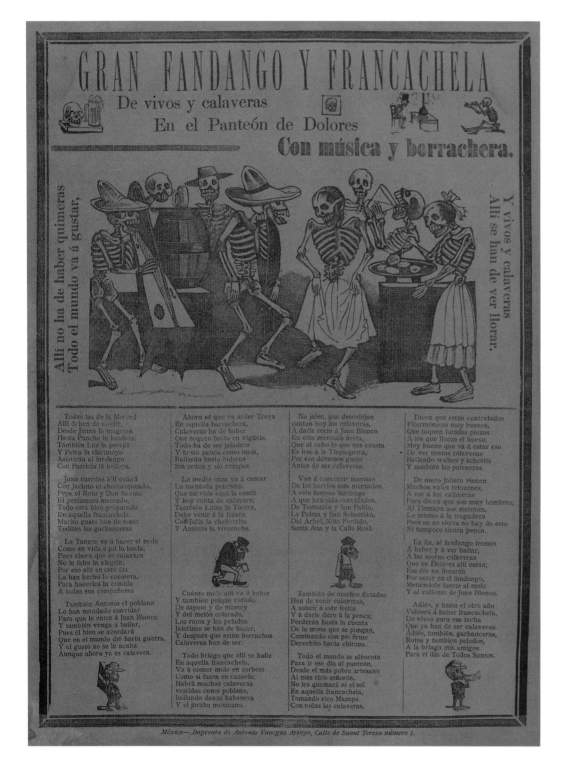

4 JOSÉ GUADALUPE POSADA

Dancing and revelry

(*Gran fandango y francachela*)
c.1910
Photorelief, letterpress on orange paper
362 x 263 mm
1994,0410.6

Set in the municipal cemetery in Mexico City
(Panteón de Dolores), this scene shows a group
of skeletons gathered to mark the Day of the
Dead festivities. That on the left plays the harp
to accompany those dancing in the foreground.
Another gulps beer from a large glass while a
female skeleton heats tortilla on a stove.

The male skeletons wear hats and the females
are dressed in pleated skirts, typical dress for
Mexican peasants. Rhyming verses beneath the
print provide a detailed account of a popular Day
of the Dead celebration. The verses also remind
us that festivities such as this take place in every
neighbourhood and are open to everybody.

5 JOSÉ GUADALUPE POSADA

A skeleton from Guadalajara

(*Calavera Tapatia*)

1910

Photorelief, letterpress on buff paper

360 x 262 mm

1998,1004.18

A male skeleton dressed in a jacket and tie is shown sitting at a table and smoking a cigar. He holds a small glass and a bottle of tequila. On the table is a cut lime, a drinking glass, a cork bearing the name 'La Tapatia', a small knife and a deck of playing cards. On the right there is also a pot containing *posole*, a popular Mexican dish made from corn, shredded pork or chicken and chilli with radish, onion, lettuce and coriander. This collection of items suggests that the skeleton is in a *cantina* – a Mexican bar traditionally reserved for men, yet a female skeleton, defined by her fringe, peers over his shoulder.

The word *Tapatia* in the title is used colloquially in Mexico to describe people from the city of Guadalajara, regarded as the city most fully embodying Mexican identity. Written in the first person, the verses in the columns surrounding the image emphasize this fact, mentioning the state of Jalisco of which Guadalajara is the capital. The verses also recount the way in which the skeleton has defeated people from other states in fights as a display of masculinity. In Mexican culture the *cantina* was a space associated with *machismo*, and this print does much to support this stereotype.

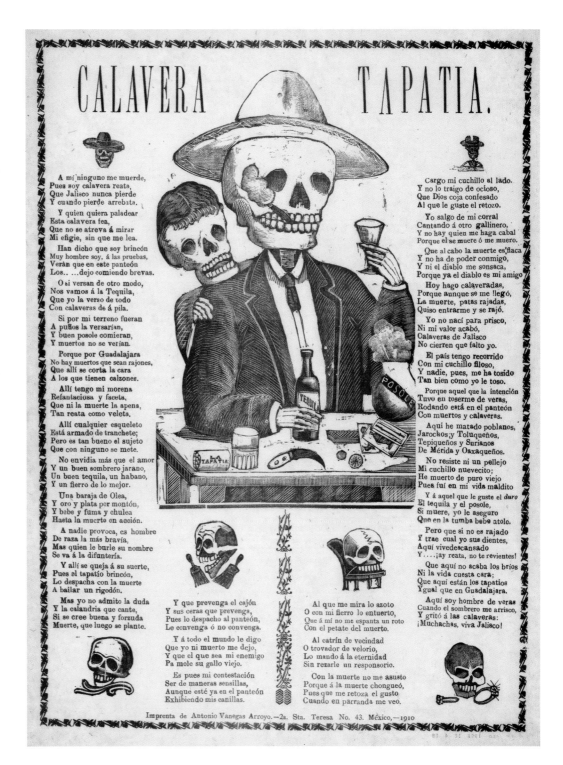

¡Ya llegó la calavera De su viaje extraordinario, Vino á ver muy placentera Las fiestas del Centenario!

DICE LA MUERTE:

Llegó á mis manos «El Diario»
y supe que estaban prestas
las comisiones de fiestas
en honor del Centenario.
 Y no queriendo omitir
ningún festejo de ver,
me vestí para impedir
me fueran á conocer....
 Con un sombrero deforme
con muchas plumas y flores,
qué á mí me pareció enorme
y el terror de los terrores....
 Y una falda....¡caracoles!
señída á las pantorrillas......
¡santo Dios, qué apuraciones!
y yo que traía canillas......
 Mejor me quité esas cosas
Que mi esqueleto no quizo,
Saqué mis muelas filosas....
¡Y esto es darle del macizo!
 Porque sí, con tanta gente,
que ya ni en hoteles cabe,
me entusiasmo y..clavo el diente.
y ¡ah, qué sabroso me sabe!
 ¡Es de verse la listita
que llevo en tan pocos días!
mira, lector, ¡qué bonita!
¡estas son mis fechorías!
 Doña Lola, de Toluca,
se vino con su familia,
á compartir la vigilia,
las fiestas y la boruca,
 En el zócalo mirando
los fuegos artificiales
sin prole se fué quedando
por maldad de los mortales.
 A Pepa se la llevó
un sastre muy parrandero,
á Delfina un zapatero
y Elenita"se joyó"
 Con su tío de la casera....
Más, como es tan ordinaria
Le daba una tunda diaria
Y la volvió calavera.....

TEPACHEROS DIFUNTIADOS

Se abren más todos los días
Que es un gusto sin igual,
Y abundan tepacherías
En la culta capital....
 A los puercos tepacheros
Recen todos un sudario,.
Porque ya todos murieron
Vendiendo en el Centenario.

PULQUEROS QUE SE PELARON

Por vender su pulque aguado
La pelona los casó.....
Pues el pulque han fermentado
Con ca.....liche y...¡qué sé yo!
 Por eso la flaca fiera
En forma de boticario
Me los volvió calaveras
Del purito Centenario.

MOTORISTAS ATROPELLADOS

Es raro de suceder
Que un motorista se muera,
Y menos que llegue á ser
Aplastado calavera......
 La flaca les aplicó
La ley del Talión del diario
Y en poco tiempo llenó
Su Panteón del Centenario.

TENDEROS ENVENENADOS

Ya toditos los tenderos
Por surtirse de su tienda
Envenenados murieron....,
¡Qué cosas tendrían de venta!
 No existe ya ni un tendero
Que sea un hombre estrafalario
Pues la flaca tiene lleno
Su panteón del Centenario.

FARMACEUTICOS INCURABLES

Los que á todo mundo acortan
Con su malvada farmacia
De la tumba la distancia
Y todavía luego cobran.....
 Ya no queda ni un doctor
Ni siquiera un boticario.....
Todos fueron ¡oh dolor!
Al panteón del Centenario.

CARNICEROS ANÉMICOS

Su carne flaca y sin jugo.
Tanto, tanto alimentaba,
Que comerse un toro pudo
Quien con hambre se quedaba....
 La muerte probó sus toros
Con arrojo temerario
Y al punto cargó con todos
Al panteón del Centenario.

TORTILLERAS y PANADEROS

Más mugres ponían que masa
Y más suciedad que harina.....
Cundiendo pestes y ruina
De México en cada casa....
 La muerte puso de veras
El remedio necesario.......
Y los volvió calaveras
Del purito Centenario!

CANTINEROS QUE LA PETATEARON

Ya los pobres cantineros
Por vender tanta bebida
Con alumbre y agua hervida,
De un retortijón murieron,
 La flaca tomó en Contreras
De su vino temerario
Y los volvió calaveras
Del purito centenario.

Una mujer muy panzona,
en el zócalo, en la bola,
la pusieron á esprimir
y al fin la hicieron ¡morir!
 Payos, indios y babosos,
ratones de un agujero,
víctimas de los maldosos,
de la crisis y el ratero:
 Los niños Arriaga y Serna
se fueron á la verbena
en burros muy elegantes,
como muchos estudiantes....
 Los «Albañiles» sin chamba,
«Estafadores» de tontos,
los «Fieras Artes» de fama
y los «Globulitos» prontos,
 La muerte con sus carreras
por descuido involuntario,
me los volvió calaveras,
del panteón del Centenario.
 Caminaban muy avispas
con tompeates y faroles....
con los chuscos «Rasca tripas»
y aquellos dos domadores.
 Carmelita, Rosa y Luz,
Lupe, Aurora y Trinidad,
murieron de un patatus
al llegar á esta ciudad.
 Fueron todos los del Carmen,
á ver la iluminación,
que como ustedes ya saben
causó gran admiración.
 ¡Achis! los payos decían,
Hasta deslumbran los focos....
ó es que estamos todos locos
ó deverás es de día....
 Juan que vino de Oaxaca,
tenía los pelos parados....
y armaban gran alharaca
otros de varios Estados....
 Y mirando en las aceras
explendor extraordinario,
se volvieron calaveras
del panteón del Centenario!

Imprenta de Antonio Vanegas Arroyo. 2a. de Santa Teresa número 43.——México.——1910.

6 JOSÉ GUADALUPE POSADA

The skeleton has now arrived from its extraordinary journey, it has come to see the marvellous centenary festival

(*¡Ya llegó la calavera De su viaje extraordinario, Vino á ver muy placentera Las fiestas del Centenario!*)
1910
Photorelief, letterpress on red paper
354 x 256 mm
1994,0410.5

In this brightly coloured print a large skeleton stands at left, addressing a group of skulls scattered across the ground. A hunched skeleton at the front gazes directly at the speaker. Others watch the scene from the windows of a passing tram in the background. The scene is set in front of a cemetery, indicated by the cross on top of the arched entrance in the wall behind. The cemetery is set in the context of the centenary in 1910 of the beginning of the Mexican battle for independence from Spain.

Although Mexico's struggle for independence began in 1810, it was not achieved until 1821. President Porfirio Díaz's government organized centenary celebrations in 1910 to mark the beginning of the campaign. A committee arranged lavish celebrations which mainly took place in Mexico City during September: various buildings and monuments were inaugurated, including the Monument to Independence – a column crowned with a golden angel – and there were also banquets and balls attended not only by the Mexican elite, but also by invited foreign dignitaries. On 16 September, Independence Day, the committee hosted an historical parade telling the story of Mexico's past. The centenary celebrations were carefully orchestrated to showcase the nation and demonstrate its achievements in the hundred years since Independence. Reports about the celebrations, many illustrated with photographs, appeared in the press.

Written in the first person, the first column of verse beneath the present image describes what the skeleton saw when it went to the centenary celebrations. Instead of lavish parties, it tells of incidents such as car accidents, terminal illness and the effects of eating bad meat. The print uses the metaphor of death to produce a darker account of the centenary, inviting the viewer to reconsider it broader social implications.

7 JOSÉ GUADALUPE POSADA

The skeleton of Don Quixote

(*La calavera de Don Quijote*)
1910–13; printed 1919
Photorelief, letterpress on buff paper
360 x 272 mm
1998,1004.17

The skeleton in this print represents Don Quixote riding his galloping horse, Rocinante. Grasping a lance in one hand and the reins in the other, he charges through a crowd of skeletons, sweeping them on to the ground and hurling them into the air. The continuous verse in four columns of text beneath the print relates an anecdotal tale about Don Quixote in his own voice.

Written by Miguel de Cervantes in the sixteenth century, *Don Quixote* is a Spanish classic. Cervantes tells the story of Don Quixote de la Mancha who, with the company of his aide Sancho Panza, goes in search of adventure. With no aristocratic lineage, Don Quixote is a self-made knight who must continually overcome obstacles in his quest for adventure.

Posada's print operates on two levels. Firstly, his depiction of Don Quixote as a skeleton demonstrates the invincible nature of this legendary figure whose name continues to inspire writers and artists. Secondly, by representing *Don Quixote* in a print Posada makes a Spanish literary hero accessible to the masses of Mexico.

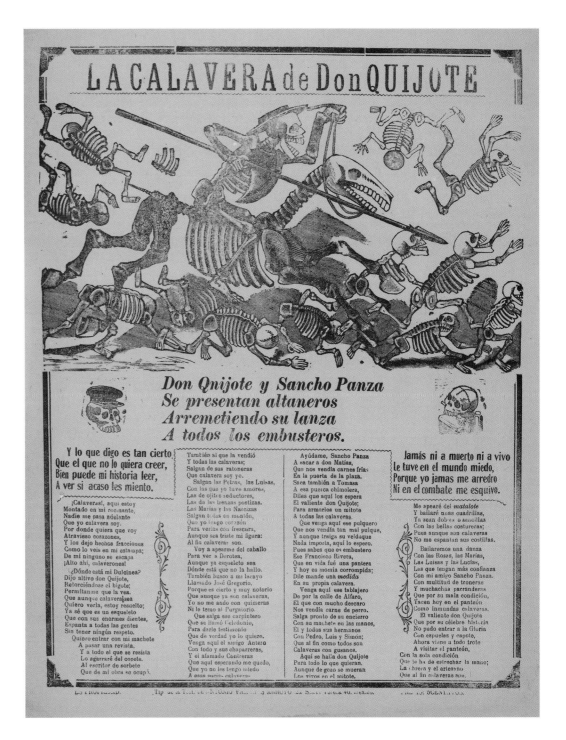

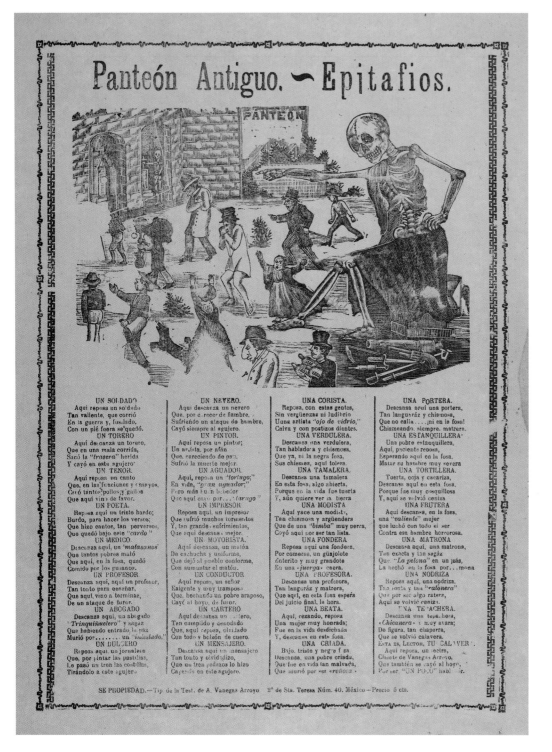

8 JOSÉ GUADALUPE POSADA

Epitaphs at the old cemetery

(*Panteón Antiguo – Epitafios*)
c.1913; printed c.1919
Photorelief, letterpress on buff paper
363 x 262 mm
1998,1004.19

Perched on a square plinth with a black cloth covering his legs, a skeleton points towards the entrance of a cemetery, identified by the word *panteón* and the alcoves in the background containing headstones. There is also an hourglass behind the skeleton, an object that often appears in Posada's *calavera* prints to symbolize mortality. A group of people flee the skeleton toward the cemetery. Some wave their arms in the air out of fear; one man clasps hands his together, begging for mercy.

The man in the foreground carrying bags of money symbolizes capitalism. A pile of weapons behind him, including a gun, a dagger, a sword and a syringe, connect capitalism with violence, indicating that the Mexican Revolution was partly a response to capitalist greed and the accumulation of wealth.

The texts beneath the print, each four lines of rhyming verse, are short epitaphs describing the fates of the people named by their profession: a soldier, a bullfighter, a doctor, a teacher, a lawyer, a fruitseller, and so on.

9 JOSÉ GUADALUPE POSADA

The skeleton of Pascual Orozco

(*La calavera de Pascual Orozco*)

1912

Photorelief, letterpress on green paper

349 x 255 mm

1994,0410.8

At the beginning of the Mexican Revolution in 1910 Pascual Orozco, a self-made businessman who ran a transport company in northern Mexico, gave his support to Francisco I Madero, a landowner from Coahuila who planned to overthrow the dictator, Porfirio Díaz. Orozco led troops for Madero during the early stages of the Revolution. After Díaz fell from power Madero became President and offered Orozco a place in his cabinet. Orozco declined the position, criticizing Madero for his lack of commitment to social change and his continuation of old-style politics. He then aligned himself with the villain Victoriano de la Huerta, who declared himself President in 1913 having led the revolt which overthrew Madero.

Revolutionary heroes and villains featured in Posada's prints from the beginning of the conflict in 1910. This print presents a satirical portrait of Orozco, who changed his allegiance during the Revolution: from a sea of skeletons he leaps into the air wielding a large dagger. He wears a sombrero, a familiar symbol of the Revolution, signifying his participation in the action. The rhyming verses below relate to Orozco's accomplishments during that period.

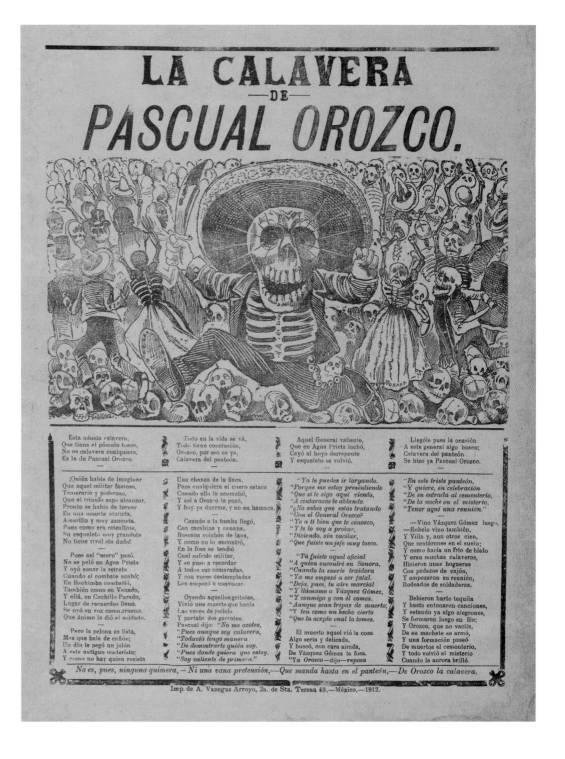

10 JOSÉ GUADALUPE POSADA

Cupid's skeleton

(*Calavera de cupido*)

'Forgotten in the tomb in the light of the moon, mischievous Cupid still tries his fortune'

1913

Photorelief, letterpress on green paper

355 x 254 mm

1992,0404.94

This print addresses the themes of love and romance. Each of the twelve compartments contains an image and a short verse on a romantic subject such as a lover's tiff or an engagement. The skeletons in this broadsheet include soldiers and sailors, men in top hats and peasants. Some are shown at full length, whereas others are busts. Hats are important symbols in this print and throughout Posada's work because they distinguish between the sexes, their social status, and in some cases determine the profession of a skeleton. Here, hats define the character of the soldier and a sailor.

The bust of a female skeleton in the second box on the top row represents Posada's famous *catrina*, a tall female skeleton wearing the clothes normally associated with women of high society. The *catrina* is now a ubiquitous symbol in Mexican art and culture. Each year for Day of the Dead celebrations, statues, figurines and other artefacts associated with the *catrina* are sold in stalls across Mexico. The *catrina* also appears in Diego Rivera's mural *Dream of a Sunday Afternoon in Alameda Park* (1948; Museo Mural Diego Rivera, Mexico City).

11 JOSÉ GUADALUPE POSADA

The skeleton of the brave Ku Klux Klan

(*Calavera de los bravos Ku Kus Klanes*)

*c.*1913; printed *c.*1921

Photorelief, letterpress on buff paper

357 x 269 mm

1998,1004.21

A large skeleton at the left confronts a figure dressed in the garments of the Ku Klux Klan, identified by his white robe and conical head-piece. The figure holds a black flag in one hand and in the other, the base of a flaming torch on which is inscribed 'KKK'. There is a pile of skulls on the ground behind the knight, which we learn from the second verse in the first column are deceased members of the Klan.

The main skeleton and the pile of skulls on the ground are motifs used in the print of the centenary in the cemetery (cat. 6).

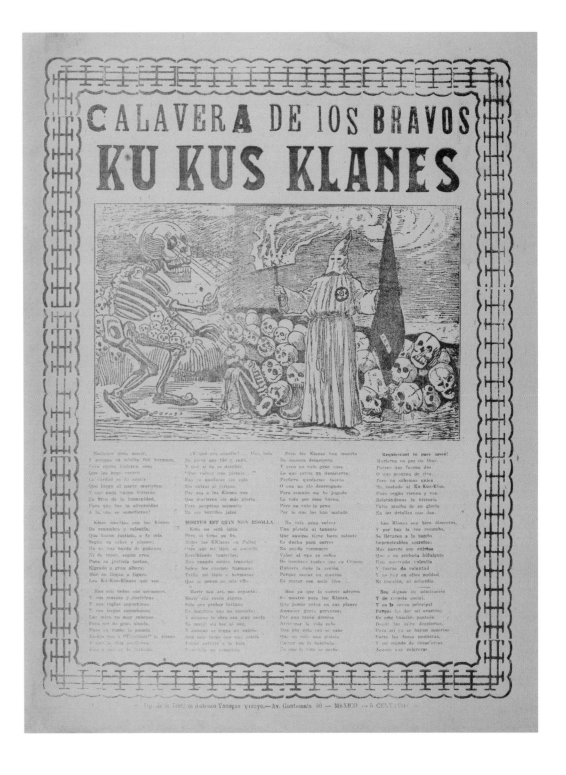

Alfredo Zalce 1908–2003

Alfredo Zalce was born in 1908 in the town of Pátzcuaro near Morelia in the state of Michoacán. His parents were both professional photographers and they intended their son to follow in their footsteps. By 1914, because of the Revolution, the family had moved to Mexico City where Zalce completed his education. When he finished school at the age of sixteen he enrolled at the Academy of San Carlos, where he studied from 1924 until 1928. One of his teachers here was Diego Rivera. In 1931 Zalce returned to the Academy to learn lithography from Carlos Mérida and Emilio Amero.

Zalce made his first woodcuts in 1933, as a member of the LEAR, the pro-revolutionary group that he founded with Pablo O'Higgins and Leopoldo Méndez. In 1937 Zalce was one of the earliest artists to make prints at the TGP, the collective he helped to establish. His prints focused on political subjects and Mexico's indigenous heritage. A trip to the Yucatán Peninsula in 1944 with his wife, the painter Frances du Casse, consolidated his interest in Mayan culture. The result was *Estampas de Yucatán*, a series of eight lithographs depicting people and nature published by the TGP in 1946.

Like several of his contemporaries, Zalce took part in the Cultural Missions organized by the government to disseminate revolutionary ideologies to rural communities. Between 1935 and 1941 he travelled throughout rural Mexico painting murals in public buildings, especially schools. In 1936 he also worked with Leopoldo Méndez, Pablo O'Higgins and Fernando Gamboa on the mural *Workers against the War and Fascism* on the stairwell at the Talleres Gráficos de la Nación in the centre of Mexico City. His most famous murals, however, are at the Palacio de Gobierno in Morelia (1954–5) and the Museo Nacional de Antropología in Mexico City.

In the early 1930s Zalce was Director of the Open Air School at Taxco and Professor of Drawing for primary schools in Mexico City and its surrounding areas. His teaching career continued and in 1944 he became Professor of Painting at the University of Mexico.

Later in life Zalce returned to his native state of Michoacán and established a Fine Arts Workshop in the town of Uruápan. He lived in Morelia from 1950 until his death in 2003 at the age of 95; his collection passed to the Museo de Arte Contemporáneo Alfredo Zalce de Morelia, established to house the bequest.

Zalce was awarded the Premio Nacional de Arte in 2001.

BIBLIOGRAPHY
Adès 1989; Craven 2002; Ittmann 2006; Taracena 1984.

12 ALFREDO ZALCE
José Guadalupe Posada and calaveras

1948
Woodcut
298 x 453 mm
2008,7069.42
Presented by Dave and Reba Williams to the American Friends of the British Museum

The print represents Posada's workshop where the master works on a print. He throws his prints into the air and they fly over a group of running skeletons. In front of the table a crouching skeleton seems to be stealing one of the sheets. The broadsheets are typical of Posada's work; the one he holds in his raised hand, known as *The ravenous calavera*, shows the scorpion skeleton, while another depicts a skeleton wearing a sombrero. *The ravenous calavera* appeared on the front cover of the November 1948 edition of the magazine *México en el arte*. The scorpion skeleton represented the dictator Victoriano Huerta, who was responsible for the death of Francisco Madero, a landowner from Northern Mexico who became President at the beginning of the Mexican Revolution after he overthrew the dictator Porfirio Díaz (see cat. 9). Zalce's print shows Posada holding the broadsheet, as its creator, although today some scholars think that *The ravenous calavera* was made by one of his contemporaries, possibly Manuel Manilla.

Posada is surrounded by four skeletons representing (from left to right) the artists Diego Rivera, José Clemente Orozco, Leopoldo Méndez and Dr Atl, all of whom admired Posada and played a role in reviving interest in his work. Rivera applauds the work of the master printmaker with great gusto. Next, Orozco and Méndez peer over Posada's shoulder, both eager to learn his craft and possibly wondering whether they will ever become as accomplished in printmaking. At the end of the table, the bald skeleton Dr Atl rests his hand on the table.

At the left there are two groups of skeletons. Those closest to Posada are dancing, playing instruments, pointing and jeering. Wearing peasant's hats, they represent those in society who would have enjoyed Posada's cheap broadsheets. The skeletons dressed in top hats and dresses, representing the upper classes, flee Posada and the images flying above them because they are afraid of their content and the propaganda that might lead to their demise.

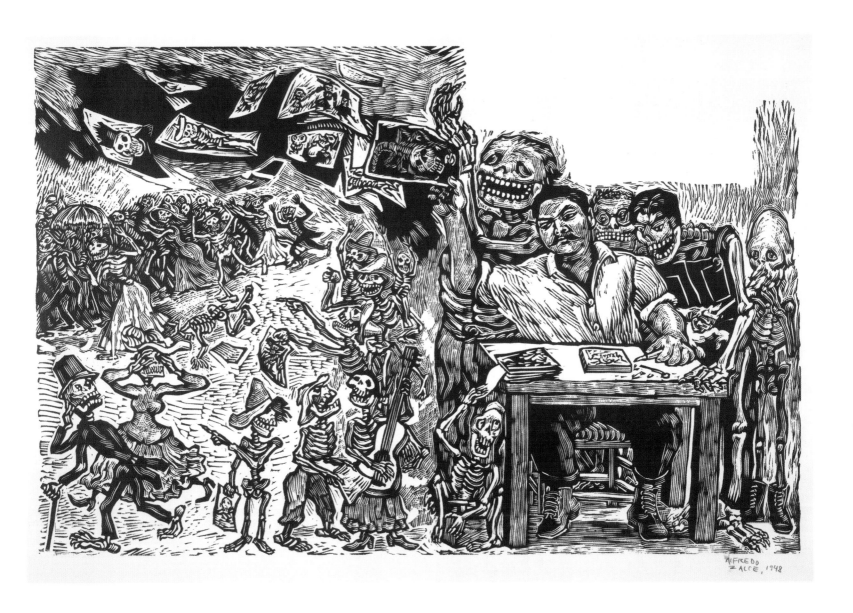

José Chávez Morado 1909–2002

José Chávez Morado was born into a humble family of mineworkers in the town of Silao, Guanajuato. His grandparents were avid book collectors and from early age he had access to their library, which contained books on science and philosophy as well as illustrated magazines from which he copied images by the French artist Gustave Doré.

Keen for adventure, in 1925 Chávez Morado boarded a steam train and left for the United States to seek work and earn his fortune. His first jobs included washing dishes and agricultural work, and he ended up packing salmon at a factory in Alaska where he worked with prisoners and illegal immigrants. The money he earned enabled him to travel to Los Angeles where he studied at the Chouinard Art Institute. He then returned to Silao, where his father opened a shop to sell his work. The enterprise was not entirely successful, so Chávez Morado then moved to Mexico City in the hope of selling more of his work.

In 1931 he won a scholarship from the government of his home state, Guanajuato, to study at the Escuela Central de Artes Plásticas, the art school of UNAM (Universidad Nacional Autónoma de México) in Mexico City, where he learnt printmaking from Francisco Díaz de León and Emilio Amero. He also spent time at the Centro Popular de Pintura 'Saturnino Herrán', where he met Leopoldo Méndez. Fascinated by Méndez's work, Chávez Morado removed his posters from lamp-posts and put them up in his room. In 1933 he became a teacher of drawing in primary and secondary schools, and two years later he was appointed head of the Sección de Artes Plásticas at the Fine Arts Department of SEP (Secretaria de Educación Pública/Ministry of Education). In the same year he married the artist Olga Costa; their home in the city of Guanajuato is now a museum devoted to their work.

Fuelled by his commitment to social change, Chávez Morado joined the Mexican Communist Party in 1937. He was a founding member of the LEAR in 1934 and then became a member of the TGP in 1938, working with the collective until 1941. At the TGP he did not believe in selling prints as art objects, spending his time instead producing leaflets and posters on political themes. With other TGP members he would post these in streets at night, a dangerous activity as rival groups prowled the streets removing anything that they considered to be propaganda.

As well as printmaking, Chávez Morado also painted murals, in particular a mural at the Alhóndiga de Granaditas in Guanajuato, a history museum of which he was Director during the 1960s. This depicted Miguel Hidalgo, the initiator of the Mexican Independence movement in 1810, and was inaugurated during the independence celebrations of 1955. Chávez Morado was also responsible for some of the sculptures in the courtyard of the National Anthropology Museum in Mexico City.

He travelled widely, visiting Cuba, Egypt, Spain, Greece and Turkey. In 1974 he received the Premio Nacional de Artes in Mexico. He died in 2002 at the age of 93, at his home in Guanajuato.

BIBLIOGRAPHY
Ittmann 2006; Tibol 1980; Williams et al. 1998.

13 JOSÉ CHÁVEZ MORADO

The ballad of the trams

(*Corrido de los tranvías*)
1939
Colour linocut on yellow paper
438 x 337 mm
2008,7108.2
Presented by the Aldama Foundation

The poster relates to the tram strikes in Mexico City in 1939. The satirical image and ballad clearly reflect the influence of Posada's broadsheets. A giant man lies on top of a tram full of passengers, which buckles under his weight. At the front of the tram, passengers pay their fares; these are fed through a tube to the man on top, representing a foreign capitalist who accumulates profits from the public transport industry.

The verses beneath the image explain that on the last day of October in 1939 not a single tram under the jurisdiction of the Inglesa Compañia was in circulation as workers went on strike. The strikers complained that they had not received a pay rise for twenty years, and that although the law restricted them to an eight-hour day, this was ignored by the tram companies who forced them to work longer hours without overtime. The workers were not entitled to meal breaks, forcing them to eat while they were driving and thus putting the lives of passengers at risk.

The workers also raised concerns about the fact that no upgrades had been made to vehicles or tracks by the tram companies; instead, all the profits were swallowed up by the capitalists.

Made at the TGP, the impression was printed again in 1943 with the title El *tragaquintos* (*The moneyeater*).

CORRIDO DE LOS TRANVIAS
(Música de "La Maquinita," o "el tren que corría por el ancha vía....")

El último día
del mes que corría
—octubre del 39—
........ ¡ H U E L G A ! No se mueve
ni un solo tranvía
de la Inglesa Compañía.
Suelto anda cada traidor,
pululan tantos falsarios,
que la HUELGA DE TRANVIARIOS
reclama este pormenor.

Pueblo Mexicano,
juzga como hermano,
dinos quien tiene razón:
si nuestros obreros
o los extranjeros
que exprimen a la Nación.
No por dicha en versos cojos
es menos interesante
la realidad que al instante
ofrecemos a tus ojos.

Desde hace 20 años
los dueños tacaños
ni un centavo de salarios
siquiera elevaron,
y así extorsionaron
a los obreros tranviarios.
Sube, en cambio, cada día
de la vida el alto precio;
pero de esto no hace aprecio
la roñosa Compañía.

La Ley del Trabajo
por día o destajo
las 8 horas establece;
pero en el Tranvía
la Ley no merece
respeto a la Compañía.
Pues tú, tranviario, laboras
más de 8 horas diariamente
sin cobrar el excedente
del doble por más de 8 horas.

Más ¿quién no ha observado
—¡peligro notado!—
¿lo que voy a referir?
El rollo al sobaco
se comen su taco
sin dejar de conducir,
Y esto que vemos les pasa
porque la Empresa los veja
y ni ya tiempo les deja
de ir a comer a su casa.

La negra conciencia
aquí se evidencia
de la Empresa imperialista,
que ya en su avidez,
torpe y ventajista,
sólo mira su interés.
SIN MEJORAR EL SERVICIO
LAS PLANILLAS SUPRIMIR
Y LOS ABONOS SUBIR
QUIERE, DEL PUEBLO EN PERJUICIO.

¿Quién se opuso a esto
con rotundo gesto
si no fueron los obreros,
que como paisanos
son leales hermanos
de todos los pasajeros?
Ante honradez tan notoria
el público apoyará
y a los tranviarios dará
de la huelga la victoria.

Las mal recordadas
"camisas doradas"
en la gran huelga anterior,
si nada lograron
bravatas echaron
para sembrar el terror.
De hijos de estos elementos
las empresas aún se valen
y sus asesinos salen
a romper los movimientos.

Y así ha ocurrido
que hubiesen herido
al camarada Solís
y hasta un peón de vía
que la guardia hacía
buenamente y sin desliz.
De nada sirven intrigas,
los atracos ni cohechos:
Al obrero tales hechos
más fuertemente le liga.

En esta contienda
que nadie se venda
es cuanto desea el país,
que sea el compa fuerte
mejore su suerte
y tenga más ropa y maíz.
Y aquí se acaba, paisanos,
el CORRIDO DE TRANVIARIOS,
de los que son solidarios
TODITOS LOS MEXICANOS.

Hojas populares del
Taller de Gráfica Popular.
Tel. Eric. 8-32-57.

Jean Charlot 1898–1979

Born in Paris, Jean Charlot played an important role in the history of Mexican printmaking. He fought in the First World War but little else is known of his early life. In 1921 he travelled to Mexico, a decision no doubt driven by the fact that he had Mexican ancestors and that one of his grandfathers had collected pre-Columbian art. Charlot assisted Diego Rivera with his mural paintings for two years before producing his own at the Ministry of Education and the National Preparatory School. Having learned about prints through the work of Honoré Daumier in France, he took up printmaking around 1923. Working with the Mexican artist Emilio Amero, he encouraged others to produce lithographs as an alternative to the woodcut which had been the most popular form of printmaking in Mexico since the nineteenth century.

Charlot contributed to the development of printmaking in Mexico through his rediscovery of José Guadalupe Posada's work; he published an article on Posada in 1925. His later books, including *Mexican Art and the Academy of San Carlos, 1785–1915* (1962) and *The Mexican Mural Renaissance, 1920–1925* (1963), demonstrated the breadth of his knowledge of Mexican art history.

Between 1926 and 1928 Charlot lived at the ancient Mayan city of Chichén Itzá in southern Mexico where he discovered pre-Hispanic culture. Here he made lithographs depicting the buildings that were being excavated by the Carnegie Institute. The time he spent at Chichén Itzá had a profound influence on him, and indigenous culture – past and present – became a predominant theme in his prints.

Like most of his contemporaries, Charlot held left-wing political values and supported the principle of making art available to the masses. He worked closely with the Stridentists (Estridentistas), a group of writers and poets influenced by the Futurist movements of Italy and Russia. Through his association with this group he designed the cover of *Urbe: Bolshevik Super-Poem in 5 Parts*, written in 1924 by Manuel Maples Arce.

Charlot left Mexico for the United States in 1929 at the beginning of the *Maximato*, a period during which the outgoing president, Plutarco Elias Calles, maintained control of the country by placing puppet presidents in office. Under Calles's jurisdiction supporters of left-wing politics were no longer welcome in Mexico. In the United States Charlot worked as a muralist and in 1940 he became a resident; in 1949 he moved to Hawaii, where he remained until his death.

BIBLIOGRAPHY
Charlot 1963; Ittmann 2006; Williams et al. 1998; Morse 1976.

14 JEAN CHARLOT
First steps

1936
Lithograph
352 x 229 mm
2008,7072.19
Presented by the Aldama Foundation

Charlot explored the motif of the mother and child in a number of his prints. Here a child attempts to take his first steps, his trepidation conveyed by his wide-open eyes and clasped hands, while his mother bends over him, enveloping his head with both hands to prevent a fall. The composition recalls both the Madonna and Child and pre-Hispanic statuary: Charlot had first-hand knowledge of artefacts at the Mayan site of Chichén Itzá, where he had lived in 1926–8. The conflation of Christian and pre-Hispanic iconography in this print highlights the hybrid nature of Mexican culture.

Leopoldo Méndez 1902–1969

Leopoldo Méndez is one of the best-known Mexican printmakers and a founding member of the TGP. Born and raised in Mexico City, he entered the Academy of San Carlos in 1918 where he was taught by Mexican artists Leandro Izaguirre (1867–1941) and Saturnino Hernán (1887–1918). From 1920 to 1922 he studied painting at the Open Air Schools in Chimalistac and Coyoacán, two areas south of Mexico City, before becoming a primary school teacher specializing in art.

In 1923 Méndez provided his first illustrations for *Irradiador* and *Horizonte*, journals linked to the Stridentists. For several years this collaboration took Méndez across the state of Veracruz, where at one point he was employed dissecting rats to inspect them for traces of the plague. After leaving Veracruz in 1929 he moved around Mexico working for educational institutions including the Ministry of Education, where he was for a short time director of a department before internal difficulties forced him to resign in 1932.

Méndez's interest in politics was central to his life and art, and from the 1920s he joined groups with political objectives. In 1929 he became a member of the Mexican Communist Party in response to the assassination of Julio Antonio Mella, a Cuban Communist. He also joined the Anti-Imperialist League which supported the Nicaraguan Revolution led by Augusto César Sandino, and participated in the politically driven artists' group ¡30-30!. In the 1930s Méndez made prints for the cover of *Frente a Frente*, the magazine of the LEAR, the group he formed in 1933 with the artists Luis Arenal, Juan de la Cabada and Pablo O'Higgins.

Méndez's most significant professional association as a printmaker was through the TGP, the group he established in 1937 with Raúl Anguiano, Luis Arenal and Pablo O'Higgins. He was committed to making political prints supporting the left-wing ideologies of the TGP and advocating social reform. This is reflected in his prints, made quickly on cheap paper and disseminated as flyers or posters: the messages these prints carried were more important than their longevity. The TGP was accommodated by the printer Jesús Arteaga at his workshop on Calle Cuauhtémoc in Mexico City.

BIBLIOGRAPHY
Caplow 2007; Ittmann 2006; Reyes Palma 1994.

15 LEOPOLDO MÉNDEZ
Calaveras' symphony concert

1934
Woodcut on yellow paper
240 x 170 mm
2008,7069.17
Presented by Dave and Reba Williams to the American Friends of the British Museum

The scene of skeletons attending a symphony concert was inspired by the work of José Guadalupe Posada (cats 1–11). A skeleton orchestra packs the stage of the concert hall, applauded from the stalls by an audience of skeletons. Two smartly dressed skeletons sitting on chairs in the foreground are inscribed with symbols. That on the left represents Diego Rivera: his chair has a dollar sign on the back and the inscription on his forehead reads 'IV Internacional', indicating his support for León Trotsky. Carlos Riva Palacio's chair on the right bears a swastika and is occupied by a skeleton bearing on his forehead the letters 'PNR', the abbreviation for the National Revolutionary Party which Palacio led from 1933–4. At the bottom right of the print, a skeleton wearing black boots and a hat and brandishing a gun chases a working-class couple out of the concert. This adds a note of irony to the image: the flyer at the bottom advertises the performance of El sol, a proletariat ballad with tickets priced at $25. But proletariat are ousted from the venue, and their low income would have not enabled them to buy tickets anyway.

El sol, by Mexican composer Carlos Chávez, was performed at the Fine Arts Palace in Mexico City at its inaugural concert in 1934. Work on the building had begun as early as 1904 but was halted because of the Revolution and was eventually completed only in 1934. This cultural centre now houses a concert hall, art galleries for changing exhibitions, murals by Los Tres Grandes (Rivera, Siqueiros and Orozco) and the National Museum of Architecture.

Méndez printed this scene at the Taller Editorial de Gráfica Popular (TEGP), the printmaking collective that in 1937 became the Taller de Gráfica Popular (TGP). By producing a print in the style of Posada he associated his print, and the event to which it refers, with the tradition of criticizing Mexican society through satirical prints. Here he highlights elitist attitudes towards high culture that continued to exist and divide society after the Revolution.

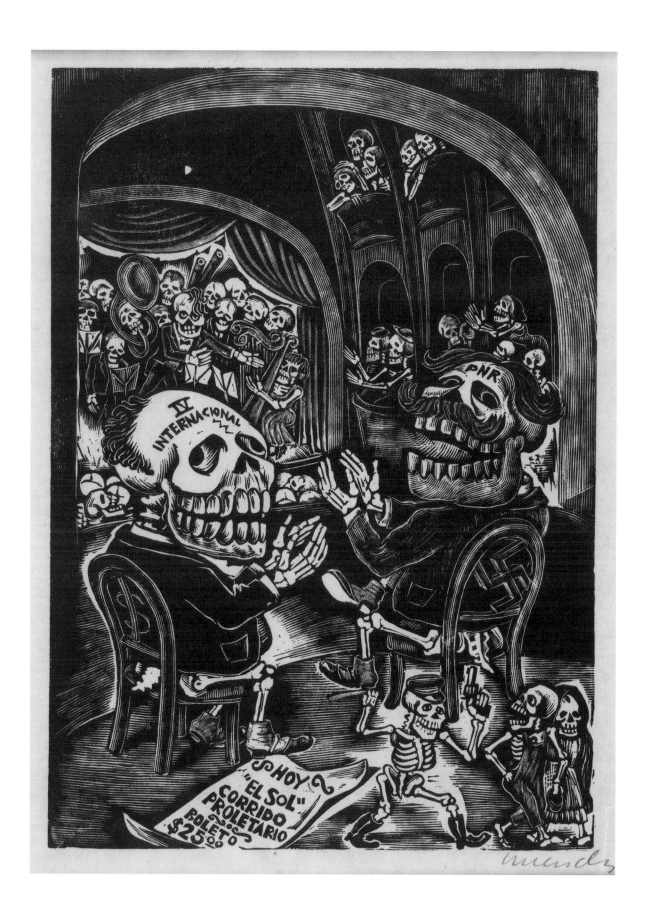

16 ANONYMOUS (PRINTED BY THE TGP)

Cool, soaked, held back skeletons

(*Calaveras refrescadas, remojadas y re...tendidas*)
1958
Woodcut
405 x 300 mm
2008,7072.20
Presented by the Aldama Foundation

The TGP produced this six-page satirical newspaper of skeletons in the style of José Guadalupe Posada. A flooded street is shown on the front cover and the three verses beneath tell the story. The first verse, 'Las Inundaciones', locates the floods in the cities of Guanajuato, Nuevo León, Nayarit and Tamaulipas. However, in the background are buildings from Mexico City such as the Monument to the Revolution and a skyscraper, probably the Torre Latinoamericana, built in 1956.

At the left, skeleton firefighters hose water into the street, drowning a group of skeleton protestors. The rhyme in the middle, entitled 'Los bomberos' ('Firemen'), explains that firemen trying to break up a protest sprayed so much water that they caused a flood. 'Los granaderos' ('Soldiers') are the subject of the third rhyme and are presumably the drowning protestors. The title 'Calaveras' cuts diagonally across the print, its lettering formed from bones and daggers.

The other five pages of the newspaper also show skeleton scenes and ballads. They include the story of Macrina Rabadan, the first female to become a member of the Mexican parliament; the struggle of underground railway workers against corrupt trades union leaders; and the success of the Latin American people in their fight against dictatorships.

Carlos Orozco Romero 1898–1984

Carlos Orozco Romero was born in Guadalajara, Jalisco. He felt compelled to distinguish himself from the renowned Mexican painter José Clemente Orozco by adopting his mother's maiden name, Romero. At the age of twenty Orozco Romero began his career as a caricaturist for Mexican national newspapers such as *Excelsior*, *El Universal* and the illustrated weekly magazine *Revista de Revistas*. In 1921 he won a scholarship from the state of Jalisco, which enabled him to travel to France and Spain. His trip ended with an exhibition of his work at the Winter Salon in Madrid.

In 1922, soon after returning from Europe, Orozco Romero met the French artist Jean Charlot (p. 60), who introduced him to printmaking techniques. By 1923 Orozco Romero had not only started to make prints, but he had also taken charge of the printmaking classes at the Escuela Preparatoria in Guadalajara where he remained until 1925. He painted a mural at the state museum in Guadalajara in 1923 and published a book, *Pequeños Grabadores en Madero*, which included prints made by some of his young pupils.

In 1925 Orozco Romero moved to Mexico City where he met artists including David Alfaro Siqueiros and Xavier Guerrero, both of whom were interested in the role of art in revolution. Orozco Romero professed to be interested the same ideas, rather than in mural painting, and he produced most of his work on the easel, particularly in the style of international modernism. From 1928, with Carlos Mérida, he directed the Galería de Arte Moderno in Mexico City where he enrolled at the Academia of San Carlos and studied lithography with Emilio Amero. The award of a Guggenheim fellowship in 1939 allowed him to travel to the United States.

BIBLIOGRAPHY
Cortés Juárez 1951; Ittmann 2006; Stewart 1951; Williams et al. 1998.

17 CARLOS OROZCO ROMERO

Three colour prints

(*Tres aguafuertes en color*)

1939

Colour aquatint

160 x 188 mm, 197 x 160 mm, 197 x 160 mm

2008,7069.28–30

Presented by Dave and Reba Williams to the American Friends of
the British Museum

These three prints are among the earliest examples
of the colour aquatint technique in Mexico. In the
booklet introducing Orozco Romero's prints, the
artist and printmaker Francisco Díaz de León
explains that even experienced artists avoided the
colour aquatint technique because the process was
complex and involved knowledge of how to ink
plates so that colours did not come into contact
with each other. Artists found the process arduous
and time consuming, especially as collectors
had less interest in buying cheap prints. Having
earlier worked in a variety of other printmaking
techniques, Orozco Romero was the natural
printmaker to experiment with the colour
aquatint process.

These prints also reflect the artist's affinity
with modernism through the use of bold colours,
clear lines and open surfaces. Each of the prints
uses several colours, including black which acts as
shadow. Printed in green, brown, black and grey,
the first print of the three depicts a Mayan temple
with the geometric lines. The cloud above the
temple resembles an eye, a motif commonly used
in Surrealism. In the other two, figures dance or
embrace each other.

Gabriel Fernández Ledesma 1900–1983

Gabriel Fernández Ledesma was born in Aguascalientes, the capital of a central Mexican state of the same name. In 1917, when he was seventeen, he moved to Mexico City, to study at the Academia de Bellas Artes (Academy of Fine Arts). During his time at the Academy he learnt the woodcut technique, which had recently been revived in Mexico by the French artist Jean Charlot (p. 60). In 1922 Ledesma began making prints and by 1925 he had established his own art school, the Centro Popular de Pintura 'Santiago Rebull'. Located in a suburb in the South of Mexico City, San Antonio Abad, this school put into practice the revolutionary ideology of making art accessible to everybody, regardless of background. Important printmakers studied here, including Jesús Escobedo and Emilio Amero, the printmaker who taught Fernández Ledesma lithography. The artist Isabel Villaseñor Ruíz (1909–53), whom Ledesma later married, was also among the alumni.

From 1930 Fernández Ledesma was involved in the management of the Sala de Arte at the Ministry of Education, with two fellow artists, Roberto Montenegro and Francisco Díaz de León. This trio produced the exhibition '100 años de litografía' ('A Hundred Years of Lithography'). The following year Fernández Ledesma travelled to Europe where he set up exhibitions in Seville and Madrid. He also participated in the film *¡Qué Viva México!* directed by Russian cinematographer Sergei Eisenstein. In 1940 he co-organized the New York exhibition '20 Siglos de Arte Mexicano' ('Twenty Centuries of Mexican Art') with Miguel Covarrubias. He was also involved in promoting Mexican Art, principally through his role in the publicity and marketing department at the Ministry for Education from 1938 until 1949.

Fernández Ledesma contributed to several magazines, including *Forma*, first published in 1926–7; *Horizonte*, a magazine from Jalapa in the state of Veracruz; and *El Sembrador*, the magazine of the Ministry of Education. However, he worked principally as an illustrator of short stories such as *Viajes al siglo xix* and *El Coyote* by Celedonio Serrano Martínez. His best-known book is *Juguetes mexicanas* (1930), which includes colour prints: he was one of the earliest printmakers in Mexico to experiment with colour.

During the early twentieth century various artists' groups emerged in Mexico with an anti-elitist stance towards art and education. Having strong views of his own, in 1929 Fernández Ledesma joined ¡30-30! for which he made flyers denouncing the elitist attitudes at the Escuela Nacional de Bellas Artes (National School of Fine Arts). He also collaborated with members of the TGP, although he was only ever a guest and never a full member. In 1947 he was assistant to the painter Miguel Covarrubias, who painted a mural on the wall of the Hotel del Prado in Mexico City. A decade later, in 1958, he became professor at the Escuela Nacional de Artes Plásticas (National School for Visual Arts).

BIBLIOGRAPHY
Adès 1989; Cortés Juárez 1951; Ittmann 2006; Williams et al. 1998.

18 GABRIEL FERNÁNDEZ LEDESMA

Archaeological Ruins

(*Ruinas arqueológicas*)
1944
Lithograph
373 x 428 mm
2008,7069.12
Presented by Dave and Reba Williams to the American Friends of the British Museum

An enormous stone head wearing a crown is being excavated by two workers at an archaeological site. The site is not identified, but excavations were taking place during the 1940s throughout Mexico as archaeologists and scientists began to piece together the country's history. Rather than showing the specialist work of archaeologists, this print depicts the physical labour involved in excavating. Mexican men wearing thin clothing and sandals work with poles to move the stone head. Other workers clear away broken pieces into a wheelbarrow at the right, and in the background others load large pieces of stone into the back of a truck. A skull in a smaller pit in the foreground at the right suggests that human remains as well as artefacts were found at this site. Given the political climate and concern for the rights of workers, the skull might also refer to the fate of the men whose relentless toil would result in their death.

The stone head resembles those found at Olmec sites in Mexico and are thought to represent Olmec rulers. The Olmec civilization flourished on Mexico's Gulf Coast in the state today known as Veracruz. The date of this print coincides with the discovery that the Olmec civilization might have been the oldest in Mexico.

María Luisa Martín 1927–1982

María Luisa Martín was born in Salamanca, Spain, and emigrated to Mexico in 1939 because of the Spanish Civil War (1936–9). Her father had been a drawing teacher in Spain, and he subsequently worked both at the National School of Architecture and the Institute of Fine Arts in Mexico City. Martín began studying art with her father and in 1944 enrolled at La Esmerelda, the art school run by the Ministry of Education, where she trained in painting, sculpture and drawing. Her teachers included Alfredo Zalce and José Chávez Morado. Following her first solo exhibition in 1950, Martín became a guest artist at the TGP for several years and then a member of the collective from 1955 until 1966, when political friction within the group led to her departure.

During the early 1950s Martín worked with Diego Rivera on his murals at two sites in Mexico City: the university city of UNAM (Universidad Nacional Autónoma de México/National Autonomous University of Mexico) and the Teatro de los Insurgentes (Theatre of the Insurgents). She was committed to social justice and took a particularly strong stance against imperialism. Her prints have been shown in solo and group exhibitions in Mexico, Spain, Chile, Eastern Europe, Texas, Nicaragua, Germany and Holland. In 1955 she visited China and Eastern Europe where she exhibited her print *Paz y amistad* (*c*.1955), now her best-known work.

BIBLIOGRAPHY
Cabada 1983; Prignitz 1981; Williams et al. 1998.

Alberto Beltrán 1923–2002

Alberto Beltrán was born in Mexico City and upon completing his primary education at the age of eleven was apprenticed as a tailor in his father's workshop. Around the same time he also enrolled at the Academy of San Carlos where he took evening classes in commercial art, studying with Carlos Alvarado Lang. From 1938 he studied at the Escuela de Arte Comercial (School of Commercial Art) while working in a graphic arts studio.

Early in his career Beltrán made postcards and illustrated brochures for Alfabetización para Indígenas Monolingües (Literacy for Monolingual Indians), part of a national campaign to improve literacy. He spent time with anthropologists in rural parts of Mexico and eventually established himself as a book and magazine illustrator. He published prints in *El coyote emplumado* and *Ahí va el golpe*, two magazines which he founded, and later edited the arts section of *El Día*, a Mexican daily newspaper.

In 1944 Beltrán joined the TGP. He contributed to the group's exhibitions and publications, including the twentieth anniversary print show at the Palacio de Bellas Artes (Fine Arts Palace) for which he made an advertisement poster, *Life and drama of Mexico* (cat. 45). Through the TGP he met many other artists, among them Andrea Gómez, whom he later married.

After leaving the TGP in 1960 Beltrán turned to teaching. He was appointed Director of Fine Arts at the University of Veracruz from 1965 to 1966, and General Director of the Department for Research into Popular Tradition at the Ministry of Education.

BIBLIOGRAPHY
Adès 1989; Haab 1957; Ittmann 2006; Prignitz 1981.

19 MARÍA LUISA MARTÍN AND ALBERTO BELTRÁN

Goodbye Mother Carlota

(*Adiós Mamá Carlota*)

1956

Linocut

300 x 417 mm

2008,7069.16

Presented by Dave and Reba Williams to the American Friends of the British Museum

Unlike the majority of Mexican prints of this period, this depicts an event that occurred in the nineteenth century. Carlota (Charlotte of Belgium) was the wife of Emperor Maximilian who was sent to Mexico by Napoleon III when he tried to annex Mexico to France in the 1860s. Maximilian became Emperor of Mexico in 1864, but his rule ended in 1867 when Mexican Republicans led by Benito Juárez ordered his execution by firing squad. This event was later painted by the French artist Edouard Manet. In support of her husband, Carlota travelled to Europe by ship in order to plead with Napoleon for more troops as Mexican rebels who contested Maximilian's power rebelled against his rule.

In this print Carlota is shown aboard the ship, accompanied by a group of dwarfed royalists hiding under her skirts. One of them has fallen into the sea and the others run towards the edge of the boat, lifting Carlota as though they want to throw her overboard. This symbolizes the precarious nature of the royal cause and Carlota's fated trip, as Napoleon III recognized the strength of the Mexican troops and refused to help Maximilian.

Although the print is signed by Martín, it was produced in collaboration with Alberto Beltrán. Its title refers to a ballad which Carlota and her ladies-in-waiting had heard on their journey to the port.

Ignacio Aguirre 1900–1990

Ignacio Aguirre was born in the town of San Sebastián, Jalisco, a state in western Mexico where his family worked in the mining industry. He gained first-hand experience of the hardships of life in early twentieth-century Mexico through his work and his experiences of war. For a short time in 1917 he was employed as a mineral sorter before finding work in the offices of a local store. From 1915 to 1917 he joined the revolutionary forces, fighting on the side of Venustiano Carranza against Pancho Villa. As President, Carranza was instrumental in the formation of the 1917 Constitution; Pancho Villa was a general in the Mexican Revolution, leading troops in northern Mexico and considered a bandit because he often stole land from the rich to give to the poor and hijacked trains. In 1920 he also fought in the Revolution against General Alvaro Obregón.

By 1921 Aguirre had left Jalisco for Mexico City where he worked for the government at the Ministry of Communications and the President's private office until 1929. During his time in Mexico City he avidly read about modern art, and from 1929 he shared a studio with the artists Rodríguez Lozano and Julio Castellanos. In the same year he visited Mexican villages through the Cultural Missions Programme, a state-organized initiative which sent artists around rural Mexico to produce public art such as mural paintings in order to disseminate the ideologies of the Mexican Revolution. He also became a drawing teacher in schools and was appointed Assistant Professor of drawing at UNAM (National Autonomous University of Mexico). He continued teaching throughout his career; from 1938 he took on a number of educational assignments, including teaching evening classes for workers.

From 1933 until 1936 Aguirre was a member of the LEAR and became involved with the TGP in its early days. He regularly contributed to TGP exhibitions and publications until 1965 when he left the collective. In 1950 he participated in producing propaganda prints with the TGP for the film *Memorias de un mexicano*, a documentary about Mexican life and culture during the regime of Porfirio Díaz. He also worked on mural projects in the late 1930s, some on his own and others in collaboration with artists such as Pablo O'Higgins and Alfredo Zalce.

During the 1940s Aguirre showed his work in New York, and during the following decade he exhibited in Eastern Europe and China. In 1968 he became a member of the editorial team for the publishing house Nuestro Tiempo, and in 1976 he was appointed co-editor of the newspaper *Estrategía*. Aguirre was married to the American dancer Anna Sokolow until his death in 1990.

BIBLIOGRAPHY
Cortés Juárez 1951; Williams et al. 1998; Prignitz 1981; TGP 1949.

20 IGNACIO AGUIRRE

Emiliano Zapata, the great leader of the revolutionary peasant movement

1948
Linocut
400 x 262 mm
2008,7130.2
Presented by the Aldama Foundation

Despite his privileged upbringing, Emiliano Zapata became associated with the agrarian struggle, an important movement within the Mexican Revolution that aspired to improve conditions for those who worked on the land. In this print he stands firmly in a cornfield, holding a rifle to protect the crop, his posture resembling that of a soldier on guard and reflecting his role as leader of the agrarian uprisings during the Mexican Revolution.

Corn (or maize), Mexico's staple food, is a symbol of its agrarian base. Aguirre also refers to the significance of corn in early Mexican culture: it was an important symbol in pre-Hispanic iconography, and Cinteoltl was the Aztec God of the crop. Festivals were held to celebrate and thank divine forces for crops at harvest time, some of which continue to take place in various forms today.

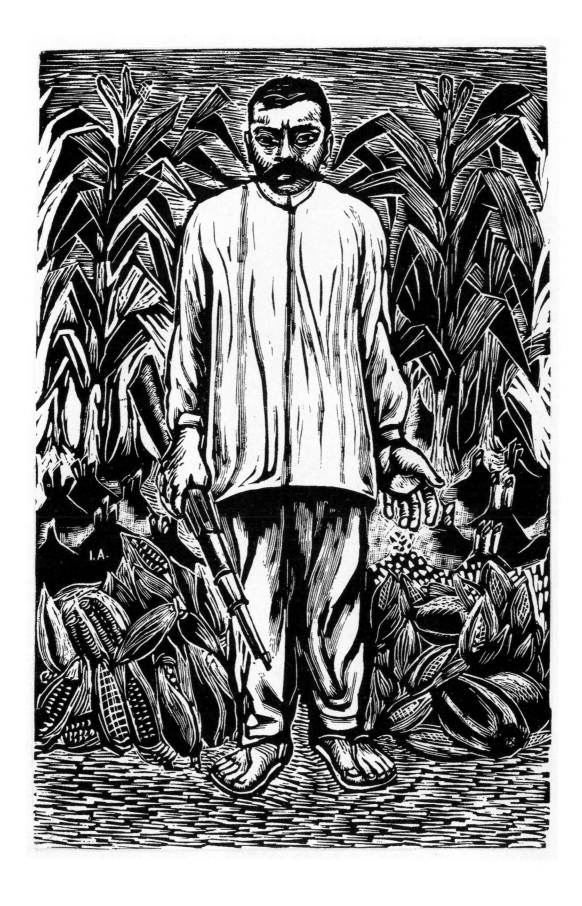

Ángel Zamarripa 1912–?

Born in Morelia, Michoacán, little is known about this artist. In 1946 he studied the woodcut technique at the Escuela de Artes de Libro (Book Arts Workshop) in Mexico City, at the same time as studying lithography with Carlos Alvarado Lang at the Escuela Nacional de Artes Plásticas (National School for the Visual Arts). He was one of the founders of the Sociedad mexicana de grabadores (Mexican Society of Printmakers), a group of artists who made prints with less political focus than those of the TGP. Zamarripa exhibited with the Mexican Society of Printmakers in 1947.

BIBLIOGRAPHY
Cortés Juárez 1951; Covantes 1982; Haab 1957.

21 ÁNGEL ZAMARRIPA

Emiliano Zapata

c.1953
Woodcut
146 x 198 mm
2008,7072.21
Presented by the Aldama Foundation

This print addresses the need for agrarian reform in Mexico. By the time it was made Zapata had long been dead, and its aim is to preserve his memory. He is shown in half-length, standing against a mountainous landscape and stormy skies. Filling over half of the image, Zapata looks past the viewer, a contemplative expression on his face. At the right clouds and bolts of lightning provide a dramatic backdrop for the mountain symbolically reflecting the effect he had on agrarian reform.

Several banners are also visible. The most prominent carries the name 'Anencuilco', Zapata's hometown in the state of Morelos; this is flanked by two others bearing revolutionary slogans, 'tierra y libertad' ('land and freedom'), and 'libertad, justicia, ley' ('freedom, justice and law'), expressing the agrarian concerns of the Revolution. Behind them is a Mexican flag, at its centre the national symbol of the eagle holding a serpent in its mouth.

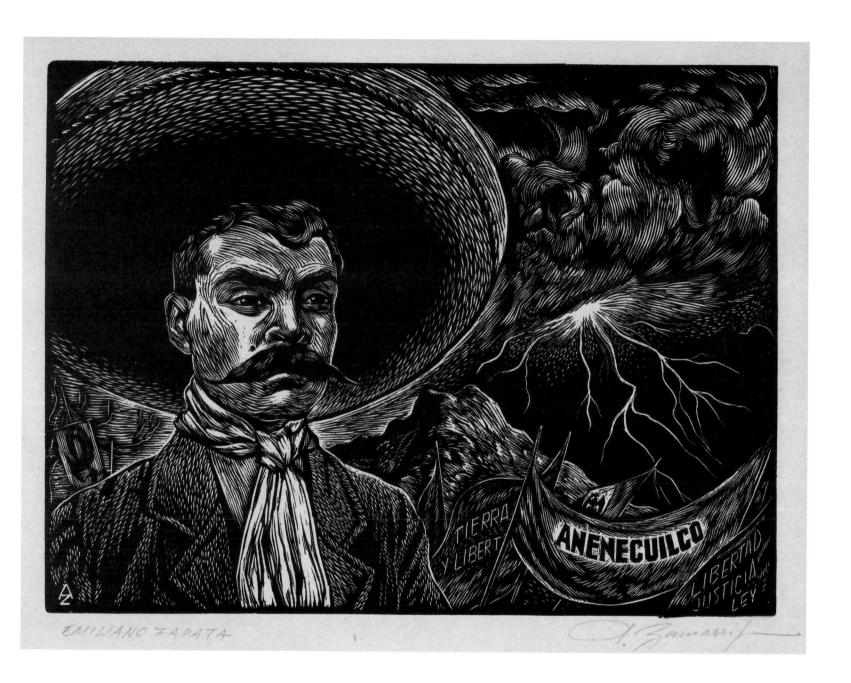

EMILIANO ZAPATA

José Diego María Rivera 1886–1957

One of the best-known Mexican artists, Diego Rivera, was born in Guanajuato. At the age of twelve he entered the San Carlos Academy in Mexico City. Later he travelled to Europe on scholarships funded by a benefactor, Teodoro A. Dehesa, the State Governor of Veracruz who was introduced to Rivera's work by the artist's father. Rivera remained in Europe for fourteen years, travelling to various cities – Madrid, Paris and London – studying Western art and showing his work. He returned to Mexico at the invitation of the Mexican government in 1921 to work on a mural project commissioned by the State.

Rivera's activity as a printmaker is less known than his work as a painter, but the small number of prints he made were fundamental to the history of Mexican printmaking. Unlike most of his contemporaries, who produced prints of political subjects, Rivera reluctantly made his prints for commercial purposes and sold them through the New York based Weyhe Gallery, under the direction of Carl Zigrosser during the 1920s.

In 1930 Rivera produced his first lithographs in editions of a hundred. Three of these depicted flower stalls in Mexico; another two were female nudes, one of his wife, Frida Kahlo (cat. 26), and the other of his friend Dolores Olmedo Patiño (cat. 25). His last print of 1930 was a self-portrait. He also experimented with techniques and produced three proofs known as 'lithomontages' from the block he had used for his self-portrait (see cat. 24).

Rivera's second phase of printmaking began in 1932, when he produced a set of five lithographs for the Weyhe Gallery. These all showed details from mural panels that he had completed in Mexico during the 1920s, including the image of Zapata which has become one of the most important and recognizable Mexican prints (cat. 22). A final print he made in 1938, *Communicating vessels* (illustrated p.6), was his first in colour. This is based on surrealist author André Breton's text of the same name, in which he explores the relationship between sleep and waking, a concept that Rivera represents by one open and one closed eye. Breton integrated Marxist theory into his text and Rivera followed this political slant because he made this print to stand in for a lecture that Breton had planned to give in Mexico City in 1938 but which was cancelled due to political tensions.

Politically, Rivera allied himself with the Left and was an intermittent member of the Mexican Communist Party. His mural paintings reflected his ideology, whereas his printmaking activity, with the exception of *The communicating vessels*, did not address politics. He was never a member of the TGP; his collaboration with other printmakers was forged instead through his role as a founder of *El Machete* in 1922, as editor of the illustrated magazine *Mexican Folkways* from 1924 to 1929, and afterwards through a commitment to revolutionizing art.

BIBLIOGRAPHY
Adès 1989; Craven 2002; Ittmann 2006; Shoemaker 2006; Williams et al. 1998.

22 JOSÉ DIEGO MARÍA RIVERA

Emiliano Zapata and his horse

1932
Lithograph
414 x 335 mm
2008,7132.1
Presented by The Art Fund

Emiliano Zapata (1879–1919) was one of the leaders of the Mexican Revolution and became a popular subject in Mexican art. Made over a decade after his death, this print celebrates his legacy as an advocate of agrarian reform. Based on a detail from one of Rivera's murals at the Palace of Cortés in Cuernavaca (fig. 7, p. 20), a colonial city south of Mexico City, it has become the most famous of all Mexican prints. Whereas Rivera produced the print as a commercial proposition through the Weyhe Gallery in New York, it also conveys a strong socialist sentiment extolling the virtue of revolution.

Holding a machete in his right hand and the reins of his horse in his left, Zapata, with his distinctive moustache, stands triumphantly in front of a group of his supporters. He wears radiant white garments matching the colour of his horse. Behind him men clutch weapons such as bows and sickles associated with rural culture; their light-coloured clothing is muted in comparison to the radiance of their leader. Beneath Zapata's feet a man with a moustache and the clothing of a Spanish conquistador has fallen to the ground and dropped his sword. He symbolizes the tyranny of past conquerors and also those who attempted to destroy the possibilities of a new social order. The sword is a symbol of the power and repression that the Revolution aimed to overcome.

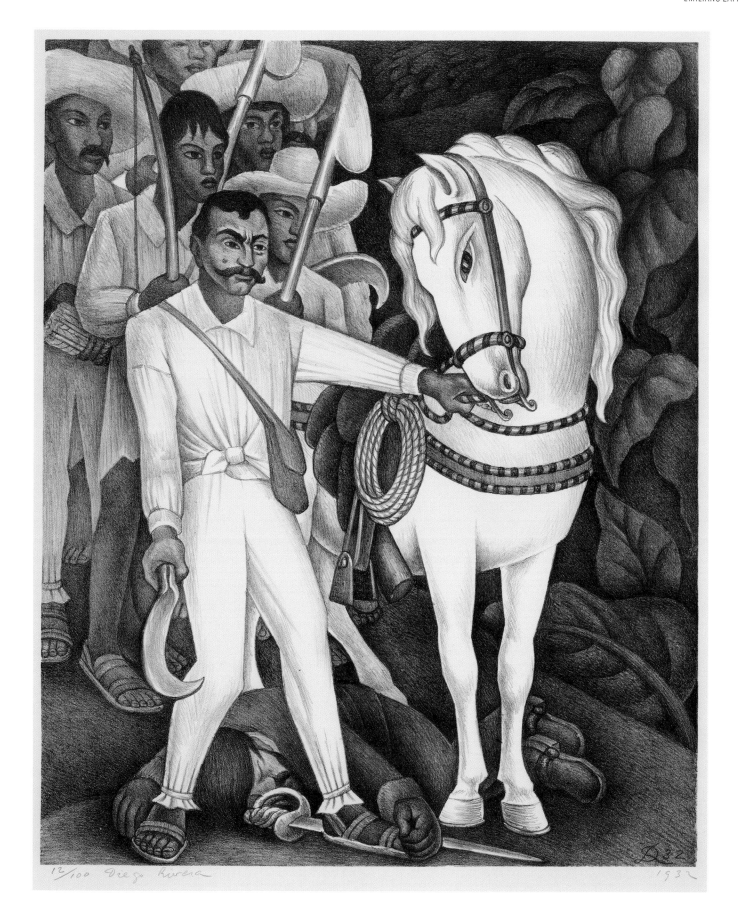

12/100 Diego Rivera

1932

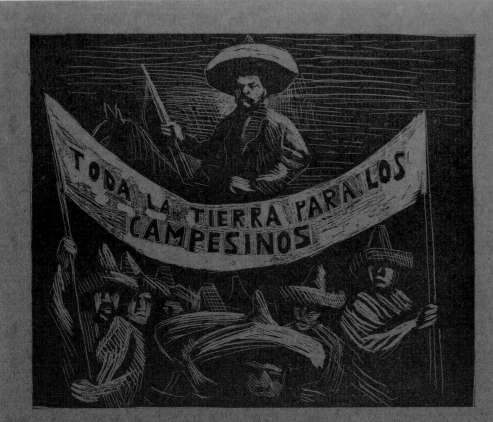

ZAPATA

El lider más grande de los campesinos mexicanos fue ase-
sinado a traición en San Juan Chinameca, Estado de Morelos,
el día 10 de abril de 1919.
Su grito de "TIERRA Y LIBERTAD", vale todavía como con-
signa de la Revolución Mexicana porque:
1o —Todavía no ha sido entregada toda la tierra a los campe-
sinos.
2o —Todavía no tienen los campesinos de nuestro país esa ver-
dadera libertad que se llama: "La Libertad Económica",
que les permitirá librarse de todos sus explotadores: pa-
trones sin escrúpulos, acaparadores, usureros, autorida-
des vendidas a los ricos, etc., etc.
Sin embargo, el Gobierno del Presidente Cárdenas repar-
tiendo más tierras que todos los anteriores, refaccionando a los
campesinos y organizándolos convenientemente, ha dado gran-
des pasos en favor de la Revolución Agraria, pero:

Con todo y su mérito, el pueblo del campo de-
berá seguir luchando por conquistar los 70.000,000
de hectáreas que aún están en el poder de los gran-
des propietarios y así realizar los ideales de Zapata.

ABAJO LOS EXPLOTADORES DEL CAMPESINO MEXICA-
NO!
¡VIVA EMILIANO ZAPATA! ¡VIVA LA REVOLUCION
AGRARIA!

Hoja del Taller de GRAFICA POPULAR.

23 ANONYMOUS (PUBISHED BY THE TGP)

Zapata, All land for the peasants

(*Zapata, Toda la tierra para los campesinos*)
1938
Woodcut printed on red paper
295 x 202 mm
2008,7108.7
Presented by the Aldama Foundation

The printmaker responsible for this print is unknown, but it was printed at the TGP shortly after the workshop was established. The print shows Zapata on his horse behind a banner held by his supporters bearing the slogan 'Toda la tierra para los campesinos' ('All land for the peasants'). The figure of Zapata is used to encourage continued social reform in Mexico, and is printed on red paper, the colour of revolution.

The text beneath the image explains that although Zapata, who fought for agrarian reform during the Mexican Revolution, was assassinated in April 1919, his cry of 'Land and Freedom' still needed to be heard in Mexico. When this print was made in 1938, President Lázaro Cárdenas, who held office from 1934 to 1940, had started to distribute land as part of the reform process. However, not all the land had been given back to the peasants, nor did they benefit from better economic circumstances, and exploitation by landowners persisted. The text motivates peasants to continue the struggle that Zapata had started, and to fight for the remaining 70,000,000 hectares of land that still belonged to major landowners, ending with the powerful words: 'Down with those who exploit Mexican peasants. Long live Zapata! Long live the agrarian revolution!'

24 JOSÉ DIEGO MARÍA RIVERA (for biography see p. 76)

Self-portrait

1930
Lithograph
380 x 285 mm
2008,7114.21
Presented by Deborah Kiley in memory of Erhard Weyhe

Obsessed with his own image, Rivera made around twenty self-portraits during his career. For this lithograph he sat in front of a mirror in order to produce an accurate likeness. The result demonstrates his great skill as a draughtsman: the sensitively and carefully rendered features are highlighted by his broadly defined garments. On another occasion he superimposed images of himself to make a 'lithomontage'. He also superimposed an impression of this self-portrait on an impression of his nude of Frida Kahlo wearing beads (cat. 26).

25 JOSÉ DIEGO MARÍA RIVERA

Nude with long hair (Dolores Olmedo Patiño)

(*Dolores Olmedo Patiño*)
1930
Lithograph
420 x 235 mm
2008,7062.1
Presented by the Aldama Foundation

Dolores Olmedo Patiño was an art collector, philanthropist and close friend of Diego Rivera. In 1957, shortly before Rivera's death, she became patron of a group of houses and museums associated with the artists' life, including the house in which he and Frida Kahlo had lived in Coyoacán, and Anahuacalli, the fortress-style building in Mexico City that Rivera built for his art collection. In 1994, when she was eighty-six years old, Olmedo Patiño also established a museum in Mexico City to house her own collection of Mexican art.

This portrait was among the first of Rivera's lithographs and reveals the influence of Henri Matisse. It was printed in Mexico City and published by the Weyhe Gallery in New York shortly after it was made, as part of a series of more than a hundred proofs by the artist. In that series the sitter was not identified.

26 JOSÉ DIEGO MARÍA RIVERA

Nude with beads (Frida Kahlo)

1930
Lithograph
418 x 275 mm
2008,7062.2
Presented by the Aldama Foundation

This portrait depicts Rivera's second wife, the artist Frida Kahlo (1907–54), sitting on a bed wearing stockings and shoes and fastening rows of beads around her neck. An accident whilst travelling on a trolleybus during her adolescence had left Kahlo disabled; she was also unable to bear children. The couple both conducted extra-marital affairs, and divorced in 1939, only to remarry the following year. Kahlo died at the age of forty-seven. The circumstances of her death remain unknown but there is some suggestion that she committed suicide. Primarily a painter, Kahlo made only one print, a self-portrait in which she expressed her pain after a miscarriage in 1932.

Rivera made this print in Mexico City a year after he married Kahlo, and it is one of the first he made when approached by Carl Zigrosser of the Weyhe Gallery. It shows the influence of Rivera's time in Europe, the soft curves of the sitter's body and the use of large, smooth surfaces resembling the style of Henri Matisse, particularly his Fauve works.

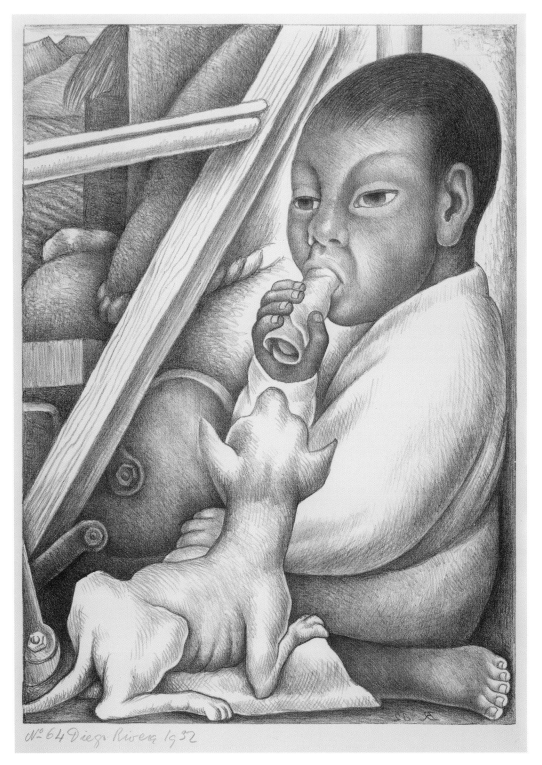

No 64 Diego Rivera 1932

27 JOSÉ DIEGO MARÍA RIVERA

Boy with chihuahua

1932
Lithograph
420 x 301 mm
2008,7069.36
Presented by Dave and Reba Williams to the American Friends of
the British Museum

An Indian boy is seated on the ground, watched
by a dog as he eats a rolled tortilla. Tortillas are a
staple food in the Mexican diet, especially in rural
communities where maize grows in abundance.
A frame, possibly of a piece of agricultural
equipment, rests next to the boy and cuts
diagonally across the print, forcing him into the
right half of the composition. In the background,
a hut with a straw roof and fields locate the boy
in a rural environment.

Rivera made this print in New York in 1932 as
part of a set of five lithographs commissioned by
Carl Zigrosser. All five show details of mural panels
painted by Rivera a few years earlier in Mexico. *Boy
with chihuahua* is a detail from his fresco *The rains*,
which forms part of the mural cycle in the building
occupied by the Ministry of Education in Mexico
City. Three others in the series reproduce details
from the same murals. These include *The rural
schoolteacher*, an image illustrating the Open Air
Schools designed by the post-revolutionary
government with the aim of educating the rural
population and assimilating its members into
mainstream society. Another, *Emiliano Zapata and
his horse* (cat. 22), shows a detail from Rivera's
mural at the Palacio de Cortés in Cuernavaca.

The American printer George C. Miller printed
the lithographs in editions of a hundred in New
York, and the Weyhe Gallery published them for
sale to American art collectors.

David Alfaro Siqueiros 1896–1974

Born in Chihuahua, Mexico, in 1896, David Alfaro Siqueiros trained as an artist at the Academy of San Carlos in Mexico City from 1911. A scholarship from the Mexican government enabled him to study in Europe from 1919 to 1922. He rejected traditional artistic values, devoting himself instead to making art available to the masses. Siqueiros was always very politically active, and later in life he wrote about the relationship between art and politics in twentieth-century Mexican art in his book *Art and Revolution* (1973).

As a printmaker Siqueiros worked mainly in woodcut and lithography, producing images on themes such as labour, capitalism and social justice. Some of his prints appeared in *El Machete*, an illustrated magazine he founded in 1924 with Diego Rivera and Xavier Guerrero. Published initially for the Sindicato de los Obreros Técnicos, Pintores y Escultores (Union of Technical Workers, Painters and Sculptors), *El Machete* later became the official publication of the Mexican Communist Party – a cause supported by Siqueiros.

Alongside Diego Rivera and José Clemente Orozco, Siqueiros was one of three mural painters known collectively as Los Tres Grandes (the Three Greats) who decorated the walls of public buildings not only in Mexico City but throughout the country and in the United States. In Mexico City Siqueiros worked on murals at the Escuela Nacional Preparatoria (National Preparatory School), the Poliforum and the National History Museum. Between 1925 and 1930 he became less active as an artist, devoting himself instead to politics. In the 1930s his political activity took him to Spain, where he fought against General Franco in the Spanish Civil War. He returned to Mexico in 1939 but was exiled to Chile in 1941, having been imprisoned for his involvement in a plot to assassinate Leon Trotsky in Mexico City. He also travelled to Uruguay, Argentina, Cuba and the United States, where his commitment to political causes continued to influence his work.

BIBLIOGRAPHY
Adès 1989; Ittmann 2006; Rochfort 1997; Siqueiros 1975.

28 DAVID ALFARO SIQUEIROS

The wedding

(*El casamiento*)
1930
Woodcut
90 x 130 mm
2008,7072.8
Presented by the Aldama Foundation

In 1930 Siqueiros spent six months in prison after he was arrested for his association with the Communist Party, which had been banned in Mexico. During his jail sentence he made a series of thirteen woodcuts from scraps of wood. These focused on social issues such as class, poverty, prostitution and strikes. He was released from prison in 1931, but was forced into exile in the town of Taxco, a silver-mining city south-west of Mexico City; it was here that he collated his thirteen woodcuts into a portfolio entitled *Siqueiros: 13 Grabados*, printed on orange paper. William Spratling (p. 132) from the Weyhe Gallery wrote an introduction.

This impression is from an earlier edition of Siqueiros's prison series, printed on buff paper. Signed in pencil by the artist and numbered 5/10, it shows a man and a woman each holding a baby in their arms. To the right, a man wearing a top hat, standing in an opening, looks at the group. The only indication of the subject is the title of the print, written in pencil, *El casamiento* (*The wedding*).

29 DAVID ALFARO SIQUEIROS

Portrait of Moisés Sáenz

1931
Lithograph
545 x 405 mm
2008,7069.39
Presented by Dave and Reba Williams to the American Friends of
the British Museum

Moisés Saénz was the Deputy Secretary of
Education in Mexico, serving under José Manuel
Puig Casauranc in the government of Plutarco
Elías Calles between 1924 and 1928. The
government ministers supported the continuation
of state sponsored mural paintings, despite the
defacement of some panels at the National
Preparatory School by angry students who claimed
that the walls belonged to them rather than to
the masses. The size of the head in this print
foreshadows the colossal figures that became
characteristic of Siqueiros's mural paintings.

The Weyhe Gallery in New York published this
print based on a painting of 1930 now hanging in
the Museum of Contemporary Art in Mexico. It is
one of four prints Siqueiros made during his time
in Taxco. An edition of thirty-five was printed in
New York, of which Siqueiros kept fifteen. The
popularity of the Taxco prints led to the production
of a further edition of twenty.

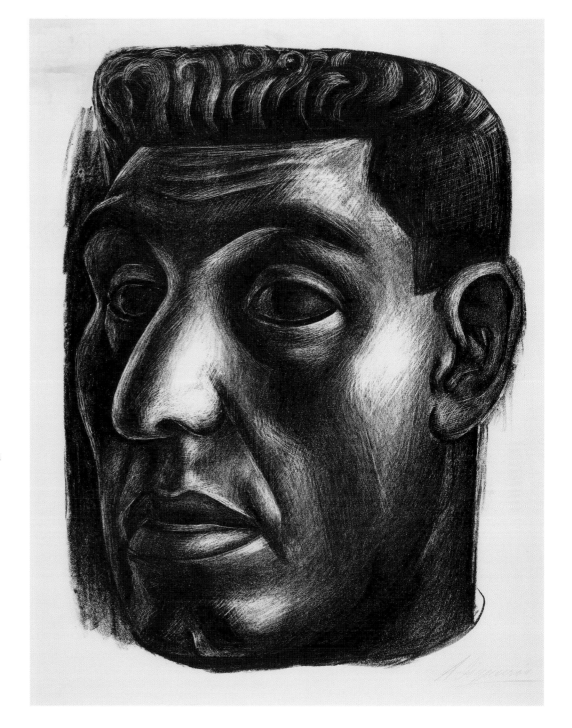

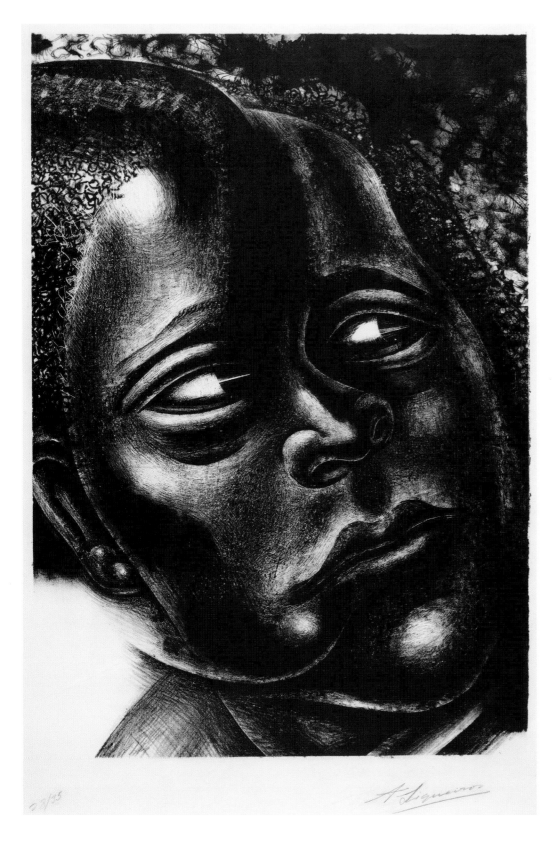

30 DAVID ALFARO SIQUEIROS

Black woman

(*Dama negra*)
1935/6
Lithograph
500 x 350 mm
2008,7069.37
Presented by Dave and Reba Williams to the American Friends of the British Museum

Siqueiros made this print in New York around the same time as his self-portrait (cat. 31). It is based on a painting he made around the same time, now lost and known only through a photograph. In the painting the sitter wore a colourful patterned scarf; Siqueiros omitted this detail in the print because its effect would not have been so dramatic in black and white. In 1956, when he wished to publish copies of this print in offset, he borrowed an impression to reproduce it as the original stone had been lost.

This print demonstrates Siquerios's skill in producing large-scale compositions. Its contrasting effects show different details of the woman's physiognomy: her face is made up of smooth surfaces, suggesting the soft texture of her skin, while rougher scratching was used for her hair and the background.

31 DAVID ALFARO SIQUEIROS

Self-portrait

1936/7

Lithograph

533 x 370 mm

2008,7069.38

Presented by Dave and Reba Williams to the American Friends of the British Museum

In New York in 1934 Siqueiros made a self-portrait that was never printed; this is his second attempt at a self-portrait. It was probably printed by George C. Miller who specialized in prints by Mexican artists, but we cannot be absolutely certain.

Siqueiros was best known for his small prints that addressed political subjects; however, this lithograph reflects his considerable skill in composing large-format works.

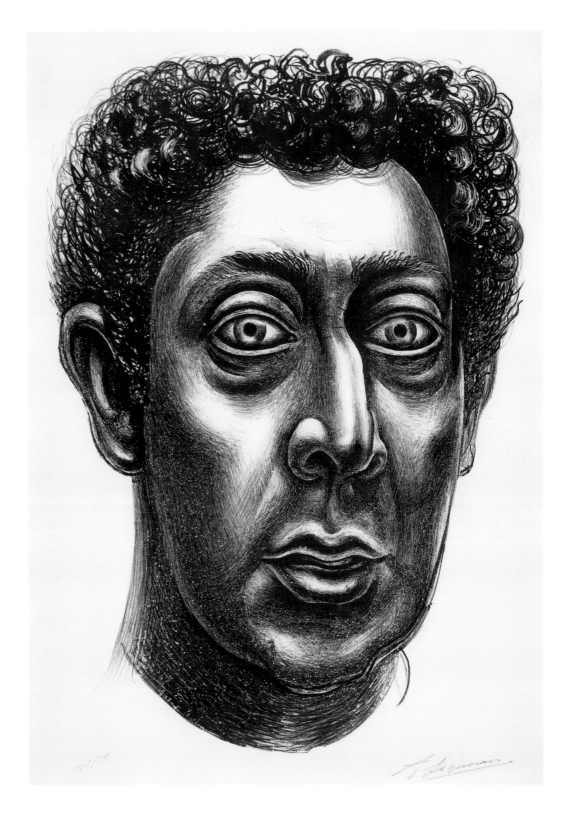

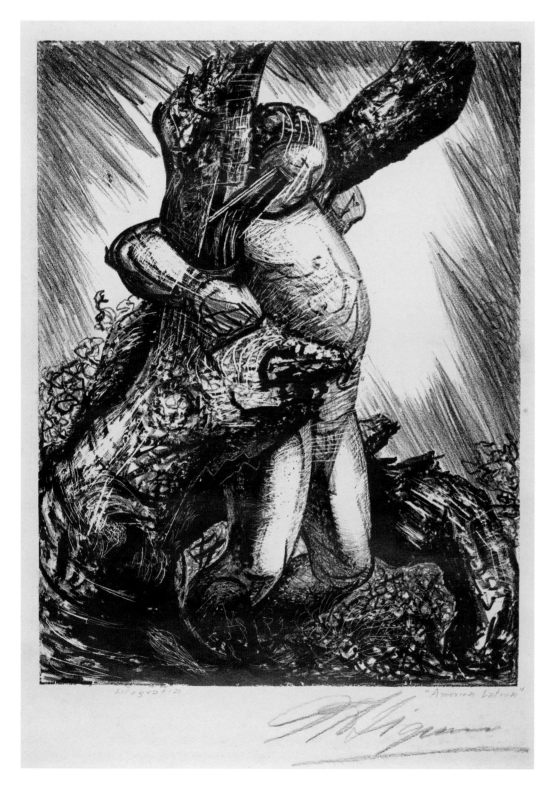

32 DAVID ALFARO SIQUEIROS

Latin America

(*América Latina*)
1945
Lithograph
300 x 228 mm
1999,0627.6

The figure tied to a tree trunk is an allegory of the Latin American continent. The print draws heavily on religious iconography: the branches of the tree resemble the wings of an angel in the form of a cross, supporting the head of the figure; a penumbra surrounds the head like a halo. The figure seems unable to lift the heavy structure to which it is tied, evoking Christ carrying his cross, and the suffering of the continent is suggested by scratching on both the figure and the trunk. This highlights Siqueiros's view of Latin America as a beleagured continent struggling under the weight of its history, its people having endured centuries of oppression, firstly through colonialism and secondly through their continual struggle for political stability. Its long history of violence stretched from the Spanish Conquest in the fifteenth and sixteenth centuries, through the oppression of the nineteenth century to the wars of Independence in the modern era.

Siqueiros based his print on a photograph of himself tied to a tree trunk, taken by the photographer Leo Matiz (1917–98). The print was made at the TGP in Mexico City.

José Clemente Orozco 1883–1949

Born in Zapatlan, Jalisco, a state on Mexico's west coast, José Clemente Orozco is one of Mexico's best-known artists, highly regarded for his murals in public buildings in Mexico and the United States which often draw on satire and caricature to address social issues such as revolution and the divisions between rich and poor.

Orozco's family moved to Mexico City in 1890, where from 1897 he was educated at the Escuela Nacional Preparatoria (National Preparatory School), a building he later decorated with mural panels. He went on to the School of Agriculture of San Jacinto, where he considered a career in agriculture, engineering or architecture, but decided instead to become an artist.

Orozco trained at the Academy of San Carlos from 1906–14, when he studied under the painter Dr Atl. He began his professional life as a caricaturist, producing illustrations for Mexico City newspapers *El Imparcial* and *El hijo del ahuizote*. In 1915, during the Mexican Revolution, he moved to Veracruz on Mexico's south-east coast in order to contribute to *La Vanguardia*, a newspaper which supported Venustiano Carranza, the State Governor of Coahuila who was President of Mexico from 1914 until 1920, and responsible for devising the 1917 constitution.

In 1917 Orozco made the first of several visits to the United States, remaining there until 1922 when the Mexican government offered him a commission to paint murals at the National Preparatory School. It was during his second visit in 1927–34 that he began printmaking, from which he was able to earn a living. His first lithograph, made in 1928, *Vaudeville in Harlem* (cat. 33), reflects not only his discovery of lithography but also his enthusiasm for American culture. The print sold well and Orozco made others to sell through the Weyhe Gallery in New York. His next series of lithographs was based on his murals at the Escuela Nacional Preparatoria. These were the last prints he sold through the Weyhe Gallery, as in 1929 he joined forces with the American journalist Alma Reed to establish Delphic Studios, a commercial art gallery to compete with the Weyhe Gallery.

Orozco returned to Mexico in 1934 and began work on five lithographs which drew on his skills as a caricaturist to criticize post-revolutionary society, depicting such subjects as protests, folklore and the degenerate nature of society. Other prints were based on his mural panel *Catharsis*, which he completed in the same year at the Fine Arts Palace in Mexico City. He continued to make prints, experimenting with a range of techniques from aquatint to etching, until his death in 1949.

BIBLIOGRAPHY
Adès 1989; Ittmann 2006; Tibol 1987.

33 JOSÉ CLEMENTE OROZCO

Vaudeville in Harlem

1928
Lithograph
303 x 401 mm
2008,7069.24
Presented by Dave and Reba Williams to the American Friends of the British Museum

This was Orozco's first lithograph. Set at a vaudeville performance in the Harlem district of New York, a silhouetted audience watches acrobats leap around a brightly lit stage. Vaudeville was a form of theatrical entertainment popular in the United States in the late nineteenth and early twentieth centuries, broadly equivalent to the British music-hall tradition with its combination of comedy, dancing, and music. Orozco makes a clear distinction here between the performers and the spectators, the figures echoing those of Picasso and Matisse in their abstraction. The monochrome print has a photographic quality to it, yet it expresses Orozco's excitement at the novelty of American culture that he encountered on his arrival in the United States the previous year. It was printed by George C. Miller in 1929 and sold through the Weyhe Gallery, at a time when prints by Mexican artists in the United States were extremely popular.

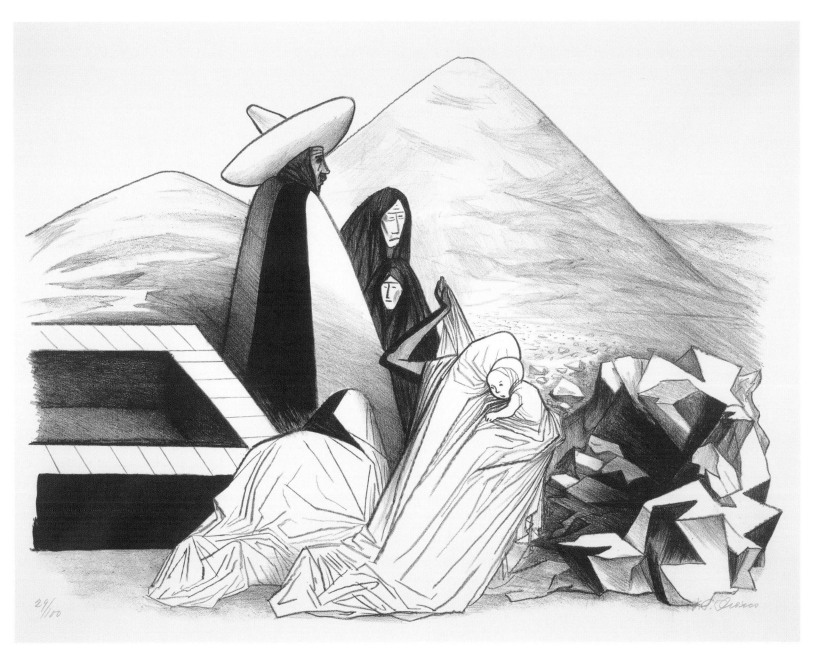
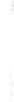

34 JOSÉ CLEMENTE OROZCO

Mexican landscape

1930
Lithograph
325 x 435 mm
2008,7069.27
Presented by Dave and Reba Williams to the American Friends of the British Museum

This print shows a family surrounding a tomb; they stand between a low wall structure on the left and a pile of rocks on the right, symbolizing the natural world and the built environment. Two women kneel on the ground in front of the tomb, one holding a baby. A man wearing a poncho and a sombrero stands in the centre, and beside him are a woman and child dressed in black, the universal symbol of mourning. The landscape in the print is barren and desolate, made dramatic through the use of bold outlines. The contrast of black and white also highlights the hardship of living in rural areas.

The print was published in an edition of a hundred by the Delphic Studios in New York, set up by Orozco with the American journalist Alma Reed in 1929.

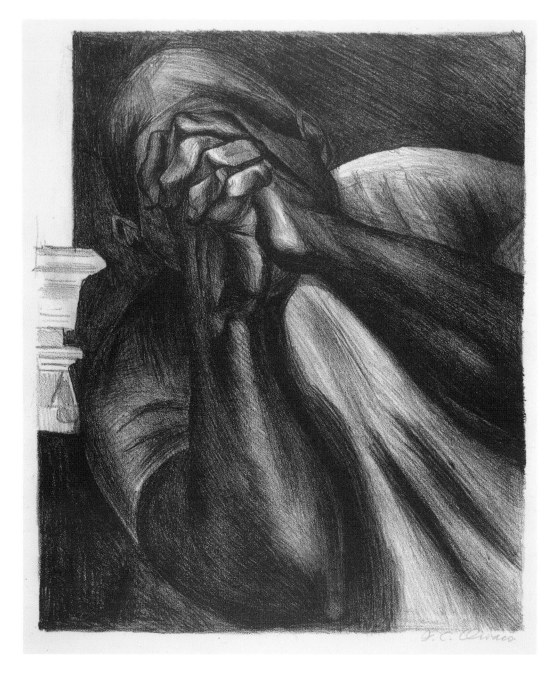

35 JOSÉ CLEMENTE OROZCO
Grief

1930
Lithograph
303 x 251 mm
2008,7069.25
Presented by Dave and Reba Williams to the American Friends of
the British Museum

The print is a detail from Orozco's mural panel
The Revolutionary Trinity, painted at the Escuela
Nacional Preparatoria, Mexico City, between 1923
and 1926. One of five lithographs he based on
the murals, it was printed in New York by George
C. Miller in an edition of a hundred. In this and
other prints made around the same time Orozco
demonstrates his sympathy for the victims of the
Mexican Revolution by focusing on themes such
as oppression and hunger.

Here, a man holds his clasped hands up to
his head, covering his face. With his shoulders
tense, his posture conveys grief, reinforced by his
interlocked fingers. On the left in the background
is a pillar copied from the wall structure of the
Escuela Nacional Preparatoria: Orozco was clearly
interested in recording the context of his figure
from the mural. The colossal figure alongside the
pillar conveys well the monumentality of the
mural project.

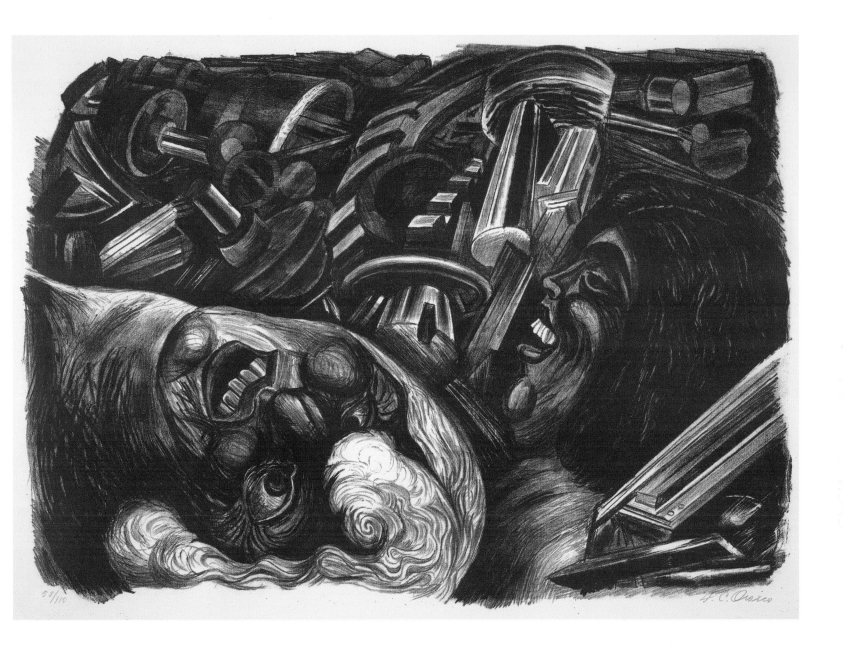

36 JOSÉ CLEMENTE OROZCO

Machines (fragments)

1935
Lithograph
315 x 435 mm
2008,7069.26
Presented by Dave and Reba Williams to the American Friends of
the British Museum

This print is copied from a detail from Orozco's mural *Katharsis* (1934) which adorns one of the walls of the Fine Arts Palace in Mexico City. One of his most famous works, *Katharsis* sits opposite Diego Rivera's mural *Man at the crossroads looking with hope and high vision to the choosing of a new and better future* (1934). Orozco's print was published by Delphic Studios in an edition of 110. This was one of several prints he made to address aspects of post-revolutionary Mexico, and also demonstrates his ability to criticize society by means of caricature.

Two prostitutes' heads roll around among pieces of broken machinery representing the decay of the machine age. Through the metaphor of broken machinery and decapitated heads the print speaks of decay and fragmentation, and of how society has sold out to capitalism.

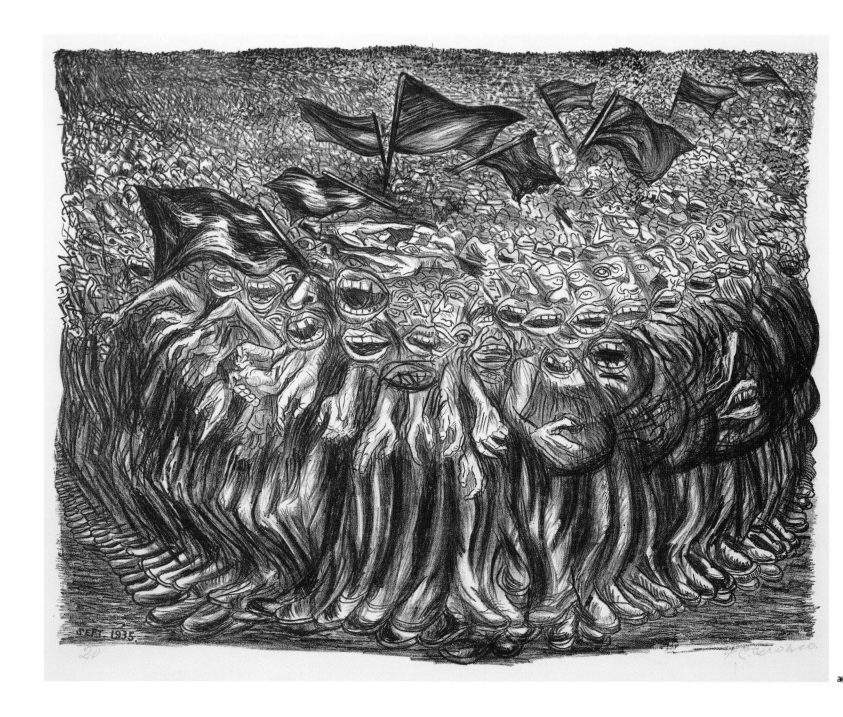

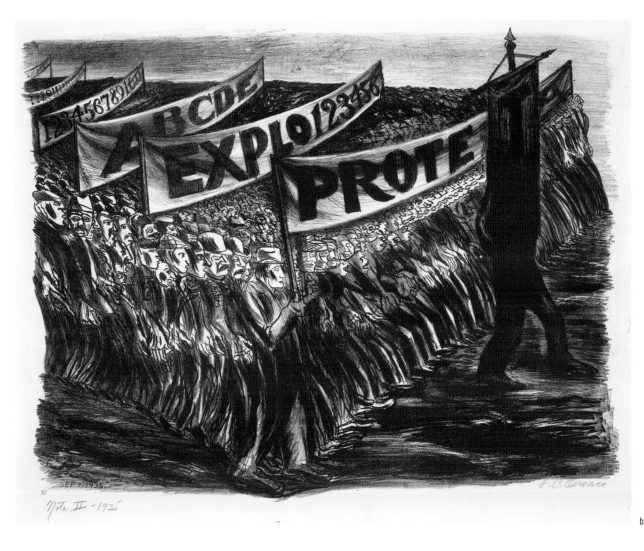

b

37 JOSÉ CLEMENTE OROZCO

a Note I (The masses)

1935
Lithograph
325 x 423 mm
1999,1031.2
Presented by Dave and Reba Williams through the American Friends of the British Museum

b Note II (Manifestation)

1935
Lithograph
335 x 420 mm
1979,0623.23

This pair of prints depicts what Orozco saw when he returned to Mexico in 1934 after five and a half years in the United States: crowds of people holding banners and flags demonstrate, venting the discontent of post-revolutionary Mexico during the 1930s because the promises of reform had not been fulfilled. Between 1920 and 1940 crowds frequently demonstrated in the streets of Mexico City. The government organized the masses, and especially the workers, into syndicates and trades unions as a mechanism for controlling protest so that violent uprisings did not occur.

Note I (The masses) caricatures protestors moving in unison. They are represented as hungry, dehumanized forms with gaping mouths. Orozco has described them as 'a hideous army of hunger-marchers with gaping mouths placed at the stomach level – the shrill cry of hunger – this solid mass of depersonalized humanity waved little flags'. Their banners are small, black and empty, symbolizing the pointlessness of their protest. Echoing Picasso and Goya, the distortion of the human form in this print relates to the demise of the individual in Mexican society, now controlled by the post-revolutionary Mexican state.

In Note II (Manifestation), those participating in the demonstration are represented as character types; some are workers and others are middle-class citizens. Shown clearly in profile and wearing hats, overalls and suits, they are made to look human but not individualized. The slogans on their banners can be easily read: emblazoned with meaningless letters, numbers and, in the case of the leading banner, the word 'protest', they show that the demonstrators had no cause and could change nothing.

Rufino Tamayo 1899–1991

Born in Oaxaca, Rufino Tamayo is one of Mexico's best-known artists. When he was very young his father abandoned the family; his mother died when he was twelve. Tamayo then moved to Mexico City in 1911 to help an aunt with her fruit stall at the market, La Merced. In 1915 he began to attend evening classes at the Academy of San Carlos in Mexico City. Two years later he became a full-time student there and was taught by Leandro Izaguirre and Roberto Montenegro. He became head of the Department of Ethnographic Drawing at the National Anthropology Museum (Museo Nacional de Antropología) in 1921, and in 1928–30 taught at the National School of Fine Arts (Escuela Nacional de Bellas Artes, ENBA) in Mexico City.

As an artist who was developing during the 1920s and 1930s, Tamayo participated in some of the artists' groups that emerged after the Mexican Revolution. In 1929 he joined the ¡30-30! group, which opposed elitist fine-art traditions and preferred to work with cheap materials. Tamayo also became a member of the LEAR from about 1935, demonstrating that he maintained contact with the Mexican art world even though he was by then living in New York.

Tamayo spent part of his career away from Mexico. His earliest trip abroad was in 1921, when he travelled to the United States with his friend the composer Carlos Chávez (1899–1978). He returned to New York in 1930 and lived there with his wife, Olga Flores Rivas, until 1949, although he spent time in Mexico each summer. In New York he worked as a painter at the Works Progress Administration (WPA) Federal Art Project, completing an easel painting every month for a fee. During the 1950s he travelled around the United States exhibiting his work. In 1957 he settled for a while in Paris where he painted a mural panel at the UNESCO building the following year.

For the remainder of his career Tamayo continued to participate in exhibitions around the world. In 1967 the BBC made a documentary in collaboration with US, Canadian and German broadcasting teams demonstrating the worldwide interest in the artist and his work. A lasting tribute to Tamayo's contribution is the Museo de Arte Contemporáneo Internacional Rufino Tamayo (Rufino Tamayo International Museum of Contemporary Art) in Chapultepec Park, Mexico City, which was opened in 1981. Ten years later he died in 1991 from bronchitis aged 101.

Although Tamayo is celebrated mainly for his murals and his paintings, during his career he made over three hundred prints, 90 per cent of them after 1950.

BIBLIOGRAPHY
Adès 1989; Ittmann 2006; Tibol 1995.

38 RUFINO TAMAYO

Man and woman or natives with maguey

(*Indios con maguey*)
1925
Woodcut
251 x 253 mm
2008,7114.20
Presented by Deborah Kiley in memory of Erhard Weyhe

During the 1920s and 1930s Tamayo made prints in Mexico and in New York. Their subjects included aspects of indigenous Mexico: landscapes and culture of his home state of Oaxaca, home to the Zapotec people, greatly influenced his work. In these prints Tamayo cut deeply into the block to maximize the effect of the grain, highlighting the woodcut technique.

This is one of eight prints that he made between 1925 and 1928 in New York, where they were sold by the Weyhe Gallery. Set in a mountainous landscape, an Indian man and woman face each other. Made from the same texture as the landscape, they become part of it. Maguey plants, a type of agave, grow in the background. These are a symbol of Mexican culture, and the sugars they produce are used for making tequila. Tamayo's combination of an Indian couple, the landscape, and the maguey, celebrates the country's indigenous roots.

39 RUFINO TAMAYO

Grief

(Pesar)
1930
Woodcut
252 x 250 mm
2008,7114.18
Presented by the Aldama Foundation

The large face with broad features foreshadows
the style that Tamayo later developed as a painter
and muralist. Grief is expressed by the partly open
mouth and staring eyes of the figure. The vertical
lines beneath the eyes resemble tears that run
across the entire composition. Tamayo was greatly
interested in abstraction and the power of a solid
line to convey emotion.

40 RUFINO TAMAYO

Woman with a table

*c.*1926–8
Woodcut
189 x 243 mm
2008,7114.16
Presented by the Aldama Foundation

This print was probably shown at the 1928 American
Print Makers' Society exhibition. Made to sell to
American buyers through the Weyhe Gallery as a
fine art print, the subject probably refers to the
poverty experienced by Indians in Mexico. A woman
standing in a room with one hand on a table wears
a downcast expression. The room is empty apart
from the table supporting a large vessel. The poster
made by Leopoldo Méndez in 1944, *Tram workers
fight for the benefit of the public* (cat. 79), shows a
similar figure by a table indicating poverty in the
bottom right corner.

41 RUFINO TAMAYO

Digger

*c.*1925
Woodcut
97 x 82 mm
2008,7114.17
Presented by the Aldama Foundation

The figure of a man with his back turned towards
the viewer is shown either digging beside a large
tree stump or removing a smaller trunk from a hole
he has dug. With both hands he pulls the object out
of the ground with all his strength. The focus of
the print is his activity and how his form blends
with the tree upon which he stands. Tamayo does
not differentiate between the woodcut technique to
describe the tree, the landscape, the sky and the
man: all emerge from the substance.

42 RUFINO TAMAYO

The woodcutter

*c.*1926–30
Woodcut
255 x 250 mm
2008,7114.15
Presented by the Aldama Foundation

Standing between three tree stumps, a man swings
an axe high above his head. It seems as if his figure
was carved from one of the now-vanished trunks.
Tamayo seems more interested in the tree/man
symbiosis than in the action he performs. His feet
blend with the roots of the tree and the axe melts
into the sky. The print celebrates the product of
cutting and carving.

The date of the print is uncertain; it may have
been made in 1930, or earlier, when Tamayo was
in New York in the 1920s.

Raúl Anguiano 1915–2006

Raúl Anguiano grew up in the city of Guadalajara, Jalisco, where from 1927 he studied painting and sculpture at the local art school (Escuela Libre de Pintura). In 1934 he moved to Mexico City and a year later taught at an art school, La Esmeralda, which he eventually left in 1967. He spent two years (1940–41) in Cuba and the United States, including a three-month stay in New York to study at the Art Students League.

His first solo exhibition was in 1936, the year in which he became General Secretary of the syndicate of art teachers. During the 1940s his prints were included in a number of exhibitions, and in 1949 he exhibited seventy-seven drawings and lithographs at the Sala de la Estampa of the Palacio de Bellas Artes. Throughout his career he won national and international prizes for his work and exhibited in many countries including Chile, the USSR, France, Italy and Cuba.

In 1937 Anguiano became a member of the LEAR and a year later he was one of the first artists to join the TGP. His print of Emiliano Zapata was the first to be printed by the TGP in 1938. He contributed to TGP publications and exhibitions until 1960, when he left the collective. At the TGP he made and published a series of six lithographs on the subject of popular Mexican sayings. From 1948 he was also associated with the Sociedad para el Impulso de las Artes Plásticas (Society for the Mobilization of the Visual Arts).

In 1949 Anguiano set off on an expedition to the Mayan ruins of Bonampak, an archaeological site in southern Mexico, close to the Guatemalan border, where he drew the ancient structures, the people and the customs of the Lacondón Indians. During the 1960s he visited Europe and the Middle East.

In addition to printmaking, Anguiano was also a painter and a muralist. He painted murals in Mexico City, including at the Museum of Anthropology, and in 1950 he collaborated with José Chávez Morado to make a portable mural for an architecture congress in Cuba.

BIBLIOGRAPHY
Raúl Anguiano 1985; Cortés Juárez 1951; Ittmann 2006; Cajigas 1995; Prignitz 1981.

43 RAÚL ANGUIANO

Those who ride around on each other ... are just immature

(*Por eso los hacen pandos ... por que los montan tiernitos*)
1939
Lithograph
320 x 430 mm
2008,7114.12
Presented by the Aldama Foundation

Anguiano made a series of prints illustrating Mexican sayings. The phrase 'those who ride around on each other ... are just immature' inscribed along the bottom here refers to life in the countryside, and especially to calves; by extension, it also refers to a lack of maturity. These two interpretations of the phrase partially explain the bizarre scene in the foreground, where naked women ride on men's backs, mimicking the behaviour of young animals.

The people in the print are caricatures, the women in particular resembling figures from the work of José Clemente Orozco; their pronounced make-up suggests that they represent prostitutes. The image broadly suggests the absence of civilization, underscored by the barren landscape with only a tree trunk and a few houses in the distance. The faces of the figures are individualized, and may represent specific people: the figure in the centre resembles Diego Rivera and the man who carries him Emiliano Zapata.

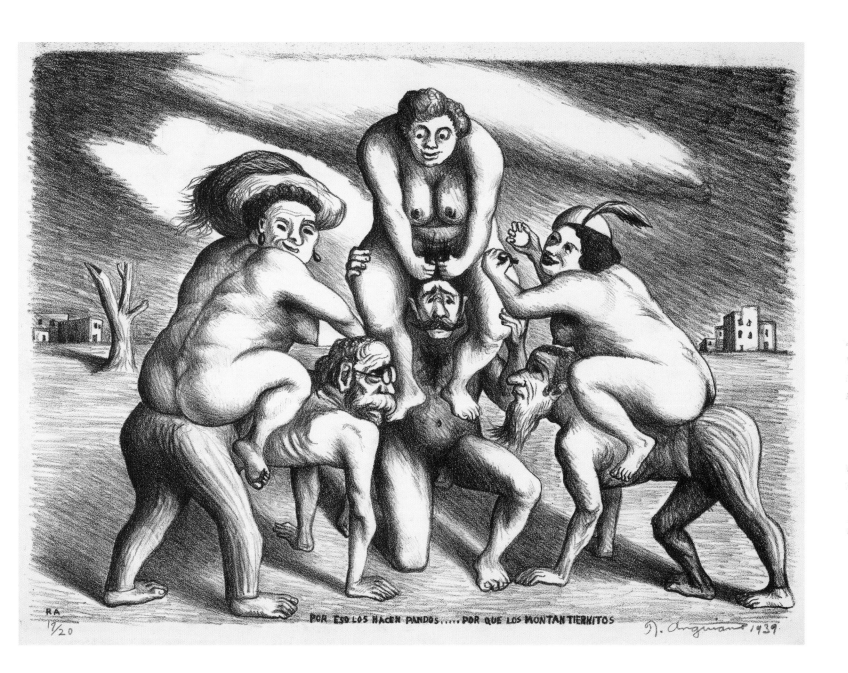

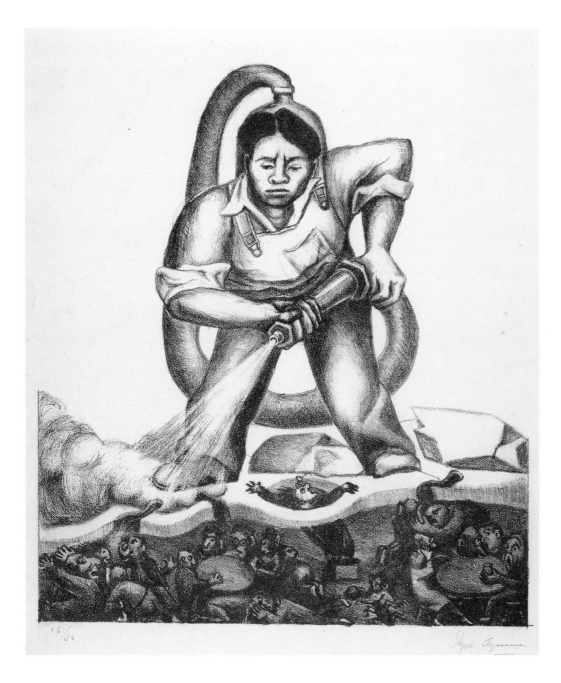

44 IGNACIO AGUIRRE (for biography see p. 72)

The firefighter

*c.*1940
Lithograph
340 x 305 mm
2008,7114.1
Presented by the Aldama Foundation

A giant man dressed in overalls and carrying a water hydrant on his back hoses a group of figures in an underground cavern. Sitting at tables playing cards, those being hosed represent gambling and corruption. One man with glasses flying off his head is sucked through the hole into the pit of corruption.

The worker symbolically cleanses the corruption with water, an agent of purification. His enormous size in comparison to those underground suggests the power of the worker over the corrupt middle and upper classes. He also represents the ideal being, a figure of strength willing to engage in activities that will cleanse the nation of its corruption and vice. The blank background highlights both his stature and the determination of his actions.

45 ALBERTO BELTRÁN (for biography see p. 70)

Life and drama of Mexico: twenty years in the life of the Taller de Gráfica Popular

(*Vida y drama de México, 20 años de vida del Taller de Gráfica Popular*)

1957

Woodcut and colour linocut

696 x 472 mm

2008,7108.1

Presented by the Aldama Foundation

In 1957 the TGP organized a print exhibition at the Fine Arts Palace in Mexico City to celebrate the twentieth anniversary of its foundation. This striking poster in orange and black advertises the event, which ran from 19 November to 28 December.

The print comprises text and several images, the arrangement of type and position of the image in the upper section recalling the front page of a daily newspaper. One of the images, printed in black, demonstrates the craft of printmaking: the hands of a printmaker are shown cutting the features of a head into a woodblock. The print made from this block appears in reverse on the left, next to an elegantly dressed skeleton holding two wineglasses. The two faces – that of the young man and the skeleton – representing the lower and the upper classes respectively look in opposite directions, emphasizing their different positions in society. More specifically, the skeleton and the upper classes have died out and a new class, represented by the boy emerging from the print, has come to life. The skeleton also refers to the work of José Guadalupe Posada, the father of Mexican printmaking, where skeleton motifs represent Mexican people from all walks of life and express popular traditions such as the Day of the Dead (cats 1–11).

The TGP's choice of title for the anniversary exhibition, 'Life and Drama', is significant because these two terms refer to the way in which printmakers at the workshop documented social and political life in Mexico. As such, the prints have a clear social significance, removed from their value merely as objects with artistic merit. Posters like this one tended to be printed on very thin, cheap paper, and were regarded as ephemeral.

Francisco Dosamantes 1911–1986

Francisco Dosamantes was born in Mexico City where from the age of fourteen he trained as an artist at the Academy of San Carlos, taking classes in sculpture, printmaking and painting. He specialized in printmaking when he joined the lithography workshop at the Academy run by the Mexican printmaker Emilio Amero, and worked mainly as a printmaker and a painter for the rest of his career.

Dosamantes regarded art as a vehicle for social change, and from the outset his work conveyed political overtones. His first political alliance was in 1928 when he joined the ¡30-30! group which denounced elitist attitudes towards art. He joined the LEAR in the early 1930s, and in 1937 became one of the first artists to work at the TGP. In 1952 he became a member of the Sociedad para el Impulso de las Artes Plásticas (Society for the Mobilization of the Visual Arts), demonstrating his continued interest in collaborating with other like-minded artists such as Raúl Anguiano, who was also a member of this group.

During the 1930s Dosamantes travelled to Mexico's rural areas to participate in cultural missions organized by the Ministry of Education. These projects were designed to make messages of social change and revolution accessible to rural communities. In 1937 he moved back to Mexico City, and from 1938 worked as a printmaker at the TGP where he made prints portraying the violence and destruction that was sweeping through Europe at that time. He also took up a post teaching art at a secondary school in 1940. But by 1941 he had returned to another cultural mission, this time in the state of Campeche in the Yucatán Peninsula, where he eventually became Director of the Art School. His work in Campeche involved making prints for the magazine *Ruta*, which campaigned for increased literacy in Mexico. Dosamantes's time in rural Mexico increased his awareness of the country's indigenous communities, and also of the link between art and social change. The focus of his prints during the 1940s shifted from politics and Fascism to Mexico's indigenous heritage.

Exhibitions of Dosamantes's work have been held in Mexico, in major cities in the United States such as Los Angeles and New York, and in Europe, Cuba and the Soviet Union as part of the TGP. The most notable of these, entitled 'Homanaje 40 años de Labor', took place at the Fine Arts Palace in Mexico City in 1970 and included prints, drawings and paintings.

BIBLIOGRAPHY
Ittmann 2006; Tibol and Arceo 1987.

46 FRANCISCO DOSAMANTES
Bombardment Spain 1937

1937
Lithograph
390 x 266 mm
2002,1027.7
Presented by Dave and Reba Williams through the American Friends of the British Museum

The Spanish Civil War of 1936–9 was of considerable interest to artists in Mexico. In this lithograph Dosamantes refers to the massacre of women and children at Guernica, a small town in the Basque region of northern Spain. The attack was carried out in April 1937 by German and Italian airforces supporting the Spanish Nationalist faction. It was the same event that inspired Picasso's iconic painting named after the devastated town.

Dosamantes depicts a colossal stone head with two holes in the side resulting from shellfire. To the right a classical column has been blown in to two parts, the upper half flying through the air. A woman with her fist in the air clutches a dead child and another child lies motionless on the ground beside a horse which has also fallen. The clenched fist is an expression not only of anguish but also of defiance at this terrible injustice.

A stamp on the back of this print indicates that it was made by the TEGP (Taller Editorial de Gráfica Popular), the group of printmakers that preceded the TGP.

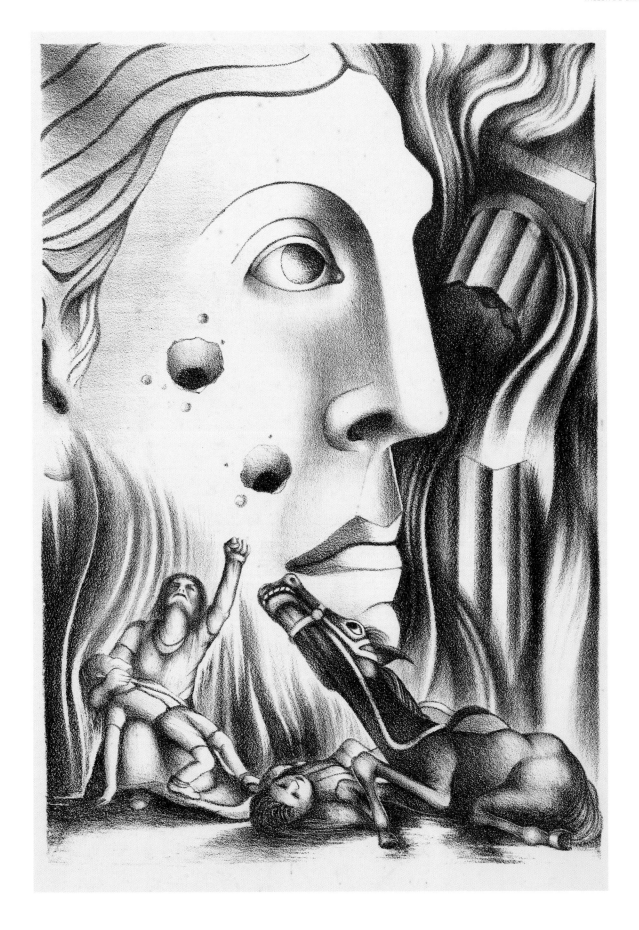

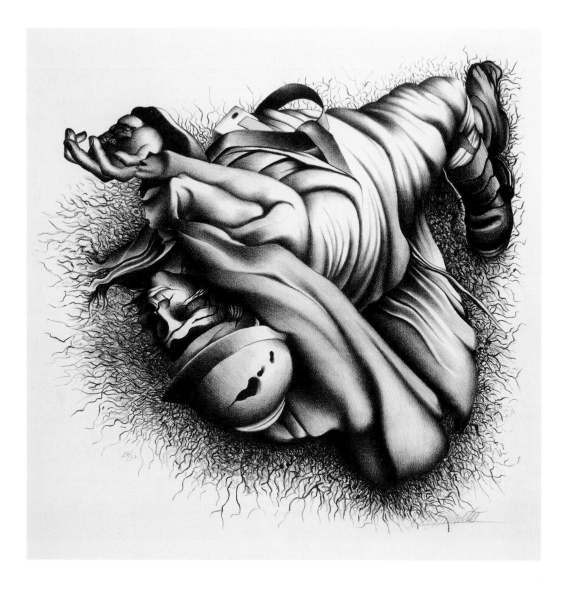

47 FRANCISCO DOSAMANTES

Dead soldier: Fascism

(*Soldado Muerto: Fascismo*)
1940
Lithograph
410 x 420 mm
2008,7077.1
Presented by the Aldama Foundation

Dosamantes made this print at the TGP as part of
the workshop's campaign against Fascism. Printed
in monochrome, the twisted human figure on the
white background is a dead soldier lying in a pool
of what might be blood, his life force ebbing from
him. There are three holes in his helmet, indicating
that he has been shot. His helmet resembles those
worn by the German army during the Second World
War and his black boots are symbols of Fascism.
Beneath his helmet the soldier's face is covered in
scratches and cracks so that it looks more like a
stone sculpture than a human head.

There is an element of surrealism to this print.
Viewed from a distance the composition has the
appearance of a beautiful still-life object on a clean
background. The beauty of the image is created by
the soft lines, the smooth texture of large printed
surfaces and contrasts of light and dark. Yet on
closer examination the print is entirely about
death. It may have been inspired by contemporary
photography, picturing the fallen soldier from
an oblique angle, his head closest to the viewer.

Unlike other Mexican printmakers such as
Posada and Méndez, who explored the theme
of death through the symbolism of the skeleton,
Dosamantes addresses the subject through a
human form.

48 FRANCISCO DOSAMANTES

Anguish

1945
Lithograph
565 x 380 mm
2008,7069.10

Presented by Dave and Reba Williams to the American Friends of
the British Museum

A monumental woman's head covered in a shawl
fills the entire sheet. The thorns around her
head twist together and point in all directions,
contrasting with the smooth, delicate texture of her
face and shawl. Her large, dark eyes are open, her
nostrils flared and her head raised. Gazing from
the thorny background, her face is pale with fear, in
contrast to the darker tones framing her. The image
employs the familiar symbol of a distressed woman
and the thorns to refer to anguish, evoking the
Christian iconography of the Virgin Mary and
Christ with a crown of thorns.

The shawl, the woman's broad features and the
grey hair on her forehead all suggest that she is of
indigenous origin, a characteristic of Dosamantes's
work during this period. Additionally, rather than
idealizing the rural life of Mexico's indigenous
people, this print represents their anguish and
distress. Dosamantes's curved lines, smooth edges
and large surfaces evoke mural paintings, where
scale is so important to legibility.

Dosamantes signed the print in pencil 'F.
2amantes'. This compound, which substitutes
a number 2 for the letters 'dos', has become the
shorthand for his surname which translates as
'two lovers'.

Jesús Escobedo 1918–1978

The son of a miner, Jesús Escobedo was born in the village of El Oro in the state of Mexico. After his mother died when he was three years old he was sent to Mexico City to live with relatives. Here he attended a religious school before moving to a state-run primary school. He began training as an artist at the age of ten, taking classes at the Centro Popular de Pintura 'Santiago Rebull'. Directed by Gabriel Fernández Ledesma, who is best known for his book illustrations, the school aimed to educate children from working-class families. The printmaker Everardo Ramírez also worked there and taught Escobedo the woodcut technique.

In 1934 Escobedo began to study at two different art schools. He entered the Academy of San Carlos, a fine arts institution, and also took evening classes at the Escuela de Artes para trabajadores (School of Art for Workers). He later became an art teacher and from 1952 taught drawing at the Universidad Obrera de México (Workers University of Mexico). Other employment included public relations at the Ministry of Education between 1937 and 1947, and he also provided illustrations for the magazine *El Nacional*.

Escobedo was a member of the LEAR, and joined the TGP shortly after it was established in 1937. He made most of his prints at the TGP, many of them in his preferred technique of crayon lithography. He and some of his contemporaries left the TGP in 1940 because of a difference of opinion between two parties over the pricing of prints. However, he again exhibited with the group in 1966 – his last exhibition – which suggests that he had re-established contact with them.

Escobedo travelled to New York in 1945 on a scholarship from the Guggenheim Foundation, enabling him to make a series of eight prints illustrating different aspects of New York City. Those he made in Mexico addressed a number of subjects, including the Mexican Revolution. He also made prints of daily life in Mexico, some of which were in the surrealist mode.

BIBLIOGRAPHY
Ittmann 2006; TGP 1949; Williams et al. 1998.

49 JESÚS ESCOBEDO

The vultures

1939
Lithograph
235 x 196 mm
2008,7114.2
Presented by the Aldama Foundation

The subject of this print is death and decay. A vulture with wings spread lifts a skull with its beak. Another skull lies on the ground next to a cactus plant, and in front of this stands another vulture. There are also human remains, including a pair of human hands on either side of the skull at the centre of the print and a human foot in the bottom left-hand corner. To the right of the vulture, underneath the skull, is a face mask reminiscent of pre-Hispanic objects.

The print also refers to the Mexican coat of arms, which shows an eagle with a serpent in its mouth, perching on a cactus plant. According to Aztec mythology the location at which the people of Tenochtitlán saw this sight indicated where they should build their civilization. During the colonial period the symbol was appropriated by the Spanish conquistadors as a means of evangelizing, and it has appeared on the national flag ever since. In Escobedo's print the eagle has been transformed into a vulture and the serpent into a skull, representing the nation as a pile of dead parts.

50 JESÚS ESCOBEDO

Off to the Front

1939
Lithograph
230 x 272 mm
2008,7114.3
Presented by the Aldama Foundation

The subject of this print is the Mexican Revolution: a steam train carrying soldiers departs for the Front where they will join other forces engaged in revolutionary battles. Sitting on the front of the train are four soldiers wearing light-coloured suits, bullet belts and sombreros, and carrying rifles. Bullet belts, rifles and sombreros symbolize the Mexican Revolution and have also become associated with the cult of *machismo*. Other soldiers travel in carts at the back of the train. As it moves away, women and children watch the train leave the village and wave goodbye. The thatched huts in the background and the long skirts and baskets of the women indicate that the train is leaving a rural village, a dismal reminder of the price of war when villages lose all their men and it becomes the sole responsibility of the women to do all the work.

The print was possibly inspired by documentary photographs of the Revolution taken by the Casasola photographic agency. Based in Mexico City, the Casasola family and other photojournalists working for them published their work in newspapers, illustrated magazines, history books and albums.

51 LEOPOLDO MÉNDEZ (for biography see p. 62)

A priest striking back

1931
Woodcut
218 x 146 mm
2008,7069.19
Presented by Dave and Reba Williams to the American Friends of
the British Museum

This print addresses the subject of anti-clericalism
in post-revolutionary Mexico. A fierce priest
wearing a black cassock wields a large crucifix
with which to strike a group of peasants. Some
fall to the ground, others standing behind him
clutch their own weapons, a sword and a sickle.
Symbolizing the corruption of the Church, the
priest violently lurches forward as coins and a set of
rosary beads fly from his pocket. A headless effigy
of Christ in the left corner lies on the ground with
the fallen peasant, his outstretched arms touching
the arm and leg of the peasant and implying a
sympathetic condition. The print represents the
Church as a repressive, violent force responsible
for demeaning agrarian culture in Mexico.

The anti-clerical sentiment reflects the laws
regarding the Church that were written into
the 1917 Constitution, where the Church was
considered a threat to the formation of the State.
The government restricted the rights of priests and
curtailed the activities of Catholic organizations.
The enforcement of these laws in 1926 led to the
Cristero Rebellion in 1926–9, a conflict between the
government and Catholics which took place mainly
in western Mexico. This uprising was led by a
group called the Cristeros, so called because they
fought for the rights of the Church in the name of
Christ. When the new laws were enforced, priests
could be fined for leaving Church premises dressed
in anything which identified them as clergy, and
many monasteries and churches were closed.

Méndez possibly made this print for a broad-
sheet, or when he was involved with the LEAR
campaign. Its size and direct appeal make its
message immediately clear.

52 LEOPOLDO MÉNDEZ

Political piñata

1936
Woodcut
290 × 217 mm
2008,7069.18
Presented by Dave and Reba Williams to the American Friends of the British Museum

A *piñata* is a large, hollow ornament filled with sweets or fruit. Made from clay or papier mâché, sometimes in the shape of a star, an animal or a famous character, *piñatas* are broken in a game during parties and celebrations.

In this print a worker uses a baton to break a *piñata* swinging on a rope above his head. The *piñata* here represents President Plutarco Elias Calles of the Partido Constitucional Revolucionario (Constitutional Revolutionary Party), and also symbolizes capitalism: the figure clutches a bag of dollars in his left hand and wears a top hat decorated with dollar signs. Inside the body of the *piñata*, a gun has blown the head off its torso, demonstrating – literally – the explosive nature of capitalism. In his right hand the capitalist holds a dagger bearing a swastika, indicating the link between Fascism and capitalism. The debris that flies from the *piñata* includes faces, swastikas and heads with acronyms or names assigned to them. At the right of the print, a group of supporters throw their hands in the air, cheering on the worker who breaks the *piñata*.

The inscription on the baton used by the worker, 'Feliz Año 1936', locates the print at the beginning of that year. Rather than addressing the past, Méndez predicts the future by warning that capitalism will be beaten by the united workers, specifically in 1936.

53 LEOPOLDO MÉNDEZ

The large obstacle

(*El gran obstáculo*)

1936

Linocut

273 x 393 mm

2002,1027.13

Presented by Dave and Reba Williams through the American Friends of the British Museum

A military tank carrying three passengers and their guns is shown approaching a giant clenched fist in the form of a Communist salute emerging from the ground. Of the three men on the tank, the one at the front desperately pulls a lever to stop it from crashing in to the fist. Behind him, two panic-stricken passengers representing Fascism and capitalism hurl their arms in the air as the tank moves closer. The man in the centre, wearing a top hat decorated with a swastika and a dollar sign, embodies Fascism and capitalism. Almost falling off the back of the tank, a third man wears a straw hat inscribed with the letters ARM signifying the Alianza Revolucionaria Mexicana (Mexican Revolutionary Alliance), a right-wing party which held pro-Nazi views.

Méndez made this print during his time at the LEAR, supporting the anti-Fascist ideology that underpinned the group. The print also demonstrates how Méndez employed surrealist elements in his work.

54 LEOPOLDO MÉNDEZ

The great assassination

(*El gran atentado*)

1944

Lithograph

400 x 545 mm

2008,7114.10

Presented by the Aldama Foundation

In 1944 this print was banned from an exhibition at the Galeria Decoración in Mexico City because it addressed the subject of a plot by the PAN (Partido Acción Nacional/National Action Party) to assassinate President Ávila Camacho (1940–46). Various artists, including Los Tres Grandes (Orozco, Siqueiros and Rivera), organized an exhibition in protest against this act of censorship. Before the publication of this print the TGP had become fragmented, but in an act of solidarity some of the artists who had previously abandoned the group returned, and new members joined.

The print shows a cloaked assassin with a peaked cap pointing a pistol at President Camacho from behind a wall. The President strides confidently with two other figures representing Miguel Hidalgo, the leader of Mexico's independence movement, and Benito Juárez, Mexico's first indigenous president who was also hailed as a hero for defending the nation from invading French troops in the mid-nineteenth century. All are drawn in outline, walking 'on air' rather than on the ground, suggesting that they are an apparition.

In the foreground, a man with horse-like features and wearing a suit stands on three nursery-style building blocks bearing the letters PAN. Swastikas fly from his open mouth, demonstrating that his words are Fascist propaganda. He also waves a flag bearing a map of the Mexican Republic inside a white circle on a dark background; the Nazi flag was a black swastika inside a white circle on a red background, implying that the PAN would turn Mexico into a Fascist state. However, the man also gives the Communist salute of a raised clenched fist. The image reflects the mixed views in Mexico's political system.

55 LEOPOLDO MÉNDEZ

God and the Four Evangelists (or Concert of fools)

Concierto de locos
1932, republished 1943
Wood engraving
147 x 148 mm
1990,1109.140.5

This print addresses the relationship between art and politics that emerged after the Mexican Revolution ended in 1920. Méndez made the engraving in 1932, apparently for a poster advertising a radio concert to be given by patients from La Castañeda mental asylum in Mexico City. It is unlikely that the concert took place, and the poster is said instead to be a satire criticizing the ludicrous ideas that were emerging about the direction of Mexican art. This print was republished in 1943, when Méndez compiled twenty-five of his wood engravings from the 1930s and 1940s in a portfolio entitled *25 Prints by Leopoldo Méndez*.

Based on religious paintings like those produced in colonial Mexico, the image shows a bearded figure wearing robes standing before a bright light, looking through a triangular eyeglass. This figure represents God and the four figures in the corners playing musical instruments are the Evangelists: all are based on characters who influenced Mexican culture after the Revolution, either through art or through their contribution to educational programmes.

The figure in the bottom right-hand corner, wearing traditional dress and playing a drum, represents the printmaker and muralist Diego Rivera. He played a key role in encouraging artists to incorporate elements of indigenous and pre-Hispanic culture into their work. Sitting on the ground opposite Rivera is his contemporary, David Alfaro Siqueiros. Playing a harp made from a sickle (one of the symbols on the Communist flag), he symbolizes Communism and art. The two figures standing up at the back are the artist Dr Atl on the left and Moisés Sáenz, Education Minister, on the right. Dr Atl shakes rattles which were used at rallies and demonstrations, possibly referring to the rise of mass politics and the artists' pro-Nazi attitudes. Sáenz, who directed various cultural programmes for the Mexican government, stands and rings a handbell to indicate how art could be used as a means of education.

56 LEOPOLDO MÉNDEZ

House lieutenant

(*Casateniente*)
1935, republished 1943
Wood engraving
111 x 150 mm
1990,1109.140.4

This print, from a series of twenty-five by Méndez (see cat. 55), shows a family being evicted from their home. A woman sits on a rolled-up mattress in the foreground, holding a baby tightly in her arms. Her husband stands behind, clutching a second child, in front of furniture thrown from the house. Behind the family are two men dressed in suits. The man on the left holds a pistol and wears a hat with a swastika on the front identifying him as a Fascist. His jacket has a badge pinned to it that reads ARM, the acronym for the right-wing Alianza Revolucionaria Mexicana (Mexican Revolutionary Alliance). He kicks his right leg in the air towards the seated woman, indicating that he has just thrown her out of her house. Standing next to him, the second man wears a hat with a dollar sign identifying him as a capitalist; he wields a stick at the evicted husband, forcing him to cower.

57 LEOPOLDO MÉNDEZ

El 'Juan'

1934, republished 1943
Wood engraving
98 x 136 mm
1990,1109.140.6

This print comes from a series that Méndez produced in his early years at the TGP and republished in 1943 as part of a portfolio of his work (see cat. 55). Its subject is the contrast between a bourgeois lifestyle and poverty. Set in a city, the façade in the background at the right of the print shows porticoes and a column. The bourgeois family standing in front of the wall are identified as such by their clothing. The woman, for example, wears a hat and jewellery, a bracelet on her right arm and a crucifix on a chain round her neck, and she has painted her cheeks with make-up. Next to her is a man, presumably her husband, who wears a suit and a hat. A dark-skinned woman in front of them holds a white child of the family, implying that they are wealthy enough to employ a nanny. A car stops in front of them and a chauffeur ushers them inside. A figure attached to the bonnet of the car indicates that it is a prestige model.

To the left of this is another family. In contrast to the wealthy group, this family's only means of transport is on foot; the father carries one of their two children in his arms and the other child walks in front of him. Both the child and its mother have bare feet, indicating their poverty and endurance as they have to walk on hard surfaces for long distances.

58 LEOPOLDO MÉNDEZ

The accident

(*El accidente*)
1934, republished 1943
Wood engraving
141 x 97 mm
1990,1109.140.7

The print shows a worker falling from a ladder at a construction site. The expression of anguish on his face as he plunges towards the ground is emphasized by his large hands, which are unable to grasp anything to save his life. On the ground, a tiny figure raises his arms in panic. In the background, smoke bellowing from a furnace implies that work continues at the construction site despite the tragedy.

The subject refers to the many Mexican workers who died in accidents when working on building projects because of dangerous conditions and lack of helmets and other protective clothing. It is a reminder that urban developments in a progressive society were often at the expense of human life. This print is another from the series of twenty-five that Méndez made addressing social and political issues in post-revolutionary Mexico (see cat. 55).

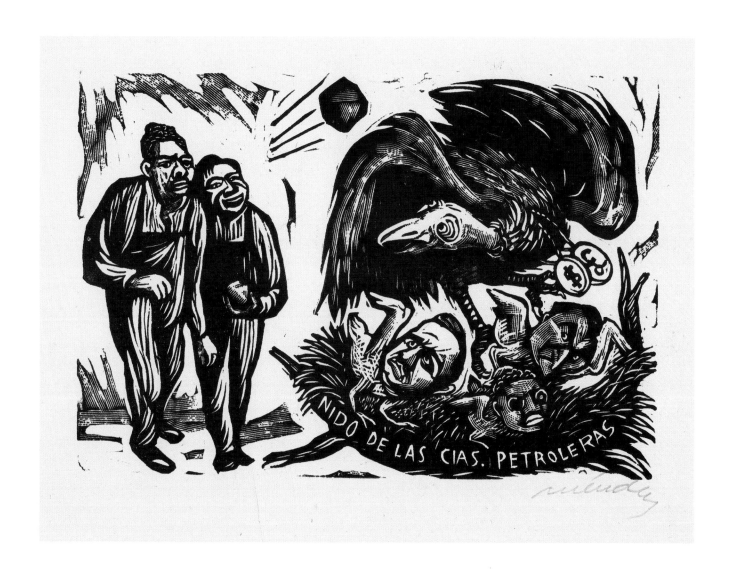

59 LEOPOLDO MÉNDEZ

The nest of the petroleum companies

(*Nido de las cías petroleras*)
1940, republished 1943
Wood engraving
127 x 185 mm
1990,1109.140.18

The print addresses the greed of the oil industry in Mexico. Two workers standing together throw rocks at a vulture's nest labelled 'nido de las cías petroleras' ('nest of the petroleum companies'). Hovering above the nest is a huge vulture holding in its claws two coins bearing the pound and dollar symbols. Inside the nest are three human figures with wings representing capitalists of the oil industry. Shown in the guise of vultures, they are metaphors for the way in which petrol companies took a large proportion of profits.

This print was first made in 1940 for a TGP poster in support of President Lázaro Cárdenas's efforts to protect national interests from foreign industry. President of Mexico from 1934 to 1940, Cárdenas nationalized the Mexican oil industry in 1938.

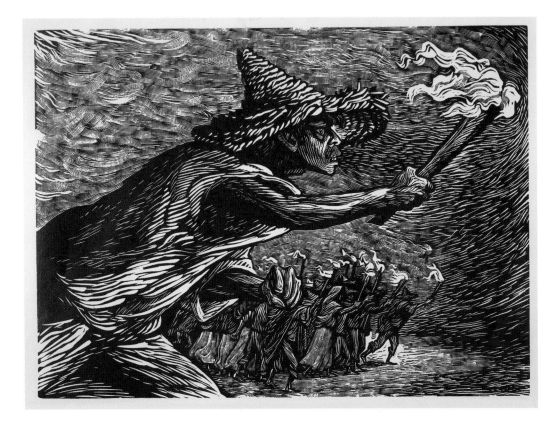

60 LEOPOLDO MÉNDEZ

The torch carriers

(*Las antorchas*)
1947
Woodcut
305 x 416 mm
2008,7069.20
Presented by Dave and Reba Williams to the American Friends of
the British Museum

In this print a mob of peasants charges through
the wilderness carrying burning torches to
illuminate the way. The most prominent figure
in the foreground is a man with a frightening
expression on his face, wearing a straw hat. The
bold technique and the way in which the figures
are sculpted from the woodblock impart a sense
of tension and turbulence to this composition.
The arrangement of forms across the picture plane
was inspired by etchings of rebelling peasants
made in 1903 by the German printmaker Käthe
Kollwitz (1867–1945).

Méndez made this print as one of a series used
in the opening credits to *Río Escondido* (*Hidden River*,
1947), a film directed by Mexican cinematographer
Emilio Fernández. The print refers to a scene in the
film in which the peasants revolt against the *cacique*
(local governor) for his violent and repressive
behaviour towards their community. Focusing
on the subject of a peasant rebellion, the print is
embedded in reality as well as the fictional narrative
of the film since agrarian reform was one of the
main motivations behind the Mexican Revolution.

Méndez made this print at the TGP; it is a
striking example of how the group continued to
address issues left unresolved by the Mexican
Revolution.

Isidoro Ocampo 1910–1983

Isidoro Ocampo was born in Veracruz on the Gulf Coast of Mexico. His early years were spent in the company of his father, a lighthouse keeper. At the age of five he went to Mexico City to begin his primary education. Later his father sent him to study commerce, but he rebelled and instead trained as an artist. Ocampo became one of the major printmakers in Mexico during the first half of the twentieth century; his prints have been compared with those of David Alfaro Siqueiros.

At the age of eighteen Ocampo enrolled at Mexico City's Academy of San Carlos where he attended night school and trained at the Escuela de Artes del Libro (Book Arts Workshop) with the printmakers Francisco Díaz de León (1887–1975) and Carlos Alvarado Lang (1905–61). Here, around 1929, Ocampo learnt lithography from Emilio Amero. From 1930 to 1934 he produced lithographs, engravings, etchings and woodcuts; in 1932 he also started to paint, but printmaking remained his principal activity.

After completing his education at the Academy of San Carlos, Ocampo worked as an illustrator at Imprenta y Editorial Cultura, an important state-run publishing house in Mexico City. During his seven years here he produced twenty-eight books.

In 1936 Ocampo joined the LEAR, where he collaborated with other printmakers on an adult literacy project. He also became a member of the TGP, yet unlike many of his colleagues he did not openly support Communism through his work. At the TGP he made prints for posters and other items for public dissemination. He left the TGP in 1940 when a dispute over the pricing of prints caused a schism in the collective. He briefly rejoined the group but left finally in 1944. In spite of this break, the collective included his prints in their 1946 publication *Mexican People* (cat. 119). During his life he exhibited work in Mexico, Europe, North and South America, and contributed to all three shows that the TGP organized in the United States. He also taught in the Escuela de Bellas Artes and the Academy of San Carlos.

A major theme running throughout Ocampo's prints was poverty, but he also tackled issues of international concern such as Fascism. He observed urban life in Mexico and was one of few printmakers to illustrate workers at leisure.

BIBLIOGRAPHY
Ittmann 2006; TGP 1949; Williams et al. 1998.

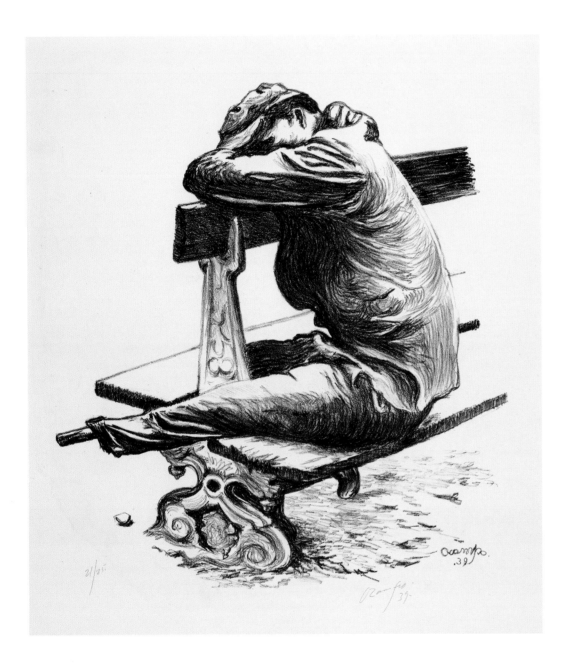

61 ISIDORO OCAMPO
What next?

1939
Lithograph
317 x 293 mm
2008,7114.8
Presented by the Aldama Foundation

A worker with no legs sits on a park bench, resting his head on his arm. During the time when this print was made artists rarely showed workers as individuals, but instead mainly as part of the generalized repressed mass of humanity. Ocampo focuses on a single figure and isolates him against a blank background in order to emphasize his desolation.

Ocampo based this print on a photograph published in 1936 in *Frente a Frente*, the magazine of the LEAR. The photograph, illustrating an article about war and peace, showed a worker with amputated legs. It is not clear to which conflict Ocampo's print refers, since it was made in the year in which the Spanish Civil War ended and the Second World War began. The title *What next?* questions how much more violence and destruction was to come. The print echoes the work of Spanish printmaker Francisco Goya (1746–1828), who would often use single figures to explore the theme of human suffering.

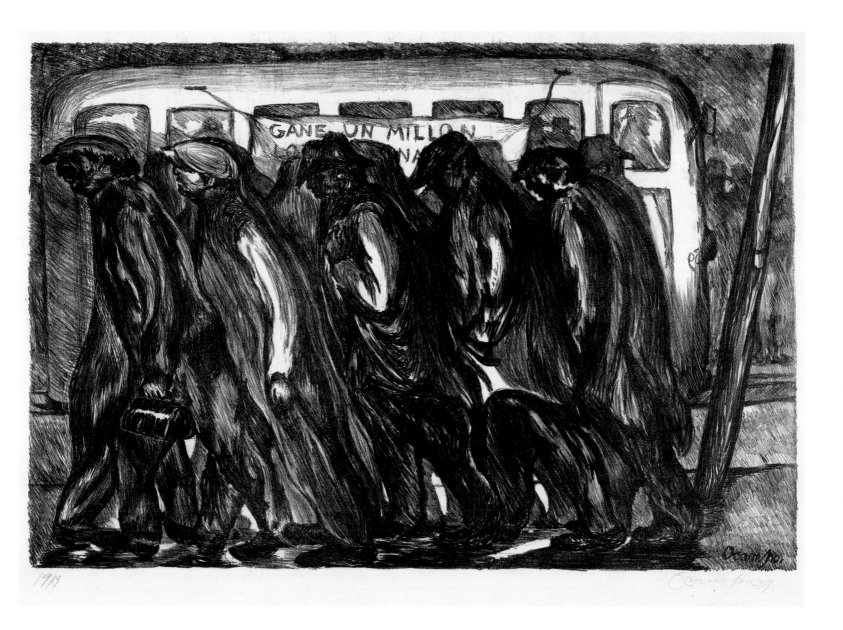

62 ISIDORO OCAMPO

Win a million

(Gane un millón)

1939
Lithograph
335 x 500 mm
2008,7114.7
Presented by the Aldama Foundation

A group of male workers dressed in dark garments walk along a street, some hanging their heads. The telegraph pole on the right and a bus behind them symbolize the modern city. The workers represent the masses who migrated to the cities of Mexico after the Revolution, in the hope of finding work and a brighter future. However, the darkness of the print and the way that the figures are barely distinguishable from each other suggests that they were not successful in their quest, encouraging the viewer to sympathize instead with their situation.

Through the windows of the new bus passing on the other side of the road appear the silhouettes of passengers who belong to the middle classes, who do not have to walk the streets because they can afford to ride on the bus. A banner on the bus reads 'Gane un millón' ('Win a million'), advertising the national lottery. The only hope the workers have of escaping their repressive lives is to buy a lottery ticket. But luck eludes them: the bus travels in the opposite direction and the workers do not so much as recognize the significance of the banner which promises to change their lives. Through depicting citizens travelling in different directions and in different ways, Ocampo thus emphasizes the social divisions in Mexico.

Mercedes Quevedo

All that is known about Mercedes Quevedo is that she was a member of the TGP from 1958 until 1965, and that she worked as a secretary in the Department of Finance, Mexico City, from 1963.

BIBLIOGRAPHY
Prignitz 1981.

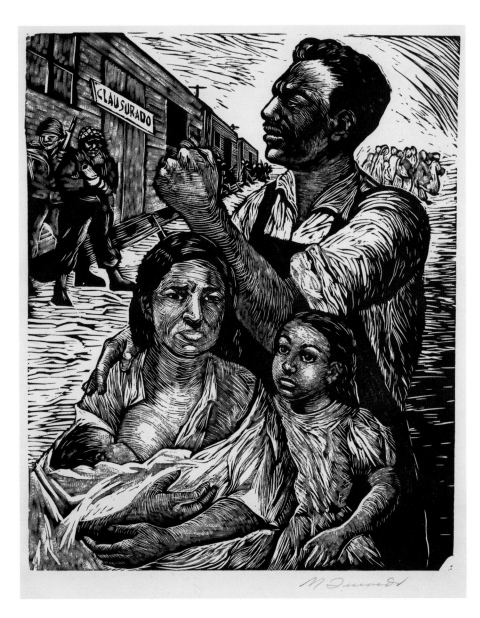

63 MERCEDES QUEVEDO

Family

*c.*1940s
Woodcut
305 x 247 mm
2008,7069.31
Presented by Dave and Reba Williams to the American Friends of the British Museum

This print shows a man raising his fist to defend his wife and children. The woman is suckling a child and looks directly at the viewer. The family are Indians and the man wears worker's overalls. In the background, a row of wooden buildings possibly representing shops are closed, as indicated by the sign nailed to one of the doors that reads 'clausurado' (closed). A soldier with gun and helmet, who has possibly arrested another man, stands on guard outside the abandoned buildings. In the top right-hand corner people are leaving, suggesting that they are being driven out, the effect of which is represented in close detail by the family in the foreground.

Everardo Ramírez 1906–1992

Born into a peasant family, Everardo Ramírez grew up in Coyoacán, a village on the outskirts of Mexico City which has since been absorbed into its urban sprawl. Throughout his life Ramírez lived in this area and his work often focuses on aspects of rural life demonstrating his familiarity with those subjects. At the age of sixteen he entered the Open Air School at Coyoacán. These schools, established after the Mexican Revolution, were one of several government initiatives designed to provide an inclusive education.

Ramírez continued his artistic training at the Centro Popular de Pintura 'Santiago Rebull' in 1930; here he was taught by the printmakers Gabriel Fernández Ledesma, Fernando Leal and Francisco Díaz de León, and Ramírez possibly met Isidoro Ocampo. He later taught here, his students including Jesús Escobedo.

In 1933, with Leopoldo Méndez and Pablo O'Higgins, Ramírez became involved in the founding of the LEAR. With this group Ramírez made prints for *Frente a Frente*, the official magazine of LEAR. He also played a role in establishing the TGP in 1937, but was one of the printmakers who abandoned the collective when a feud over the pricing of prints broke out in 1940.

Whereas the linocuts by Ramírez in this catalogue demonstrate his skill with this technique, he worked mainly in woodcut. His best-known prints were published by the TGP in 1948 in a series called *Vida en mi barriada* (*Life at my city's edge*). This portfolio contained fifteen prints on the subject of life in Coyoacán.

Ramírez also worked with other members of the TGP to make prints for posters addressing political and social issues. In 1967 he began copying prints by José Guadalupe Posada at the Instituto Nacional de Bellas Artes. He was also involved in the organization of an exhibition of children's art in 1968 which coincided with the Mexico City Olympic Games.

BIBLIOGRAPHY
Ittmann 2006; Lozano 1999; Prignitz 1981.

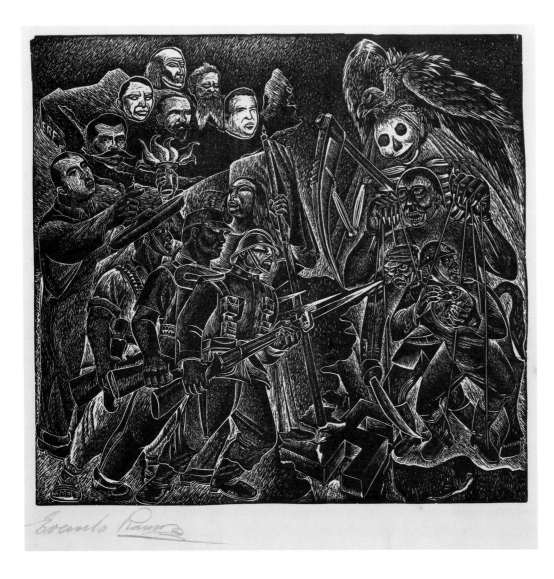

64 EVERARDO RAMÍREZ

The mother country

c.1940

Linocut

243 x 261 mm

2008,7069.35

Presented by Dave and Reba Williams to the American Friends of the British Museum

Probably made early in his time at the TGP, Ramírez's print is a political satire revealing his left-wing attitudes and those of the printmaking collective to which he belonged. The theme is the destruction of Fascism, but it also contains a repertoire of symbols relating to Mexican culture. In the centre of a chaotic scene, an indigenous woman holds a flag in one hand and uses it to crush a swastika on the ground. In her other hand she holds a flaming torch, transforming her into allegory of Liberty.

Following the orders of a man behind them, the three soldiers advance with artillery precision towards two other uniformed officers and a menacing figure with claws who controls them with ropes like puppets. One of the pair wears a flat cap and his ally, who wears a steel hat typical of the German army, clasps a globe in both hands and looks in the opposite direction – indicating the German ambition to possess the world. A skeleton in the background with a vulture perched on its shoulders attacks the moving soldiers with a large pickaxe. In the upper left are the heads of various Mexican leaders, including Emiliano Zapata, Venustiano Carranza, Miguel Hidalgo and Manuel Ávila Camacho, all of whom watch the scene but are separated from it.

65 EVERARDO RAMÍREZ

The refinery

(*El ingenio*)
1935
Linocut
227 x 200 mm
2008,7069.33
Presented by Dave and Reba Williams to the American Friends of
the British Museum

The sugar industry has thrived in Mexico since
the arrival of Hernán Cortés and the Spanish in
the sixteenth century. This print depicts a sugar
refinery and refers to the way in which modern
technology replaced traditional methods of
sugar production.

In the foreground, sugar canes grow in neat
rows. The colossal, muscular man in the centre
represents the Indians who would have worked
on sugar plantations such as this until technology
transformed refining processes. He holds
enormous sugar canes in both hands, which he
has presumably cut from the ground with the knife
fastened around his waist. Two oxen pull a cart past
the modern buildings of the processing plant on
the left. At the right are trains and rails in front of
the electric units, further symbols of encroaching
modernity .

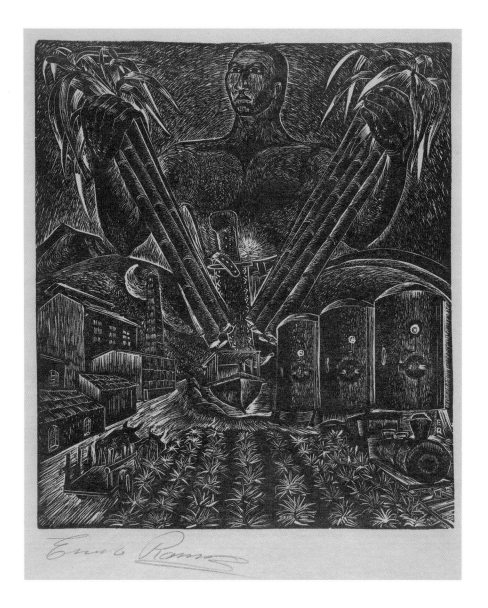

66 ALFREDO ZALCE (for biography see p. 56)

Propaganda

1939
Lithograph
335 x 306 mm
2008,7114.6
Presented by the Aldama Foundation

Propaganda is represented in this print by a bizarre scene of chaos. A head in the form of a megaphone with no other features other than a grimacing mouth rises from a group of modern buildings in the background and rests directly on an amplifier or transmitter. Two planes fly overhead, dropping leaflets, and on the ground screaming mouths attached to contorted bodies run around. These bizarre figures embody the propaganda spread by the planes.

At the left, a group of workers and soldiers laugh and point to the chaos which has been unleashed. They hold tools such as shovels, axes and rakes associated with construction work. Next to them is a pile of guns, some of which point backwards, implying that despite their complacency, the workers too remain under threat.

The distorted bodies in the foreground represent attitudes towards propaganda. The figures are harassed by the propaganda, some covering their eyes to avoid seeing what is being spread. One of the figures wearing a crucifix around its neck might symbolize the reluctance of the Church to listen to propaganda. Another has three eyes, suggesting that the figure does not know where to look as so much propaganda is being spread.

67 ALFREDO ZALCE

The press serving imperialism

(*La prensa al servicio del imperialismo*)
1939
Lithograph.
343 x 303 mm
2008,7114.5
Presented by the Aldama Foundation

Zalce's print addresses the subject of the press manifesting state propaganda controlled by the government. An inflated balloon with a human head and hands floats through the sky. Its body is made from the front pages from Mexican newspapers *Excelsior*, *El Universal*, *La Prensa*, *Novedades*, *Omega*, and *El hombre libre*. To the left of *Novedades*, one of the newspapers has an indistinct title which at first looks like 'Ultimas noticias' ('The Latest News'), yet upon closer examination reads 'Ultimas mentiras' ('The Latest Lies'). It is unlikely to represent an actual publication, but indicates the corrupt nature of the Mexican press as it supports the views of its benefactors.

The figure holds its right hand in a three-finger presidential salute. Around its waist it wears a bullet belt, which had become synonymous with the iconography of the Mexican Revolution, suggesting the role of the press as a weapon in this conflict.

On the ground beneath the balloon a few people gather, looking on and pointing, and one of them operates the pump which inflates the balloon. At the far left a man wearing a crucifix probably represents the control exerted by the Church over the press. The most prominent pump, attached to which is a flag labelled 'aire gratis' (free air), is inscribed with a pound sign, an unusual choice to symbolize capitalism as the dollar was more normally used; this may represent British financial support for the Mexican press in the 1930s.

William Spratling 1900–1967

William Spratling was born in New York. Although he did make several prints during his career, his main contribution to printmaking was through his involvement with the Weyhe Gallery, where he promoted Mexican printmakers such as David Alfaro Siqueiros and Diego Rivera. His skills were many: he worked as an artist, journalist, architectural draughtsman and silver designer. His training, which included architecture and its history, began at the Art Students League before he went on to Auburn University, where he later held a teaching post. He also taught at Tulane University from 1921–9, contributing to architecture programmes. In 1945 he was the subject of a biographical documentary made by Warner Brothers.

Spratling earned his living writing for newspapers and magazines, including the *New York Herald Tribune*; his articles discussed architecture and culture, many of them focused on Mexico. He was a friend of the American writer William Faulkner, with whom he co-authored a book, *Sherwood Anderson and Other Famous Creoles* (1925). During the 1920s he met Carl Zigrosser, then managing director of the Weyhe Gallery. The two men established a lifelong friendship and Spratling became instrumental in coordinating work for the Weyhe Gallery in Mexico.

From 1926 Spratling started teaching summer courses on colonial architecture at the Universidad Nacional de México. He relocated permanently to the small mountain town of Taxco in 1929, one of the first of a number of writers and artists to settle there. His arrival in Mexico was planned to coincide with a Weyhe exhibition in Mexico City organized by Zigrosser, showing prints by European artists such as Gauguin, Picasso and Toulouse Lautrec. Spratling exhibited some of his own prints, along with those of other American artists involved with the gallery, including Alfred Stieglitz. Once established in Taxco, Spratling set about obtaining prints from Siqueiros and Rivera to sell at the Weyhe Gallery, and in 1931 he wrote an article for the *New York Herald Tribune* about Siqueiros, who had moved to Taxco when he was released from prison the previous year. Spratling also used his position to introduce artists and friends to Carl Zigrosser, which is how Caroline Durieux and Carlos Mérida became known by the Weyhe Gallery.

For his own prints, Spratling worked with George C. Miller who printed them in New York. These included the prints for his book *Little Mexico* (1932). He also established a reputation as a silversmith, opening a silver workshop, the Taller de las Delicias, the first of its kind. This ran until 1945, when he went bankrupt; undeterred, he established a new silver workshop just two years later. He also collected archaeological artefacts, some of which he donated to the Museo Nacional de Antropología (National Anthropology Museum) in Mexico City. Spratling died in a car accident in 1967; his autobiography was published posthumously in the same year.

BIBLIOGRAPHY
Ittmann 2006; Oles 1993.

68 WILLIAM SPRATLING

Acuitlapan

1931
Lithograph
162 x 190 mm
2008,7114.19
Presented by Deborah Kiley in memory of Erhard Weyhe

The print shows the village of Acuitlapan, situated near Taxco in the state of Guerrero, south of Mexico City. A simple wooden fence surrounds three thatched huts blending into the mountainous landscape.

The print was made for his book *Little Mexico*, which accounts for the miniature scale of the village, its inhabitants and livestock. Spratling later had the images from the book, including this one, printed as limited editions by George C. Miller in New York.

The Mexican landscape in this print is not typical of the way in which foreign artists tended to represent Mexico. Spratling's work is more abstract than that of his contemporaries such as Leon Underwood and Howard Cook.

Spratling 21/35

Howard Cook 1901–1980

Howard Norton Cook was born and raised in Springfield, Massachusetts. Upon completing his school education in 1918, he won a scholarship to attend the Art Students League in New York, where he studied for four years. After a trip to Europe in 1922, he returned to the Art Students League to study etching with the American artist Joseph Pennell (1857–1926), and also began learning about the woodcut technique. He made his first lithographs during a trip to Paris in 1929, demonstrating his willingness to work with different printmaking methods. 1928 proved to be an important year in Cook's career: he met Carl Zigrosser in New York and formed a life-long link with the Weyhe Gallery which sold and promoted much of his work. From 1930 he worked with George C. Miller, who printed his New York series.

Travel was a major part of Cook's life. A year after visiting Europe he spent time in the Far East, where his appetite for adventure was further aroused. Two years later he set off for Istanbul, Malta and France, ending up in Paris. In 1926 his travels took him to the Panama Canal, where he sailed as a quartermaster on the New York to San Francisco route. He then travelled to the village of Taos in New Mexico where he met the artist Barbara Latham, whom he later married. Cook travelled extensively in the United States, often by car, making his most notable trip to the American South in 1934 on the second of two Guggenheim fellowships.

It was his first Guggenheim fellowship, awarded in 1932, that enabled him to live and work in the small town of Taxco in Mexico for eighteen months. Here he made prints showing aspects of life in this rural village. Several of these received prizes, including the John Taylor Arms Prize awarded by the Society of American Etchers for *Mexican interior* (cat. 70), and an Honourable Mention from the Philadelphia Print Club for *Acapulco girl* (cat. 69). In Taxco he painted his first fresco, depicting a lively fiesta at the Hotel Taxqueño. From that point he turned his attention to mural painting rather than printmaking.

Cook exhibited in the United States where he also worked as an illustrator for the magazines *Forum* and *Colliers*. During the Second World War he worked as an illustrator for the forces in Norfolk, Virginia, and later in the South Pacific. In 1956 he became ill but it was not until 1963 that he was diagnosed as suffering from Multiple Sclerosis. He was confined to a wheelchair for the last ten years of his life.

BIBLIOGRAPHY
Duffy 1984; Ittmann 2006.

69 HOWARD COOK

Acapulco girl

1932
Wood-engraving
255 x 203 mm
2008,7114.13
Presented by James and Laura Duncan

This striking image shows an Indian girl wrapped in a light shawl, standing in front of a large palm tree with a village of small, neatly arranged huts in the background. The broad forms and smooth surfaces of the print suggest the technique of fresco painting with which Cook was experimenting for the first time during his trip to Mexico in 1932. Similar to the aims of the Mexican muralists – particularly Diego Rivera – Cook's depiction of an Indian girl serves to highlight Mexico's often forgotten indigenous cultures. The significance of the rope around her right hand is not obvious but might refer to the hardship of agrarian work.

Made during Cook's visit to Mexico on his first Guggenheim fellowship, *Acapulco girl* received an Honourable Mention from the Philadelphia Print Club two years later. It is also one of the few examples of wood engraving from this period that demonstrate Cook's particular skill with this technique, while also reflecting his American training.

70 HOWARD COOK

Mexican interior

1933
Etching
270 x 412 mm
2008,7114.14
Presented by James and Laura Duncan

Set inside a Mexican home, the main subject of the print is the family. Of the interior only the stone floor, cooking utensils and a collection of decorated ceramic pots hanging on the wall are visible. These provide props for the domestic context. There is a hint of the sepia photograph about the gradations of shading and the family portrait style of the composition.

A striking aspect of the print is its stillness, an effect that Cook achieves through the use of folds in the garments and the contrast of dark and light evoking the monumentality of sculpture. The huge feet and pensive expressions of the figures underscore their statuesque forms; the standing girl on the left is frozen in motion, her hands positioned above a large ceramic pot. Their stillness, however, is punctuated by the faint outline of a mariachi musical group in the background, a symbol of Mexican popular culture.

The print's sensitive representation of an indigenous family made it an instant success: within a year it had been awarded the Society of American Etchers' John Taylor Arms Prize and the Philadelphia Art Alliance Prize Print Award.

Leon Underwood 1890–1975

Born in London, George Claude Leon Underwood was a British painter and collector who throughout his career made prints. At the age of twenty he enrolled at the Royal College of Art where he probably studied sculpture until about 1913; he then set off travelling in pursuit of inspiration for his art. His travels took him to Poland, Turkey, West Africa and Mexico. He also served in France during the First World War.

In 1921 Underwood established the Brook Green School of Art, where he taught life-drawing; among his students was Henry Moore (1898–1986). The school remained active until 1954, instructing students in art theory, history and technique, including wood engraving. The philosophy of the school was underpinned by Underwood's interest in Primitivism, which was reflected in his collection of African Art and his book *Art for Heaven's Sake* (1934).

Underwood visited Mexico in 1928, inspired by the drawings of British artist Frederick Catherwood who had accompanied the American writer John Lloyd Stephens on an expedition to the ancient Mayan cities in Mexico, including Chichén Itzá, in the 1850s. Underwood travelled with an American writer, Phillips Russell, and the pair retraced the steps of Lloyd Stephens and Catherwood. They also published a travel narrative, *The Red Tiger: Adventures in Yucatán and Mexico* (1929), which included illustrations by Underwood. Based on drawings that he made as he travelled, his Mexican prints were made in London on his return.

Underwood also documented his Mexican journey in *The Island*, the journal of art and literature which he co-founded in 1931 with Joseph Bard, a Hungarian poet and an expatriot in Britain. Underwood designed the covers for the journal.

BIBLIOGRAPHY
Jeffrey 2001; Ittmann 2006; Neve 1974.

71 LEON UNDERWOOD

Woman and child, Tehuantepec

1928
Wood Engraving on Japanese paper
265 x 151 mm
2008, 7086.1
Presented by the Aldama Foundation

Tehuantepec is a town in the state of Oaxaca, southern Mexico. Populated by Zapotec Indians, Tehuantepec is particularly well known for its matriarchal social system, setting it apart from mainstream Mexican culture which is predominantly patriarchal. The town and its people have been a constant source of inspiration to artists and writers enchanted by its exotic appeal. In particular, the landscape, customs, costumes and food have encouraged artists to return to Tehuantepec.

Underwood did not make any prints in Mexico and this print was made from a drawing when he returned to London. A girl stands on tiptoe to reach up to a woman, probably her mother. The mother wears a typical Zapotec dress with a frill border and simple embroidery on the bodice, and carries a bowl of fruit on her head and another beneath her arm. With its landscape of palm trees, Indians and fruit, the image exemplifies how foreign artists conceived of what they saw as the exotic aspects of Mexico.

72 LEON UNDERWOOD

Woman of Tehuantepec

1928
Wood-engraving
153 x 254 mm
1996,0929.7

From the series that Underwood made when he returned to London after time in Mexico, this print represents a reclining woman from Tehuantepec. Whereas other prints showing women identify their sitters, such as those by Diego Rivera (cats 25 and 26), in Underwood's print the woman is simply described as 'a woman of Tehuantepec'. She wears traditional Zapotec clothing on which Underwood uses fine hatching to emphasize the embroidery. She holds a piece of fruit in one hand and rests her head on the other, a patch of bright light illuminating her figure, possibly suggesting her emancipated status. Her curvaceous body is reminiscent of sculpture and was probably influenced by Underwood's own collection of African art. The expressive lines of the print also echo the work of Underwood's contemporary, Henri Matisse.

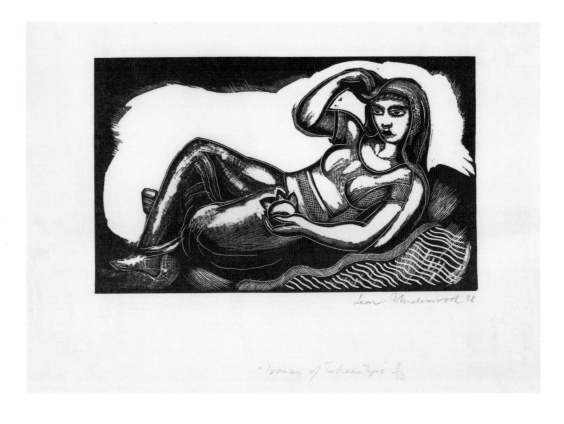

73 LEON UNDERWOOD

Mexican Fruit

(*Frutas mexicanas*)
1929
Wood-engraving
135 x 195 mm
1991,0615.179

A carefully arranged basket of fruit placed on a balcony dominates the view of the town beyond. The assortment includes bananas, pineapples, squash, apples and oranges: although familiar to us today, when this print was made the fruit would have been regarded as exotic. Pineapples were often a sign of hospitality, here suggesting the welcoming nature of Mexico.

The architectural detail of the balcony and surrounding buildings provides information about Mexican towns. The simple geometric architectural form with decorative flourishes suggests a colonial town, characteristic of those that rose in Mexico after the Conquest during the fifteenth and sixteenth centuries.

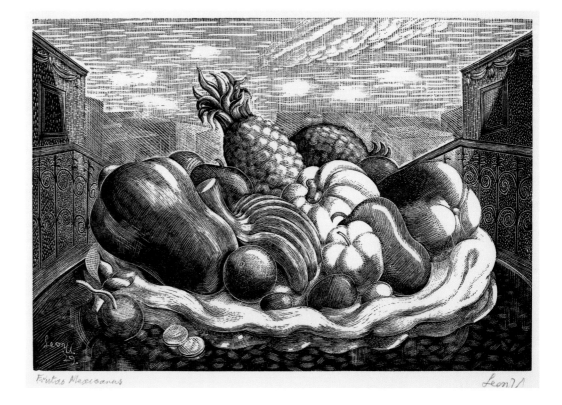

Ángel Bracho 1911–2005

Ángel Bracho was born in Mexico City, the son of an army officer and a peasant woman. He spent only four years in primary education before having to start earning a living. His jobs included helping a butcher, working as a barber and later driving buses. He also painted furniture, which may have encouraged him to become an artist. In 1928 he joined the San Carlos Academy in Mexico City where he began taking night-classes designed especially for workers, and from 1929 until 1934 he studied there full time, specializing in drawing and painting.

On leaving the Academy Bracho began to paint murals at the Abelardo Rodríguez market in Mexico City. He became a drawing teacher in 1935, a skill he put to use when he participated in the cultural missions organized by the Ministry of Culture. The aim of the cultural missions was to share art with the rural population through public mural paintings and education programmes. Bracho taught drawing in the states of Oaxaca in the south, Nayarit and Sinaloa, both on Mexico's central west coast, and Baja California on a peninsular in the north of the country.

From 1933 to 1938 Bracho was a member of the LEAR, and he was one of the first artists to join the TGP when it was founded in 1937. Here he made his first lithograph, and was appointed Director in 1952–3 and President in 1961–3. The most important work he published at the TGP was the *Ritual of the Huichol Indian Tribe* (1940), a portfolio of prints about an indigenous community that had maintained a traditional lifestyle despite the imposition of Christianity in Mexico in the fifteenth and sixteenth centuries.

Bracho continued to form professional associations with other artists throughout his career. In 1948 he joined the Sociedad para el Impulso de las Artes Plásticas (Society for the Mobilization of the Visual Arts) where he worked with artists such as Francisco Dosamantes. He won a gold medal in 1960 at the Buenos Aires Biennial, and in 1979 the Casa de Cultura (Cultural Centre) of the state of Michoacán in central Mexico organized an exhibition to honour his forty-two-year commitment to the TGP.

BIBLIOGRAPHY
Adès 1989; Covantes 1982; Prignitz 1981; Ittmann 2006; Williams et al. 1998; Tibol and Arceo 1987.

74 ÁNGEL BRACHO

Victory

(*¡Victoria!*)
1945
Lithograph
744 x 530 mm
2008,7073.15
Presented by the Aldama Foundation through The Art Fund

With a bold headline in bright red lettering, this poster celebrates victory over the Nazis at the end of the Second World War. At the bottom of the print is the phrase 'destrucción total del fascismo' ('complete destruction of Fascism'); above this the black type indicates that the TGP, the workers and all those who fought for progress in Mexico were delighted by the victory of the Red Army and the Allies against Hitler's regime. The victorious forces are represented by the flags of, from left to right, the United States, the Soviet Union and Great Britain. The Soviet flag is the most prominent, suggesting that the TGP supported the Red Army in particular.

The triumph is represented in the print through the striking colour combination. In the centre is a German helmet with Hitler's head on it, a bayonet poking through one of his eye sockets. This lies among the debris of war, including parts of weapons, a swastika and a classical column. Flames rage all around this pile of rubbish, creating a scene of Hell. In the upper left the rays of light suggest that a new day has dawned.

¡VICTORIA!

Los artistas del Taller de Gráfica Popular nos unimos al júbilo de todos
los trabajadores y hombres progresistas de México y del Mundo por el
triunfo del glorioso Ejército Rojo y de las armas de todas las Naciones
Unidas sobre la Alemania Nazi, como el paso más trascendente para la

DESTRUCCION TOTAL DEL FASCISMO

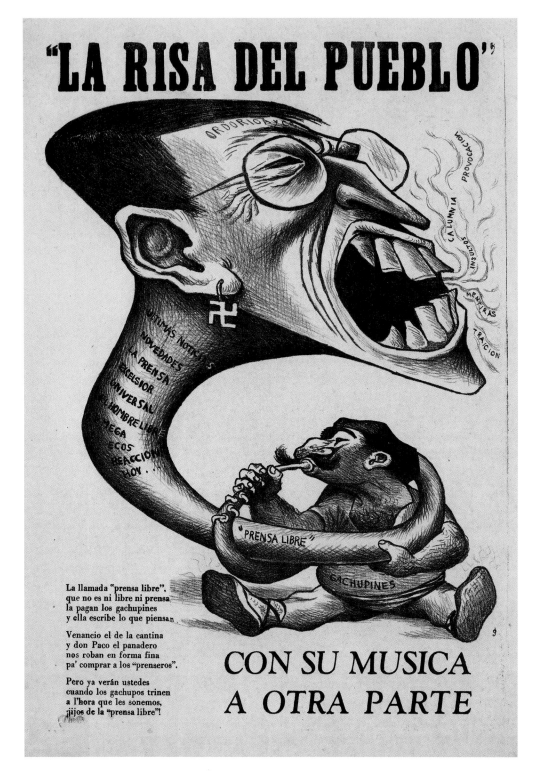

75 JOSÉ CHÁVEZ MORADO (for biography see p. 58)

The laughter of the public – away with your nonsense

(*La risa del pueblo. Con su musica a otra parte*)
1939
Lithograph
575 x 355 mm
2008,7073.5
Presented by the Aldama Foundation through The Art Fund

This print satirizes the Mexican press. A small, stout man with a moustache labelled 'gachupines' sits on the ground blowing the mouthpiece of a horn. *Gachupín*, a word with negative connotations, is used in Mexico to describe foreign immigrants, especially Spaniards living in Mexico, and has been used since the time of the Spanish Conquest in the sixteenth century. He blows a horn labelled 'prensa libre' ('free press'), yet the rhyme in the bottom left-hand corner of the print suggests that the press was anything but free. Blowing in to the horn, it is the *gachupines* who control the content of the press.

A number of Mexican daily newspapers, all of them pro-Franco, are listed on the neck of the pipe. The head acting as the bell represents the editor Miguel Ordorica, whose name is emblazoned across his forehead. He wears a swastika earring to demonstrate his support for Fascism. Spitting from his mouth are the words 'provocación' ('provocation'), 'calumnia' ('slander'), 'insultos' ('insults'), 'mentiras' ('lies') and 'traición' ('treachery'), describing the attitudes of the TGP towards the foreign-controlled press. In 1939 there were campaigns in Mexico against Franco's supporters in which many journalists participated. This poster clearly supported their cause.

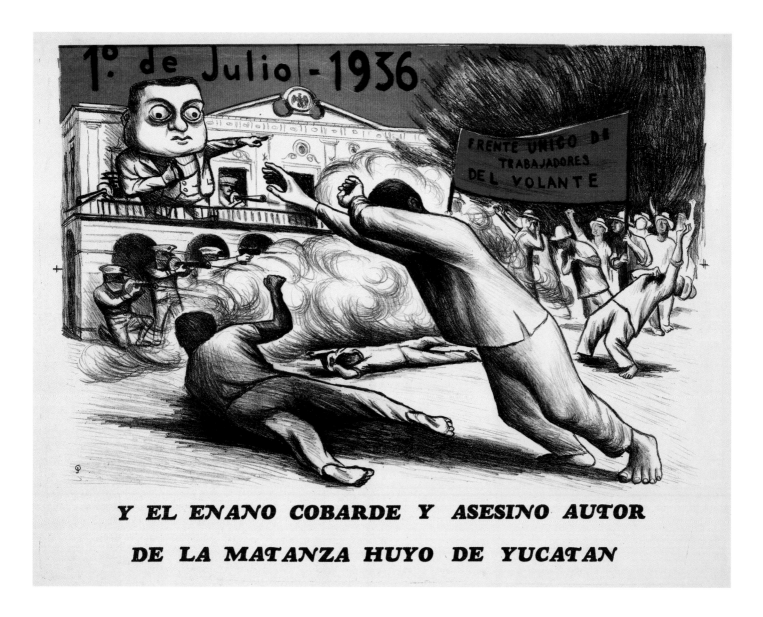

76 JOSÉ CHÁVEZ MORADO

1 July 1936: the cowardly dwarf and author of the assassinations fled Yucatán

(1o de julio 1936 y el enano cobarde y asesino autor de la matanza huyo de Yucatán)

1938

Colour lithograph

460 x 580 mm

2008,7073.11

Presented by the Aldama Foundation through The Art Fund

A puffed-up man representing the State Governor stands on the balcony of a building as soldiers from inside shoot rifles at the protestors gathered in the square. The colonial building with an elegant façade is the town hall of Mérida, the capital of Yucatán. Pointing his finger towards the demonstrators, it is the Governor who calls for the soldiers to fire on those in the square. This is highlighted by the words at the bottom of the print, 'asesino autor' ('author of the assassination'). In the square, protestors fall to the ground and the violence of the scene is accentuated by blood on their shirts. They hold a banner bearing the slogan 'Frente unico de trabajadores del volante' ('United Front of Taxi Drivers'), identifying their occupation.

The print commemorates an actual event: on 1 July 1936 taxi drivers in the city of Mérida staged a protest which ended in violence when soldiers were ordered to fire at the demonstrators, some of whom were killed. The State Governor instigated the attack but fled after the event, hence the description of him as a cowardly dwarf. Made at the TGP two years after the event, it shows the TGP's awareness of political atrocities and highlights members' sense of solidarity with workers. The print is also an important example of featuring a regional rather than a national demonstration.

LA ENTRADA TRIUNFAL

DEL GENERALISIMO

77 JESÚS ESCOBEDO (for biography see p. 110)

The General's triumphant entrance

(*La entrada triunfal del Generalisimo*)
1940
Lithograph
670 x 440 mm
2008,7073.7
Presented by the Aldama Foundation through The Art Fund

In 1940 General Juan Andreu Almazán ran in the Mexican presidential election as leader of the right-wing and conservative Revolutionary Party of National Unification. He was beaten by the Mexican Revolutionary Party (PRM) candidate Miguel Ávila Camacho, who became President for a statutory six-year term (1940–46). This representation of General Almazán, his arm raised in the Fascist salute, deliberately casts him in the guise of General Franco, Spain's dictator, as a warning of what might have happened had he won the election. His clothes are decorated with swastika, dollar and skull-and-bone symbols, branding him a capitalist and a Fascist. The word 'Huertismo' sewn on to the pocket to which his medals are pinned links him to the Mexican dictator Victoriano Huerta, who in 1913 took the Mexican presidency by force.

Almazán holds a decanter of tequila in his right hand and pours it in to the mouth of a bound peasant holding a placard bearing the words '¡Bienvenido Emperador Almazán!' ('Welcome President Almazán'), referring to his attempts to coerce the poor classes through whatever means necessary. In the background is a scene of disorder: a man vomits as others behind him swig from bottles, referring to the social unrest in Mexico following Camacho's victory over Almazán in the presidential race. With support from Catholics, peasants and the middle classes, Almazán was the favoured candidate. However, he lost much support when international Fascism engulfed Europe and the then Mexican President, Lázaro Cárdenas, declared Mexico neutral, an action which made the Mexican people wary of Almazán and his right-wing attitudes.

Arturo García Bustos b.1927

Arturo García Bustos was born in Mexico City where he remained throughout his childhood and early adult years. He began his training as an artist in 1941 at the Escuela Nacional de Artes Plásticas (National School of Visual Arts). The following year, he entered the painting and sculpture school, La Esmeralda, in Mexico City where he worked with Frida Kahlo. At the same time he took courses on architecture at the Escuela Nacional Preparatoria, also in Mexico City, and decided then to focus on painting and printmaking.

García Bustos was involved with various artists' groups. At the age of eighteen he founded the Grupo de Artistas Jóvenes Revolucionarios (Young Revolutionary Artists Group) with Arturo Estrada and Guillermo Monroy, two artists he had befriended at La Esmeralda. With Fanny Rabel (1922–2008), the three young artists became known as 'Los Fridos' as they followed Frida Kahlo, their teacher, to her hometown of Coyocán when her poor health made it impossible for her to continue teaching at La Esmeralda.

In 1945 García Bustos became a member of the TGP, where he learnt lithography from Leopoldo Méndez and Pablo O'Higgins. He joined the workshop at around the same time as Alberto Beltrán (1923–2002), Mariana Yampolsky (1925–2002) and Elizabeth Catlett (b.1919), who represented the new generation of printmakers there. In 1949 he co-founded the Salón de la Plástica Mexicana (Salon of Mexican Plastic Arts) where he worked with Amador Lugo.

Teaching and travelling were important aspects of García Bustos's professional life. He taught printmaking at the Escuela Nacional de Bellas Artes of Guatemala City from 1953, and while there he founded the Taller de Grabado (Print Workshop). By 1956 he had returned to Mexico where he was a teacher of fine arts in the Benito Juárez University of Oaxaca. He left for Korea a year later, where he attended printmaking classes with Korean master printmaker Wang Yong Ja. This was followed by an apprenticeship in China, and later that year he travelled to Moscow for the World Festival of Youth.

During his career García Bustos gathered numerous accolades, including first prize in a competition organized by the National Autonomous University of Mexico (UNAM) in 1947. He painted many murals and his most significant fresco is probably at the Museo Nacional de Antropología (National Anthropology Museum) in Mexico City, *Pobladores de las siete regiones de Oaxaca* (*Inhabitants of the seven regions in Oaxaca state*, 1964). He is married to the Guatemalan painter Rina Lazo, with whom he shares a studio in Coyoacán, a suburb in the south of Mexico City. Their house is famous because La Malinche, who betrayed the Aztecs at the time of the Spanish Conquest, lived there in the fifteenth century.

BIBLIOGRAPHY
Covantes 1982; Ittmann 2006; Morales 1992; Prignitz 1981; http://blancoartcollection.org/category/rina-lazo/

78 ARTURO GARCÍA BUSTOS

28 Years of fight against imperialism

(*¡28 años de lucha contra el imperialismo!*)
1947
Linocut
670 x 440 mm
2008,7073.6
Presented by the Aldama Foundation through The Art Fund

This protest poster supports the twenty-eight-year fight of the Mexican Communist Party against the forces of imperialism. A giant peasant wearing a large sombrero raises a clenched fist; in his other hand he holds a machete to cut off a pair of hands, one of which is labelled 'imperialismo' ('imperialism'). The hands symbolize the violence attached to imperialism. The peasant's face is covered by banners held by a group of protestors forming his torso; these are workers, some of them carrying axes and others waving their fists to indicate the intensity of the protest, which is also emphasized by the dense hatching of the print. A pair of hands reaches out towards the word 'Mexico' just beyond their grasp, indicating that the Mexican nation could become free from imperialism but still has a long way to go before this could be achieved.

79 LEOPOLDO MÉNDEZ (for biography see p. 62)

Tram workers fight for the benefit of the public

(Los tranviarios luchan en beneficio de todo el pueblo)

1943

Linocut

635 x 870 mm

2008,7073.8

Presented by the Aldama Foundation through The Art Fund

In the 1940s Mexico's tram system was in an abysmal state: although more passengers were travelling by tram, their capacity had not increased and there were fewer trams running than in the first decade of the century. According to the poster, the main company responsible for running and maintaining Mexico's tram network, La Compañia de tranvías de México, is accused of keeping all the profits without reinvesting in the services for the public. The picture of a seated man stuffing dollar coins into his mouth in the centre of the poster represents the greed of foreign businessmen responsible for running and maintaining the tram network. As a consequence, tram travel had become unsafe for passengers, drivers and pedestrians. Tired of such exploitation, the tram workers lobbied the government to set up an inquiry into the system and the poster advertises the results.

Engineers, economists, lawyers and transport technicians worked on the inquiry and argued that Mexico City needed a more efficient tram service, that investment was necessary to improve capacity and safety, and that travel could be made cheaper.

The main conclusion of the inquiry was that if the company did not invest in the network, then the government would nationalize it. Despite the benefits of a publicly owned company, this would inevitably lead to job losses and families would lose their homes as a result. In the bottom right-hand corner of the poster, the picture with the inscription '4000 hogares sin pan' ('4,000 homes without bread') shows a mother seated at an empty table, her head in her hands, while her child stands waiting for food.

The tram company continued to generate enormous profits but workers received no pay increase, despite their campaigning. The image in the bottom left-hand corner of the poster refers to this, using the metaphor of hands inscribed with the amounts 5 and 10 *centavos*; the extra payment the workers had asked for but did not receive.

Francisco Mora 1922–2002

Born in Uruapán, a small town in the central Mexican state of Michoacán, Mora was the son of a musician and a weaver. At primary school he demonstrated his talent for art by decorating the school walls. From 1933 to 1935 he attended the Technical School of Industry in Morelia, the state capital of Michoacán, and then moved to a regional rural school for the next four years, where he began drawing and painting. In 1940 he won a scholarship to paint a portrait of the State Governor, which enabled him to enrol at the art school of the Universidad de San Nicolás de Hidalgo in Morelia.

Mora moved to Mexico City in 1941 and shortly after his arrival won a scholarship to study at the art school La Esmeralda, where he was a pupil of Diego Rivera. He joined the TGP in the same year, and remained a member of the collective until 1965, contributing to exhibitions and publications. It was his involvement with the TGP that encouraged Mora to produce art focusing on social justice: he made posters for trades unions and prints for government campaigns against illiteracy. In 1945 the Association of American Artists commissioned him to produce a series of lithographs about mining, and in order to accurately depict their working conditions Mora spent some time in the mines. In 1947 he became a teacher of adult evening classes in Mexico City organized by the Ministry of Education.

During the 1950s and 1960s Mora began to exhibit his work in Mexico and abroad. In the early 1960s he travelled widely, visiting China, Mongolia, the Czech Republic, the Soviet Union and the Republic of Guinea in West Africa. His trip to the Republic of Guinea had a great impact on his work and he subsequently used African art as his main source of inspiration. In 1973 he was invited by the governments of East Germany and the Czech Republic to tour Europe, including visits to Holland, France, Belgium and the United Kingdom.

Mora was a founding member of the Salón de la Plástica Mexicana (Salon for Mexican Visual Arts) in 1968 and previously had a similar affiliation with the Frente Nacional de Artes Plásticas (National Front for the Visual Arts). In 1975 he received a medal from the Academia Mexicana de la Educación (Mexican Education Academy), of which he was a member. He married the African-American artist Elizabeth Catlett in 1947; the couple both had studios at their home in Cuernavaca, south of Mexico City.

BIBLIOGRAPHY
A Courtyard Apart 1990; Williams et al. 1998; *Presencia c.*1976; TGP 1949.

80 FRANCISCO MORA

Free the political prisoners taken on 1 May 1952

(*Libertémos a los presos políticos del 1º de mayo 1952*)
1953
Linocut
672 x 935 mm
2008,7108.5
Presented by he Aldama Foundation

Mora made this poster at the TGP for the National Proletariat Front for the Defence of Political Prisoners and the Persecuted. In Mexico, as in other countries, Labour Day is observed on 1 May and is marked by rallies and parades to commemorate the formation of workers' unions. Presumably the events of Labour Day in 1952 led to the unjust imprisonment of protestors; this poster demands their release. The man wearing a suit illustrated here reinforces the notion of freedom, his outstretched arm breaking through the lettering. He stands in front of a banner that serves as a symbol of protest, his action suggesting the urgency of this campaign, emphasized by the bold, black typeface.

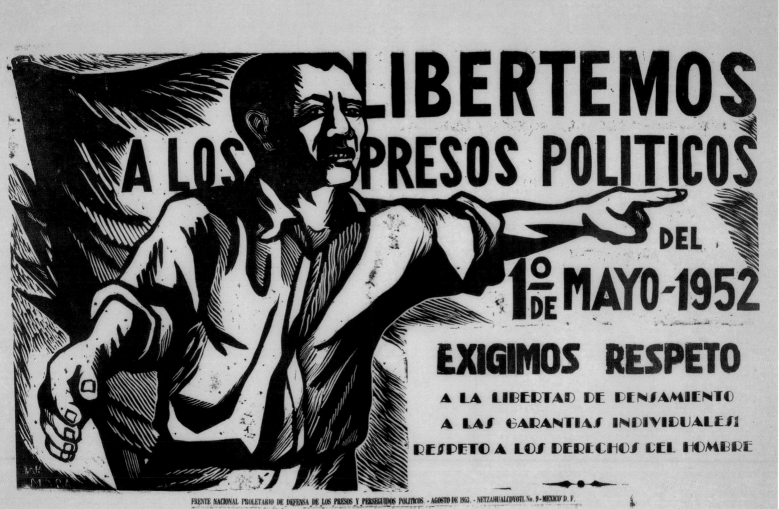

81 ISIDORO OCAMPO (for biography see p. 123)

Facism. The Japanese Fascist

(*El Fascismo. El Fascismo japonés*)

1939

Lithograph

435 x 595 mm

2008,7073.12

Presented by the Aldama Foundation through The Art Fund

A bespectacled man with a spider's body dominates this print. He represents Hirohito, the Japanese emperor who called for Japan's involvement in the Second World War; it also refers to Hirohito's invasion of China in 1937.

The poster employs the motif of Hirohito to advertise a seminar on the subject of Fascism in Japan which was planned for Friday 9 July 1938 at the Fine Arts Palace in Mexico City. The speaker was Daniel Cosío Villegas, an important Mexican

economist. This was one of several posters made by artists at the TGP to publicize the seminar series organized by the Liga pro cultura alemana en México (League for German Culture in Mexico). Some of the seminars focused on Fascism in different countries, such as Latin America, Spain, Italy and Germany, while others were thematic, including such topics as Anti-Semitism and how to fight Fascism.

Pablo O'Higgins 1904–1983

Pablo (Paul) O'Higgins was born in Salt Lake City, Utah, where he grew up with his parents, a lawyer and a farm worker. Because of his father's work he also spent time San Francisco and in San Diego, where his parents had a ranch in El Cajón. O'Higgins enrolled at the art school there but left after two weeks in order to study independently; he supported his education by working as a topographer's assistant. One of his teachers, Miguel Foncerrado, invited him to Guaymas, a port city in northern Mexico.

It was around this time that O'Higgins learnt about Diego Rivera's mural project at the National Preparatory School in Mexico City and he wrote to the artist asking for work. In 1924 he left for Mexico where he became Rivera's assistant on the murals at the National School of Agriculture in Chapingo and at the Ministry of Education in Mexico City. He worked with Rivera until 1927 before going to the state of Durango to take part in the government's cultural missions project, teaching rural communities about national ideologies using art as a didactic tool. In the same year O'Higgins joined the Mexican Communist Party, a decision which may have influenced his decision to go to the Soviet Union in 1931 to study for a year at the Moscow Academy of Art.

Upon his return to Mexico, O'Higgins painted his first mural in 1933 at the Emiliano Zapata School; shortly afterwards he became lead artist on the fresco panels at the Abelardo Rodríguez market in Mexico City. At the same time he worked at the Museum of Industry as Sub-director of the Graphics Department. Throughout his career he continued to paint murals on public buildings in both Mexico and the United States. His most notable work is probably the pre-Hispanic themed mural at the National Anthropology Museum in Mexico City (1963–4).

O'Higgins was a founding member, with Leopoldo Méndez, of the LEAR in 1934; with their contemporary, Luis Arenal, they then went on to establish the TGP in 1937, and O'Higgins continued to be a member until 1960. At the TGP he contributed to exhibitions and made prints for posters advertising anti-Fascist conferences in Mexico City. Other prints were less overtly political, focusing instead on aspects of Mexican daily life, such as *The breakfast* (cat. 99).

His commitment to fighting Fascism led him to return to the United States for a short time in 1945 with the intention of joining soldiers at the shipyards during the Second World War, but he was quickly enlisted to paint murals. In 1949 he co-founded of the Sociedad para el Impulso de las Artes Plásticas (Society for the Mobilization of the Visual Arts). O'Higgins resided in Mexico for most of his career, but in 1968 travelled to Europe and visited the Soviet Union, where he gave classes on fresco painting.

BIBLIOGRAPHY
Adès 1989; Ittmann 2006; Williams et al. 1998; Poniatowska and Bosqués 1984; TGP 1949.

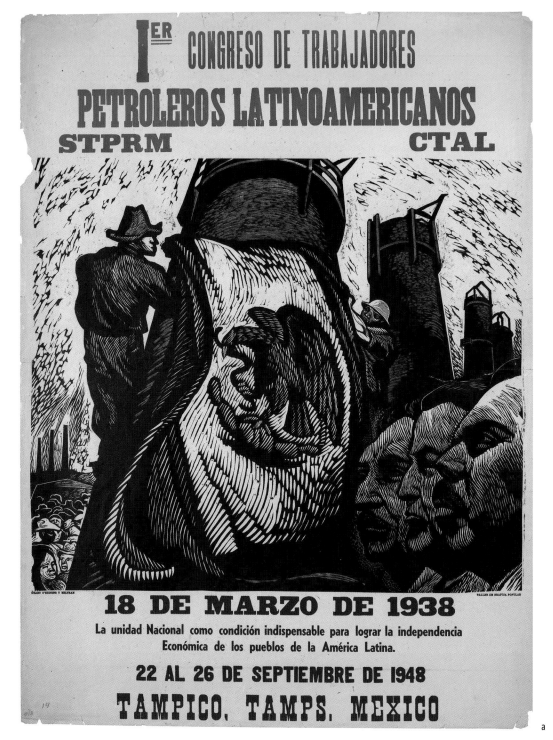

82a PABLO O'HIGGINS AND ALBERTO BELTRÁN
(for biography of Beltrán see p. 70)

1st congress for workers of the petroleum industry in Latin America

(*1er congreso de trabajadores petroleros Latinoamericanos*)
1948
Linocut
930 x 660 mm
2008,7073.2
Presented by the Aldama Foundation through The Art Fund

82b PABLO O'HIGGINS AND FRANCISCO MORA
(for biography of Mora see p. 148)

4th C.T.A.L. Congress, Santiago, Chile, 22–29 March, 1953

(*IV congreso de la C.T.A.L. Santiago de Chile. 22–29 marzo 1953*)
1953
Linocut
930 x 660 mm
2008,7073.1
Presented by the Aldama Foundation through The Art Fund

These two prints were made at the TGP and refer to trades union congresses. In the first, O'Higgins and Beltrán advertise the first congress for workers of the petroleum industry in Latin America with a title in green lettering across the top. The acronyms STPRM and CTAL stand for Sindicato de trabajadores petroleros de la república mexicana (Syndicate for Petroleum Workers in the Mexican Republic) and Confederación de trabajadores de América Latina (Confederation of Latin American Workers). Red lettering along the bottom of the print informs us that the congress was to take place on 22–26 September 1948 in Tampico, a city in the state of Tamaulipas on Mexico's west coast.

The image shows a petrol refinery where two workers fasten a Mexican flag to one of the towers. This symbolizes the nationalization of the Mexican oil industry which took place during the presidency of Lázaro Cárdenas, on 18 March 1938, a date which is referred to in red letters beneath the image. Before nationalization foreign investors owned the oil companies and received huge profits; subsequently, the Mexican government was able to invest the profits in national development. More workers are gathered for the occasion in the bottom left-hand corner of the print and in the distance there is a factory with three chimneys. In the right-hand corner are the profiles of three Mexican presidents: from left to right, Lázaro Cárdenas, Miguel Ávila Camacho and Miguel Alemán. The slogan in red at the bottom beginning 'La unidad Nacional...' urges nationalization of industries in Latin America as a means of securing economies that are free of foreign investment.

The second poster, by O'Higgins and Mora, publicizes the congress of the CTAL which took place in Santiago, Chile, on 22–29 March 1953. This shows workers, including a miner in the foreground, marching with banners with the words 'independencia nacional' ('National independence'), 'paz' ('peace'), and 'PAN', the acronym of the National Action Party; these words are repeated in the slogan at the bottom of the poster, and call for workers to unite to support these causes. In the background are pylons and hills locating the protest at an industrial site.

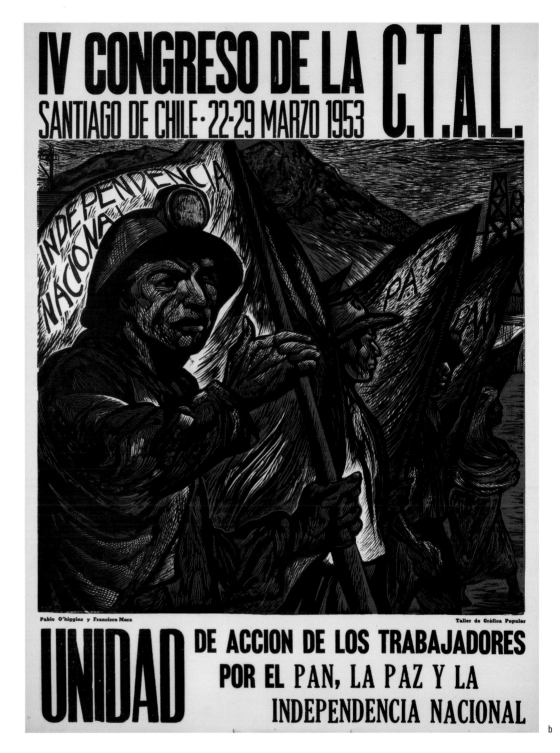

b

Una banda de rufianes
la del Automóvil Gris,
que tantos robos hizo antes
vuelve de nuevo a salir.

No son revolucionarios
ni mexicanos siquiera:
son sólo unos mercenarios
que se alquilan a cualquiera.

Don Pablo va a la cabeza
y lo sigue León Ossorio,
Iturbe y Bolívar Sierra
en ridículo jolgorio.

Son bribones chantagistas
que viven de cosas ruines,
sirviéndole a los callistas
y estafando gachupines.

83 PABLO O'HIGGINS

The joke of the nation: the return of the grey automobile

('*La risa del pueblo'. El retorno del 'Automóvil gris*')
1939
Lithograph
405 x 555 mm
2008,7073.13
Presented by the Aldama Foundation through The Art Fund

El *Automóvil Gris* is the title of a silent film, made in Mexico in 1919, about a notorious gang who drove around in a grey car carrying out murders and abductions. Set in Mexico in 1915, the film portrays the terrorized upper classes. In this print, four bandits ride in an open-top grey car similar to the 'automóvil gris' of the film. Having just ransacked a building and leaving a woman lying on the ground outside, the gang drives away. The print should be regarded not as an advertisement for the film but a political statement. It is a satirical print, the title *La risa del pueblo* suggesting that what is presented is laughable. The verse in the bottom left-hand corner underscores this sentiment, pointing out that the grey automobile gang, who are cheats and swindlers, have returned.

The man wearing a hat and sitting on the front of the car represents Pablo González, a nationalist who supported Venustiano Carranza, the revolutionary leader responsible for the 1917 Constitution who led troops into Mexico City in 1916. In the print he carries a pistol in one hand and a scroll in the other. The scroll is inscribed 'article 123' and 'article 127' of the Constitution; these were accepted as legislation in 1917, the date some scholars argue marks the end of the Mexican Revolution. Article 123 refers to workers' rights and article 127 regards payment to government officials. By leaving the building with the scroll, the gang effectively steals the Constitution to symbolize their disapproval of these articles of the law.

Adolfo León Ossorio, an ally of González, sits at the back of the car with three other men. On the bonnet, a plaque reads 'Comité de salvación pública', suggesting that the gang members were involved in terror tactics, such as the scene they leave behind them, supposedly with the intention of saving the country from social and moral decay. They have raided the building, ripping off a door and throwing a chair outside, as well as attacking a woman. A banner divided into three horizontal stripes with an eagle in the centre – a form of the Mexican flag – hangs over the doorway, indicating that the space is associated with the government and the gang have contested this national space.

84a ALFREDO ZALCE (for biography see p. 56)

The USSR is defending the freedom of the world – let's help!

(*La URSS defiende las libertades del mundo. ¡Ayudemosla!*)

1941

Lithograph

430 x 590 mm

2008,7073.10

Presented by the Aldama Foundation through The Art Fund

84b LEOPOLDO MÉNDEZ (for biography see p. 62)

Mariscal S. Timoshenko

1942

Lithograph

433 x 615 mm

2008,7130.3

Presented by the Aldama Foundation

The two prints were made at the TGP and demonstrate the workshop's support for the Red Army during the Second World War. In Zalce's print, a crouching Soviet soldier, identifiable by the red star on his cap, holds a rifle and charges into action. Méndez's print presents a portrait of Marshal Semyon Timoshenko (1895–1970) and refers specifically to the Nazi siege of Stalingrad. Timoshenko was a military general in the Red Army who fought at Stalingrad; by honouring him in their print the TGP hailed him a hero. He wears stars on his shirt collar and appears distinguished, determined and competent.

Other impressions of this print include the subtitle 'sus triunfos son los nuestros' ('his triumphs are ours').

a

b

Emilio Amero 1901–1976

Emilio Amero was born in the town of Ixtlahuaca in the north-west of Mexico. When he was around eight years old his family moved to Mexico City. By 1915 he had started to attend art classes at the Open Air School in the village of Santa Anna, south of Mexico City, and two years later he went to the Open Air School in Coyoacán. He moved to the Academy of San Carlos in 1918 where he remained until 1921, an exact contemporary of Rufino Tamayo.

During the 1920s Amero began his career drawing pre-Hispanic artefacts at the Department of Ethnographic Drawing, an institution then run by Tamayo. In 1923–4 he started to paint murals after learning the techniques required from Fermín Revueltas and Ramón Alva de la Canal. He worked on murals at the Escuela Nacional Preparatoria (National Preparatory School) in Mexico City as assistant to José Clemente Orozco, one of the artists with whom he had come into contact by joining the Sindicato de Obreros Técnicos, Pintores, y Escultores (Union of Painters, Sculptors and Technical Workers). In 1923 Amero and his colleague Jean Charlot tried unsuccessfully to revive lithography as an alternative to woodcut. At this time Amero was also associated with the Estridentistas (Stridentists), the group of artists who followed the Italian Futurist movement and believed in non-elitist forms of art.

In 1925 he left Mexico for Cuba and then the United States, where he remained until 1930, working for various publications including *The New Yorker* and *Life Magazine*. In New York he began to experiment with lithography and met the printer George C. Miller. When he returned to Mexico in 1930 he opened a lithography workshop at the Academy of San Carlos (which had been renamed Escuela Nacional de Bellas Artes [ENBA] – the National Fine Arts School). Among his students were Julio Castellanos, Francisco Díaz de León, Francisco Dosamantes, Carlos Mérida, Isidoro Ocampo, Carlos Orozco Romero and Alfredo Zalce.

Amero continued to teach throughout his career, mainly organizing classes on drawing, lithography and fresco painting at institutions in the United States. From 1933 the United States became his permanent home, apart from a brief period in Mexico in 1938–40. Alongside his teaching duties, he contributed prints to exhibitions in the United States and painted several murals, of which his most notable was at the Bellevue Hospital in New York; this was destroyed shortly after completion in 1938 because its content was apparently unsuitable for a psychiatric hospital.

BIBLIOGRAPHY
Ittmann 2006; Williams et al. 1998; Zúñiga 2008.

85 EMILIO AMERO

Emilio Amero
Where? or the family
(*¿Dónde? O La familia*)
1948
Lithograph
313 x 259 mm
2008,7078.1
Presented by the Aldama Foundation

A child sitting on the floor in the lower right reaches up to its parents who are embracing each other. The father holds a small toy in his right hand and the mother covers her mouth as she whispers into her husband's ear. The parents are covered by a blanket which envelops them but not the child. All three figures have hollow eyes and rectangular noses, making their faces appear as if they are cast from metal. The figures show the influence of Surrealism on Amero's work.

Luis Arenal 1908–1985

Born in Mexico City, Arenal was one of the most politically active printmakers of the twentieth century in Mexico. During his childhood his family moved to the city of Aguascalientes in central Mexico, but they returned to Mexico City after his father died fighting in the Revolution. Before deciding to become an artist Arenal spent two years studying engineering in Mexico City. He emigrated to the United States in 1924, where he worked as a petrol can washer in California at the same time as studying architecture. Two years later he returned to Mexico and began his training as an artist at the Escuela Nacional de Artes Plásticas (National School of Visual Arts). In 1928 he returned to the United States where he made California his base and focused on developing as a sculptor and as a printmaker. He also began to exhibit his work on the outskirts of Los Angeles.

Arenal was in Los Angeles at the same time as David Alfaro Siqueiros and in 1932 the two men collaborated on the fresco paintings at the Chouinard Art School. Arenal also became involved with American art groups such as the John Reed Club, an artists' union, and the American Artists' Congress. Upon his return to Mexico in 1933 he was appointed General Secretary of the Mexican League Against War and Fascism. One of his most important professional associations began the following year, when he founded the LEAR with José Chávez Morado, Leopoldo Méndez and other Mexican artists. He also established the LEAR publication *Frente a Frente* with Juan de la Cabada in 1935.

In the late 1930s Arenal continued to travel to the United States, working on projects including mural paintings at Bellevue hospital in New York, and he attended the First Congress of American Artists against War and Fascism in 1936. When he returned to Mexico in 1937 he formed the TGP with Leopoldo Méndez and Pablo O'Higgins, and subsequently contributed to exhibitions at the TGP. Arenal worked with Siqueiros again in 1939 on a mural at the Electrical Workers Union building in Mexico City. He was active as a Communist and in 1940 was one of the artists involved in the unsuccessful attempt to assassinate Leon Trotsky at Diego Rivera's home in Coyoacán.

During the 1940s and 1950s Arenal continued to exhibit with the TGP, but he also worked as an architect designing bridges, houses and roads in the state of Guerrero in southern Mexico. In 1949 he became chief editor of the magazine *1945–46* which he co-founded with other intellectuals. This was the same year as his prints were published in *Estampas de Guerrero*.

Arenal was married to Macrina Rabadan, a feminist who became the first female member of parliament in Mexico. He died in 1985 in the city of Cuernavaca.

BIBLIOGRAPHY
Covantes 1982; Ittmann 2006; Williams et al. 1998.

86 LUIS ARENAL

Sleep

c.1935–40
Lithograph
325 x 445 mm
2008,7069.3
Presented by Dave and Reba Williams to the American Friends of the British Museum

A number of people wrapped in blankets sleep on the tiled floor of this large space. Their blankets are woven with simple patterns suggesting that they are hand-made and not mass-produced.

Iron girders hold up the ceiling, indicating that this is an industrial site. The sleepers are probably workers resting before the new day begins. There are no other details to suggest anything other than a harsh environment; their blankets are their only source of comfort. In the foreground, one of the figures lies on top of the blanket, wearing a nightdress. The significance of this figure is not clear but might indicate a worker so exhausted that they had no energy to crawl under the cover, or possibly a person who has died from poverty and exposure.

87 LUIS ARENAL

Head

1937
Lithograph
345 x 420 mm
1992,1003.37

The monumental scale of this head of an Indian woman resembles portraits made by David Alfaro Siqueiros (cats 29–31), with whom Arenal worked closely in the 1930s. The broad features of the woman's face such and her high cheekbones also suggest the influence of fresco painting, a technique which Arenal had learnt before he made this print. Although her head is printed in a very dark tone, details such as the braid in her hair and an earring stand out.

Celia Calderón de la Barca 1921–1969

Little is known about Calderón de la Barca's early years except that she was born in Mexico and her parents were landowners. She began training as an artist in the 1940s, entering the Escuela Nacional de Artes Plásticas (National School of Visual Arts) in Mexico City in 1942. She also joined the Sociedad para el Impulso de las Artes Plásticas (Society for the Mobilization of the Visual Arts), of which other printmakers such as Raul Anguiano and Francisco Dosamantes were members. She won a prize for a drawing in 1944 that enabled her to continue her studies at the National University.

In 1947 Calderón de la Barca went to the Escuela de Artes del Libro (Book Arts Workshop), founded by Francisco Díaz de León for the study of printmaking, and in the same year she also became a founding member of the Sociedad Mexicana de Grabadores (Mexican Society of Printmakers), exhibiting her work with the group. Several years later she held a solo exhibition of prints and paintings in a gallery affiliated with the Instituto Nacional de Bellas Artes (National Institute of Fine Arts). She spent a year in London in 1950 at the Slade School of Art supported by a scholarship from the British Council, and learnt more about printmaking during this trip. During the 1950s she travelled to Europe, South America, the United States, Canada and the Far East.

Calderón de la Barca joined the TGP in 1952 and became President of the workshop in 1963 before leaving two years later. She became the first female teacher at the San Carlos Academy, where she had earlier studied with Alfredo Zalce, Julio Castellanos and José Chávez Morado.

BIBLIOGRAPHY
Cortés Juárez 1951; Covantes 1982; Haab 1957; Williams et al. 1998; Priqnitz 1981.

88 CELIA CALDERÓN DE LA BARCA

Boy eating in an interior

*c.*1945–55
Lithograph
565 x 442 mm
2008,7069.6
Presented by Dave and Reba Williams to the American Friends of the British Museum

This print shows a young man seated on a small block on the ground. He holds a piece of food in his raised right hand and dips the other into a small bowl. His simple clothing suggesting his humble origins is emphasized by the barren room in which he sits. No other features suggest that this is a habitable space. By focusing on a single figure that fills the entire space, Calderón highlights the vulnerability of the individual and also elevates his simple daily task to a status worthy of more important subjects.

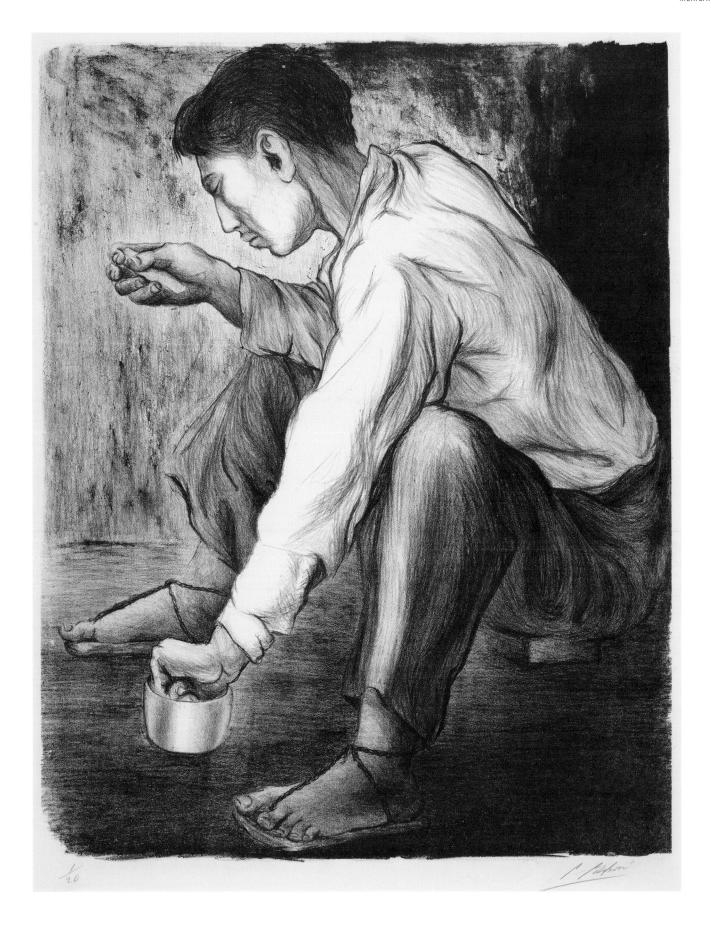

1/20

Julio Castellanos 1905–1947

Born in Mexico City, at the age of thirteen Castellanos enrolled at the Academy of San Carlos where he was taught by Saturnino Hernán and Leandro Izaguirre. Shortly afterwards he left Mexico for the United States where he designed stage sets. His career as a designer continued when he returned to Mexico in the early 1920s, but he turned to painting thanks to the encouragement of the artist Manuel Rodríguez Lozano (1876–1971), with whom he shared a workshop from 1929.

On leaving the Academy of San Carlos around 1925, Castellanos spent three years travelling around Europe, South America and the United States. He returned to the Academy of San Carlos in 1932 to study lithography with the printmaker Emilio Amero. His first exhibition took place in New York in 1926, after which he continued to show with groups in Mexico and abroad. Later in his career Castellanos became involved in public art programmes, and in 1946 was appointed head of the Department of Visual Arts at INBA (the National Institute of the Fine Arts). He established a fellowship scheme for artists, the beneficiaries of which included Frida Kahlo, Leopoldo Méndez and María Izquierdo. His staff at the department included the artists Fernando Gamboa, Fernández Ledesma and Roberto Montenegro.

From 1928 Castellanos became involved with the Contemporáneos group of artists and writers, who included Rufino Tamayo, Carlos Mérida and Carlos Orozco Romero. Instead of creating art as part of the Revolution, the Contemporáneos focused their efforts on a revolution in art. In their magazine, *Contemporáneos*, which ran from 1928 until 1932 under the directorship of Jaime Torres Bodet (1902–74), artists published their work alongside reproductions of pieces from New York and Paris to demonstrate that Mexican art was equal to that being produced in the major artistic centres.

A retrospective exhibition of Castellanos's work was organized at the Mont-Orendain Gallery following his sudden death in 1947.

BIBLIOGRAPHY
Cortés Juárez 1951; Ittmann 2006; Stewart 1951; http://www.museoblaisten.com

89 JULIO CASTELLANOS

The injured eye

c.1934–5
Lithograph
465 x 260 mm
2008,7069.7
Presented by Dave and Reba Williams to the American Friends of the British Museum

A standing woman wipes the injured eye of her seated companion. It is possible that she is blind and this scene depicts the regular attention she needs to alleviate her condition. Her hands folded on her lap imply a level of patient submission. The women are squeezed into a doorway, suggesting the physical confines of their dwelling. But the scene has a sense of monumentality, and their forms have a sculptural quality emphasized by the grey tones of the print.

Castellanos used the same image for a portable fresco panel painted in 1934. In the panel the seated woman wears a red skirt and a white apron while her companion wears a blue shawl evocative of the Virgin Mary, giving the painting a sense of religious gravity.

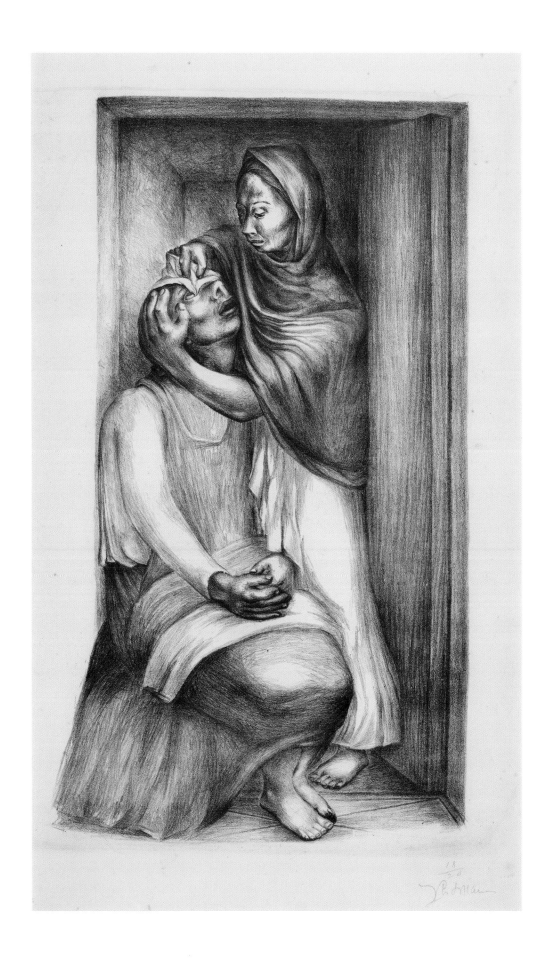

90 FRANCISCO DOSAMANTES (for biography see p. 106)

Three women

1946
Lithograph
320 x 310 mm
2008,7069.11
Presented by Dave and Reba Williams to the American Friends of the British Museum

Three Indian women stand with their backs to the viewer. They are dressed in the traditional dress of Indian women from the state of Oaxaca in southern Mexico. The most striking feature of their appearance is their neatly braided hair: the two long braids are typical of Yaltecan women, a name given to people from a particular part of Oaxaca.

The image highlights the women for their tradition – they all look identical and are not individualized. A label on the back of the print tells us that it was published in 1946 by Associated American Artists, demonstrating that this type of image appealed most to a foreign audience.

Jesús Ortiz Tajonar

Almost nothing is known about this artist except for a short article that appeared in the Mexican newspaper *La Jornada* on Saturday 14 February 1987, stating that some of his paintings discovered a year earlier had been mistakenly attributed to Diego Rivera.

91 JESÚS ORTIZ TAJONAR

Preparation of food in a Mexican village

c.1945–50
Lithograph
350 x 235 mm
2008,7069.41
Presented by Dave and Reba Williams to the American Friends of the British Museum

This print shows the importance of food in Mexican village life. In the foreground an Indian woman with plaited hair, bare feet and wearing an apron kneels on the ground to roll a fresh tortilla. She is surrounded by baskets containing all the ingredients that she needs. There is a fire for heating the tortillas and a plate to put them on when they are cooked. In the background, another Indian woman sits on the ground and gives food to a man wearing sandals and a hat. The activity takes place in a village, where people rely on their local agriculture and what they can grow themselves, rather than on imported goods.

Maize (corn) is the one of most important ingredients in Mexican food, hence the popular saying 'no maís no país' ('no maize, no country').

Galo Galecio 1908–1993

The Ecuadorian artist Galo Galecio trained at the School of Fine Arts in Guayaquil, a city on the Ecuadorian coast. From 1929 he made caricatures and other illustrations for newspapers as well as painting landscapes, and became a member of a group of artists linked to the liberal newspaper *Cocoricó*. A grant from José María Velasco Ibarra's Ecuadorian government in 1944 enabled Galecio to study in Mexico where he became a guest artist at the TGP. It was during his time in Mexico that he learnt printmaking techniques and studied fresco painting.

Galecio's album of prints *Bajo la linea del Ecuador* (*Below the Ecuadorian line*) was published in 1947 by La Estampa Mexicana. He later produced murals in Quito and Tulcán, including *La historia de Ecuador* (*The History of Ecuador*), which he painted with the artist Oswaldo Guayasamía. In Ecuador, late in his career, he became Professor of printmaking at the School of Fine Arts in Quito.

BIBLIOGRAPHY
Adès 1989; Prignitz 1981; TGP 1949.

92 GALO GALECIO

Beggars

(*Limosneros*)
c.1943–7
Lithograph
298 x 218 mm
2008,7072.1
Presented by the Aldama Foundation

Two Indian women dressed in dark shawls sit begging at the side of a busy street. One of the women holds a bowl in her left hand, to collect the offerings. A group of bourgeois gentlemen, recognizable by their smart clothing – hats, long coats and polished shoes – walk past the beggars, apparently unaware of their presence. These men represent greed as they are unwilling to give anything to help the poor.

The abstract style of the print is evocative of Cubism, but the sharp, geometric shapes also resemble pyramids from Mexico's ancient civilizations. This demonstrates the fusion of European artistic styles with the art of pre-Hispanic Mexico.

1/10

Amador Lugo b.1921

Born in Taxco in 1921, Amador Lugo is best known for his paintings and prints of the Mexican countryside. Despite having participated in many exhibitions both in Mexico and abroad, little is known about him. He began his training at the Open Air School at Taxco, which he attended in 1932–5 under the Japanese teacher Tamiji Kitagawa. It was during this time that he made his first prints.

Moving from Taxco to Mexico City in 1942, Lugo continued his training at the Escuela de Artes del Libro where he was taught by Francisco Díaz de León. After spending time at teaching college studying the pedagogy of the visual arts, he took courses at the Escuela Nacional de Artes Plásticas (formerly the Academia de San Carlos) under Carlos Alvarado Lang.

During the 1940s Lugo joined various artists' groups and contributed to their exhibitions. These included the Sociedad Mexicana de Grabadores (Mexican Printmakers Society), which he founded in 1948 with a number of artists including Raúl Anguiano and Francisco Dosamantes; the Sociedad para el Impulso de las Artes Plásticas (Society for the Mobilization of the Visual Arts); and the Salón de la Plástica Mexicana (Mexican Visual Arts Salon). He became a member of the Organización de Artistas, Pintores, Escultores y Grabadores (Organization of Artists, Painters, Sculptors and Printmakers) along with artists such as Francisco Dosamantes, Juan O'Gorman and Raúl Anguiano.

BIBLIOGRAPHY
Cortés Juárez 1951; *Exposición retrospective de Amador Lugo* 1982; Williams et al. 1998.

93 AMADOR LUGO
Untitled

*c.*1943
Colour woodcut
157 x 226 mm
2008,7072.6
Presented by the Aldama Foundation

This bird's-eye view of Mexican houses with tiled roofs reflects Lugo's fascination with landscape. This print probably represents houses in his hometown, Taxco. The simple green and brown colour scheme also suggests autumn. The print is similar to depictions of the Mexican landscape by foreign artists who visited Mexico, showing peaceful and idyllic settings. Whereas Mexican printmakers of Lugo's generation preferred to make prints of political subjects, he was less interested in using art as a medium for social change; instead, his print represents Mexico through the lens of landscape.

94 FRANCISCO MORA (for biography see p. 148)

Repairing the tracks

(*Componiendo la via*)
1942
Lithograph
310 x 420 mm
2002,1027.14
Presented by Dave and Reba Williams through the American Friends of the British Museum

This print shows three workers repairing tram tracks at night. The man repairing the tracks uses a modern tool powered by compressed air. His colleague inside the wagon pumps air into the tool, and the third worker walks beside the wagon carrying a lantern to provide more light. Strong light emanates from the front of the wagon to illuminate the scene.

Maintenance of tracks was necessary in Mexico during the 1940s to improve the conditions of the tram system. In other prints of the same era (cats 13, 79), tram workers raised their concerns about the hazardous state of the tracks. This print instead shows action being taken to improve the system. The fact that the workers employ powered machines demonstrates the arrival of modern technology to Mexico. It was during the 1940s that machines and modern appliances began to dramatically change the way Mexicans lived and worked.

Mora's depiction of workers also provides a contrast to other prints on the same subject made by the TGP such as his own print, *The miner* (cat. 97) and Ocampo's *Win a million* (cat. 62). These prints represent the oppressive experience of work, whereas *Repairing the tracks* depicts workers doing their job.

95 FRANCISCO MORA

Spectators

1944
Lithograph
320 x 409 mm
2008,7114.9
Presented by the Aldama Foundation

In Mexico during the 1940s people spent their leisure time at venues which provided popular entertainment, such as the theatre or the music hall. This print shows spectators packed into an auditorium watching an unspecified spectacle: all we can see is the light emanating from the stage. The auditorium is divided in two sections. In the part immediately in front of the stage, smartly dressed men and women are seated in tiers and lean forward to watch, their expressions conveying their enjoyment of what they are seeing; they have a clear view and the stage light which illuminates them. The spectators in the second group, standing in darkness in the wings, at a distance from the stage and with limited view, clearly have cheaper tickets and are probably from a different social class to those in the stalls. The print demonstrates that class divisions in Mexico existed in leisure time as well as in the world of work.

96 FRANCISCO MORA

The organ grinder

(*Organillero*)
1944
Lithograph
385 x 295 mm
2008,7075.4
Presented by the Aldama Foundation

Fairs and festivals take place throughout Mexico during the year, marking occasions such as saint's days, the Day of the Dead and Easter, and historical events including the commemoration of Independence. This print shows an organ grinder playing at a fair in a Mexican town. He wears simple clothes and bare feet, and looks directly at the viewer as he plays his organ, watched by dogs at the left. In the background a well-dressed couple representing the upper class move towards the entrance of a tent, their backs turned from the viewer.

The miner

—MORA—
—45—

97 FRANCISCO MORA

The miner

1945

Lithograph

295 x 485 mm

2008,7069.22

Presented by Dave and Reba Williams to the American Friends of the British Museum

Crawling on his elbows and knees, a miner passes through a dark, narrow cave, his lantern illuminating the way. His sandals offer little protection against the rough surfaces of the tunnel; his pickaxe, denoting his occupation, is positioned as if the only way he can progress is through its use.

The coarse hatching of the print conveys a sense of the rough texture of the cave floor and ceiling, emphasizing the miserable working conditions. The darkness further increases the sense of claustrophobia. There appears to be no exit to this tunnel, which envelops the figure symbolizing the ongoing struggle of workers who metaphorically crawl in their desperate search for release from their oppressive work conditions.

Mariano Paredes 1912–1979

Mariano Paredes was born in the city of Veracruz on Mexico's east coast. In 1921 he moved to Mexico City, and three years later he enrolled at the San Carlos Academy where he took evening classes in art. He remained at the Academy until 1933, where he was taught by José Clemente Orozco and Fernando Leal. In 1938 Paredes went to the Escuela del Arte del Libro (Book Arts Workshop) where he studied printmaking with the Czech printmaker Koloman Sokol. In 1945 he became an art teacher, giving evening classes at various schools in Mexico City.

Paredes became a member of the LEAR in 1933 and remained with this group until its dissolution in 1938. He was responsible for running the visual arts section of *Frente a Frente*, the LEAR monthly magazine. He was also administrator of the TGP from its foundation in 1937, but he left the group in 1942. He joined a number of other artists' groups, including the Sociedad Mexicana de Grabadores (Mexican Society of Printmakers), of which he was a founder in 1947, and the Sociedad para el Impulso de las Artes Plásticas (Society for the Mobilization of the Visual Arts).

After leaving the TGP Paredes gave his first solo exhibition, which consisted of forty woodcuts. During his career he contributed to over three hundred exhibitions in Mexico and abroad. A retrospective celebrating forty years of his work was held at the Museo de Arte Moderno in Mexico City in 1972. A few years later he gave a selection of his work to the University of Mexico. He died in 1979 and the TGP paid tribute to him with a retrospective exhibition.

BIBLIOGRAPHY
Cortés Juárez 1951; Covantes 1982; Ittmann 2006; Prignitz 1981.

98 MARIANDO PAREDES

Head of a workman wearing a flat cap

1941
Woodcut
228 x 167 mm
2008,7072.14
Presented by the Aldama Foundation

Narrow white lines against a black background define the head of a worker wearing a flat cap. Behind him are flags suggesting that he may taking part in a protest march. Portraits of workers were not common in Mexico as portraiture was a genre normally reserved for the upper classes where the sitter was named. However, by choosing a worker as the subject of his portrait Paredes here aligns himself to the revolutionary spirit by subverting this tradition of portraiture. His direct style, relying solely on the firm line, recalls the work of Henri Matisse and other modern artists who saw line as the principal means through which to convey meaning and emotion.

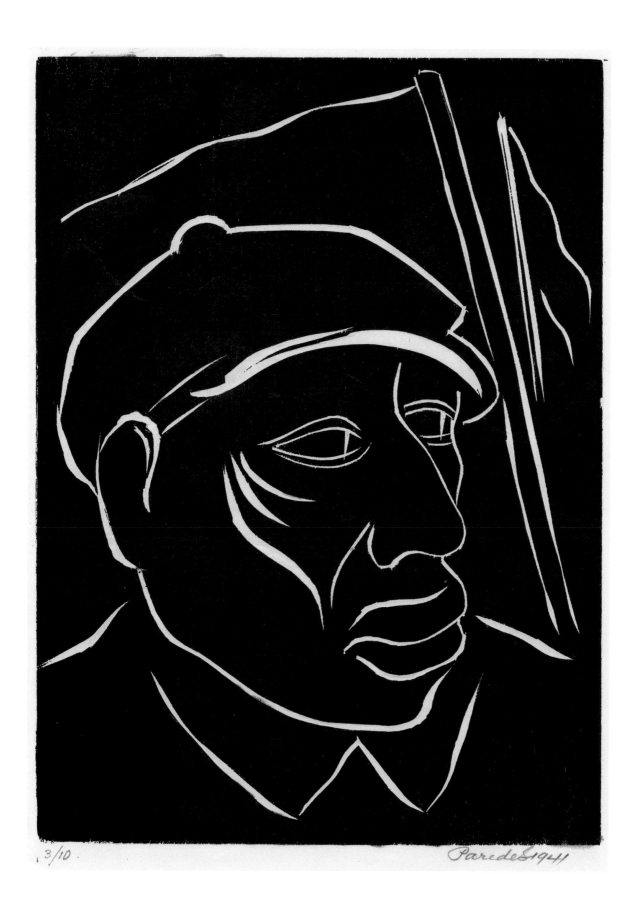

3/10. Paredes 1941

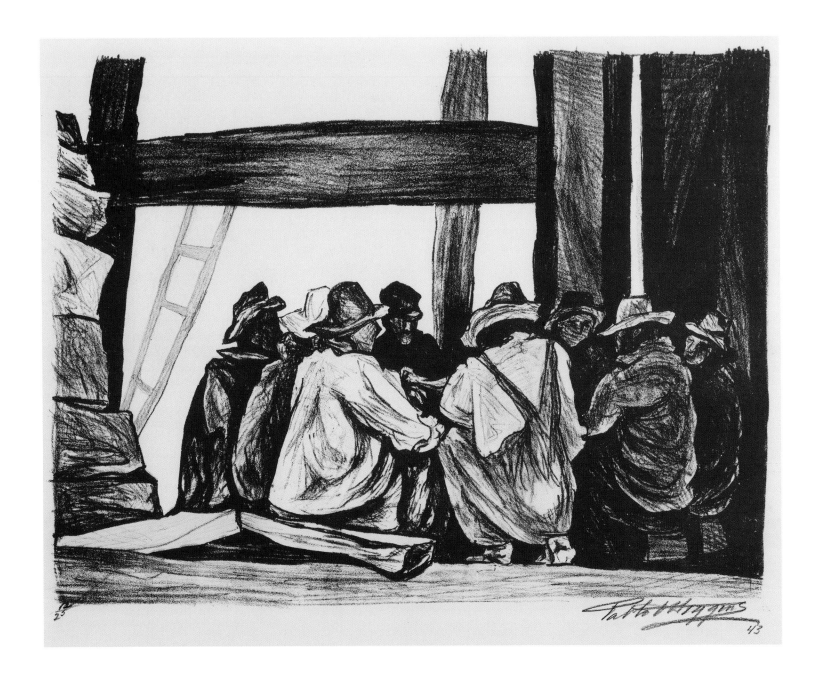

99 PABLO O'HIGGINS (for biography see p. 151)

The breakfast

1943
Lithograph
298 x 393 mm
1990,1109.143

As Mexico moved towards a modern, industrial and urban society, many workers relocated from the country to the city in search of work. This print shows workers at a construction site sitting together and sharing food. It conveys the sense of solidarity that workers experienced when they left their villages for the cities, helping them to cope with the harsh urban environment. Here they sit in a circle conversing, dwarfed by the structures around them.

In Mexico the word for breakfast, *desayuno*, describes the first meal of the day, often a light meal taken early in the morning before work. At midday Mexicans break from work to eat *almuerzo*, a larger meal. The scene depicted here most likely shows workers taking *almuerzo*, since they are already at work.

100 ALFREDO ZALCE (for biography see p. 56)

Mexico transforms itself into a great city

(*México se transforma en una gran ciudad...*)

1947

Engraving

316 x 390 mm

2008,7069.43

Presented by Dave and Reba Williams to the American Friends of
the British Museum

The print shows the emerging urban landscape of
Mexico City in the late 1940s. A cluster of high-rise
blocks – some of which are under construction –
is interspersed with blocks of low-rise colonial
buildings. The human figures represent how
urban development, and particularly the onset
of capitalism, had a devastating effect on the
population: the skeletal child standing at the left,
for example, is dying from starvation, while the
woman in a shawl at the top right holds out an
empty begging cup.

At the right, in the distance, small figures
queue outside the entrance to a building. Dressed
in shawls, they represent Indians who have come
to the city either waiting payment for work they
have done or for land which they are owed through
the land redistribution policy. Two men stuff litter
into large sacks, showing the amount of waste
generated in the city, while in the centre, a starving
dog scavenges in a bin. The figures overpowered by
buildings reflect the problems of urban expansion.

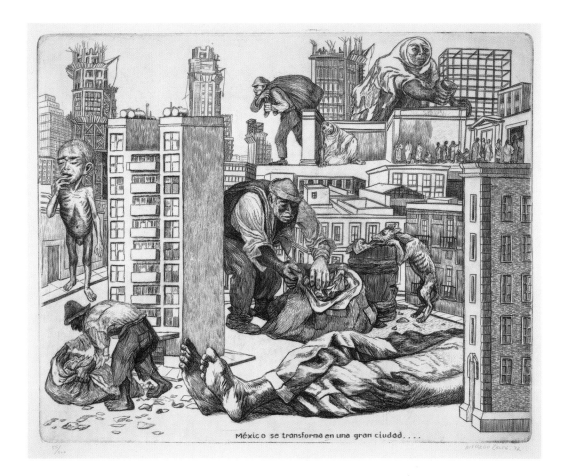

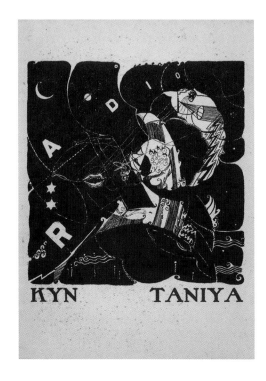

101 MANUEL MAPLES ARCE 1898–1980

Urbe: Bolshevik Super Poem in 5 Parts

(*Urbe, super poema bolchevique en 5 cantos*)
Andres Botas e hijo
Mexico City, 1924
170 x 121 mm (image)
2008,7074.5.1–6
Presented by the Aldama Foundation

Open at an unnumbered page opposite the first poem, the print by Jean Charlot shows two skyscrapers towering above a city with a hot air balloon rising behind.

The poem is about the modern city and is illustrated with six woodcuts and a front cover in black, red and white. The woodcuts depict modern modes of transport. The frontispiece shows the author, Maples Arce.

102 KYN TANIYA 1900–1980

Radio: a Wireless Poem in Thirteen Messages

(*Radio, poema inalámbrico en trece mensajes*)
Editorial 'Cultura'
Mexico City, 1924
164 x 151 mm (image)
2008,7074.30
Presented by the Aldama Foundation

Kyn Taniya's book contains thirteen poems based on the phenomenon of the wireless radio. The front cover is by Roberto Montenegro (1887–1968), a Mexican artist who was a fellow student of Diego Rivera. In a highly stylized manner it depicts a man listening to the radio at night.

103 MARIANO SILVA Y ACEVES 1887–1937

Little Silver Bells

(*Campanitas de Plata*)
Editorial 'Cultura'
Mexico City, 1925
115 x 116 mm (image)
2008,7074.12
Presented by the Aldama Foundation

Campanitas de Plata is a children's book containing fifty-four woodcuts by Francisco Díaz de León (1897–1975). The yellow and black front cover depicts the title, a bell, the sun and the moon. This print, facing page 54, shows a snake with a goat's head drinking from a fountain at midnight.

Díaz de León was born in Aguascalientes and moved to Mexico City in 1917 to study at the Academia de San Carlos. In 1922 he attended the Open Air School in Coyoacán, in the south of Mexico City, where he began printmaking and later directed a similar school in the Tlalpan district of Mexico City. Artists such as Isidoro Ocampo and Jesús Escobedo trained as printmakers with him at the Open Air Schools; Díaz de León himself took classes in lithography from Emilio Amero. León was one of the artists involved in the ¡30–30! group.

104 ROSENDO SALAZAR
Mexico in Thought and Action

(*México en pensamiento y en acción*)
Editorial Avante
Mexico City, 1926
232 x 173 mm (cover)
2008,7074.38
Presented by the Aldama Foundation

Designed by Diego Rivera, the cover shows a coiled serpent and two hands holding corn against a red background.

The book focuses on the Mexican Revolution from an intellectual and philosophical standpoint. It is illustrated with photographs of murals and portraits of intellectuals, statesmen and members of the Mexican government and other organizations of the 1920s. These include José Vasconcelos, Minister of Education in 1920–24; Plutarco Elías Calles, the Mexican President 1924–8; and Juan Lozano, an important member of the national workers' movement.

105
Form, Visual Arts Magazine

(*Forma, Revista de artes plásticas*)
Mexico City, 1927
188 x 158 mm (image)
2008,7074.40
Presented by the Aldama Foundation

Forma was a magazine about the visual arts edited by Gabriel Fernández Ledesma and published sporadically between October 1926 and mid-1928. This issue contains four woodcuts by Francisco Leal and photographs of pre-Hispanic artefacts, textiles, paintings, sport and modern architecture to accompany articles on these subjects.

Page 27, shown here, is a print by Fernando Leal of two costumed Yaqui Indians performing the 'Danza del venadito' ('Dance of the little deer'), a traditional Mexican dance from the state of Sonora in northern Mexico.

106 XAVIER ICAZA 1892–?
Panchito Chapopote: tropical tableau or tale of an extraordinary occurrence in heroic Veracruz

(*Panchito Chapopote, retablo tropical o relación de un extraordinario sucedido de la heroica Veracruz*)
Editorial 'Cultura'
Mexico, 1928
170 x 101 mm (image)
2008,7074.13.1–13
Presented by the Aldama Foundation

The protagonist of this short novel is a fictional character, Panchito Chapopote; the book contains thirteen full-page woodcuts by Ramón Alva de la Canal (1892–1985). The print facing page 24 shows Panchito shooting at the moon. In the distance is the Eiffel Tower, a symbol of France that may refer to the inebriated French poet mentioned in the text relating to this print.

107
Mexican Folkways

Mexico City, January–March, 1928
280 x 208 mm (cover)
2008,7074.39.1
Presented by the Aldama Foundation

Designed by Diego Rivera, the cover for the January
to March 1928 issue of *Mexican Folkways* depicts two
conjoined red serpents facing each other against a
grey background. One of the serpents has foliage-
like scales and the other is decorated with paint
tubes. The motif of two serpents on a coloured
background became the standard design for the
front cover of the magazine, and was reproduced
in a variety of colour combinations.

Mexican Folkways was a bilingual cultural
magazine edited by the American writer Francis
Toor (1890–1956) and included illustrated articles
on Mexican art, archaeology and folklore. Diego
Rivera was art editor of the magazine from 1926
to 1937.

108
Contemporaries

(*Contemporáneos*)
Mexico City, 1929
227 x 161 mm (cover)
2008,7074.36.2
Presented by the Aldama Foundation

Contemporáneos was a Mexican cultural magazine
published fortnightly. The front cover by an
anonymous artist shows the title, date, a summary
of the contents and an abstract design.

109
**Departamento del Distrito Federal
(Government of Mexico City)
Mexican civic calendar**

(*Calendario Cívico Mexicano*)
Mexico City, 1930
218 x 164 mm (cover)
2008,7074.27
Presented by the Aldama Foundation

This is a calendar published by the government of
Mexico City in 1930 and has a page for each week
of the year. Representing aspects of Mexican
history, culture and folklore, it contains fifty-two
woodcuts by a number of printmakers including
Ramón Alva de la Canal, Fernando Leal, Leopoldo
Méndez, Fermín Revueltas and Diego Rivera.

The front cover was possibly designed by
Ramón Alva de la Canal and shows the national
crest of an eagle which has landed on a cactus
plant, holding a snake in its beak, surrounded
by flags.

110 MARIANO AZUELA 1873–1952

The Local Political Chiefs: a novel of the Mexican Revolution, preceded by The Flies, scenes of the Mexican Revolution

(Los Caciques, novela de la revolución mexicana, precedida de Las Moscas, Cuadros y Escenas de la Revolución)
Ediciones de 'La razón'
Mexico City, 1931
203 x 145 mm (cover)
2008,7074.3
Presented by the Aldama Foundation

This book contains two stories about the Mexican Revolution by the Mexican novelist Mariano Azuela. The front cover, by an unknown artist, shows the title in blue and red lettering. *Las Moscas* is a short story presenting the history of the Mexican Revolution in a literary guise, focusing particularly on the divisions between the rich and the poor. The narrative unfolds around fictional characters based on the political leaders of the Revolution such as Pancho Villa and General Victoriano Huerta, although they are never named. *Los Caciques* focuses on the role of political bosses in Mexico and their exploitation of the common people for their own political gain.

111 RAMÓN LÓPEZ VELARDE 1888–1921

The Sound of the Heart

(El Son del Corazón)
Bloque de Obreros Intelectuales
Mexico City, 1932
127 x 96 mm (image)
2008,7074.37
Presented by the Aldama Foundation

The book contains poems by Ramón López Velarde and is illustrated with woodcuts by Fermín Revueltas (1901–35), who also designed the front cover. This print on page 82 shows a church being ravaged by the sea during a storm.

112

Crucible: a review

(Crisol, Revista de Crítica)
Mexico City, September 1934
223 x 164 mm (cover)
2008,7074.29.3
Presented by the Aldama Foundation

Crisol, Revista de Crítica was a monthly periodical published in Mexico City between 1934 and 1935. The front cover of each edition was illustrated in colour by Clemente Islas Allende; some issues have printed motifs inside, some of which are by Fermín Revueltas (1901–35). This cover depicts Mexicans at a national festival, their flag flying above the scene.

113 ANTONIO MEDIZ BOLIO
The Land of the Pheasant and the Deer
(*La tierra del faisán y del venado*)
Editorial 'México'
Mexico City, 1934
169 x 120 mm (image)
2008,7074.2.1-11
Presented by the Aldama Foundation

This book comprises nine stories based on Mayan folklore and has eleven colour prints by Miguel Tzab, a painter from the Yucatan region of Mexico who trained at the Academia de San Carlos in Mexico City.

Page 161 is shown here. It depicts a Mayan figure holding a bright yellow bird. In the bottom left-hand corner there is another creature, derived from Mayan mythology as the print was probably based on Mayan codices.

114 ROBERTO HINOJOSA
Social Justice in Mexico
(*Justicia Social en México*)
Mexico City, 1935
230 x 164 mm (cover)
2008,7074.4
Presented by the Aldama Foundation

The text of this book refers to the second Socialist Students of Mexico Conference in Uruapan in 1935. Photographs from the conference are interspersed between essays on subjects such as university reform and education in a socialist state. The cover comprises a title in abstract lettering and evoking the Communist flag, a hammer and sickle on a red background.

115 DR ATL (GERARDO MURILLO) 1875–1964
Gold, more Gold!
(*¡Oro más oro!*)
Ediciones Botas
Mexico City, 1936
195 x 125 mm (cover)
2008,7074.34
Presented by the Aldama Foundation

¡Oro más oro! is a political text about gold in the modern world. It is written by Dr Atl (1875–1964), the Mexican artist born Gerardo Murillo but who changed his name in 1902: *atl* is the word for water in Náhuatl, the language of the Aztecs. The front cover depicts the book title in bold, stencilled gold lettering.

116 CARLOS MÉRIDA 1891–1984

Illustrations of The Popol Vuh

(*Estampas del Popol Vuh*)
Graphic Art Publications
Mexico City, 1943
310 x 272 mm (image)
2008,7072.23.(1–10)
Presented by the Aldama Foundation

This lithograph (plate 5) by Carlos Mérida depicts hybrid human and bird forms, including a gigantic human head in yellow based on Mayan motifs. It is from a portfolio of ten colour prints which run in sequence, each relating to fragments of the Mayan book, the *Popol Vuh*, a sacred Mayan text about Creation written in the Quiché language. The lithographs are kept together in their original red cover with a four-page pamphlet providing an introduction to the work. Each print is accompanied by a thin sheet of paper with translated text from the *Popol Vuh* in Spanish and English. Mérida uses bright colours and abstract forms in his interpretation of the *Popol Vuh* in order to express its poetic quality.

117 JUAN DE LA CABADA 1901–1986

Melodic Incidents of an Irrational World

(*Incidentes melódicos del mundo irracional*)
La Estampa Mexicana
Mexico City, 1944
275 x 211 mm (page)
2008,7074.32
Presented by the Aldama Foundation

Juan de la Cabada retells the stories of Mayan folklore based on songs translated into Spanish from the Quiché language. The book includes many illustrations by Méndez and also reproduces extracts from some of the Mayan songs.

Page 14 is shown here: the print by Leopoldo Méndez shows a decorative serpent about to swallow a man in white wielding a stick. The serpent represents Quetzalcoatl, an eminent deity from pre-Columbian mythology.

118 JOSÉ RUBEN ROMERO 1890–1952

A few things I had tucked up my sleeve about Pito Pérez

(*Algunas cosillas de Pito Pérez que se me quedaron en el tintero*)
Colección 'Lunes'
Mexico City, 1945
211 x 139 mm (cover)
2008,7074.21
Presented by the Aldama Foundation

Seven woodcuts illustrate the tale of the fictional character, Pito Pérez, a loveable rogue who is the subject of a series of novels by Ruben Romero. The front cover by Oscar Frías (b.1920) shows a man crouching as he tries to catch a hen.

Lo que no Debe Venir.

119 TALLER DE GRÁFICA POPULAR
Mexican People

Associated American Artists
New York, 1946
285 x 350 mm (image)
2008,7069.1-12
Presented by Dave and Reba Williams to the American Friends of the British Museum

This portfolio contains twelve loose signed prints by artists who worked at the TGP, in its original board covers. Each print represents a scene from a different region of Mexico and focuses on Mexicans at work. The portfolio begins with a description of the print in Spanish and English, and a map locating the places from where the scenes derived.

The first print is by Ángel Bracho and shows a Huichol Indian in the foreground, heavily laden with goods, and another in the background carrying a child. Huichol Indians are native to the Sierra Madre Occidental mountain range in the central states of western Mexico.

120
Anthropos

April–June 1947
261 x 147 mm (image)
2008,7074.14 & 31
Presented by the Aldama Foundation

Anthropos was a cultural magazine with a particular focus on anthropology. It seems only to have survived two issues in 1947. Page 23 is illustrated here (April to June 1947 issue), a print by Leopoldo Méndez entitled *Lo que no debe venir* (*That which must not come*), in which he represents himself as an artist devoted to national causes: he lies on top of an open book, holding an engraving tool and absorbed in his work. The image includes a number of recognizable national symbols such as the city of Tenochtitlán in the background, a large cactus plant, and an eagle fastened with daggers to a cross which has a snake coiled round its trunk.

The print on the front cover of the October 1947 issue (not illustrated) is by Pompeyo Audivert (1900–77) and shows an abstract seated female nude whose left leg has been detached from her body, leaving a tree trunk growing in its place.

121 GALLEGOS LARA 1911–1947
The Final Mistake

(*La última erranza*)
Colección 'Lunes'
Mexico City, 1947
207 x 136 mm (cover)
2008,7074.23
Presented by the Aldama Foundation

La última erranza is a short story by the Ecuadorian writer Gallegos Lara. This edition is illustrated with eight woodcuts including the front and back covers. The front cover, printed in brown and red on a white background, is by Galo Galecio and shows a man cowering as others hurl stones at him from behind.

122 JULIO POSADA

The Machete

(*El Machete*)
Colección 'Lunes'
Mexico City, 1947
208 x 133 mm (cover)
2008,7074.19
Presented by the Aldama Foundation

This book of thirty-four pages by the Colombian
author Julio Posada concerns farm work, with
woodcuts illustrating scenes from the story.
Shown here is the front cover by Rodrigo Arenas
Betancourt (1919–95): a man walks along a path
with a knapsack on his back.

123 ARTURO USLAR PIETRO 1906–2001

Midnight Mass

(*La Misa del Gallo*)
Colección 'Lunes'
Mexico City, 1947
207 x 134 mm (cover)
2008,7074.22
Presented by the Aldama Foundation

There are eight woodcuts by Galo Galecio in
this story, plus illustrations on the front and
back covers. The book was published as no. 30
in the Colección 'Lunes' ('Monday Collection').

The front cover depicts a man with a moustache
wearing a suit and hat, standing in front of a village
set in a mountainous landscape.

124 LUIS SUÁREZ

Wedding in Juchitán, five reports

(*Boda en Juchitán, cinco reportajes*)
Ediciones de la Secretaria de Educación Pública
Mexico City, 1948
169 x 139 mm (image)
2008,7074.18
Presented by the Aldama Foundation

The prints in this book illustrate five stories about
wedding customs and traditions, focusing on
the marriage celebrations between a poet and a
beautiful teacher from the village of Juchitán in the
state of Oaxaca.

Facing page 62, this print by Gabriel Fernández
Ledesma depicts a party at which the bride dances,
dressed in traditional clothing and watched by
people in the background.

125 TALLER DE GRÁFICA POPULAR

The Workshop for Popular Graphic Art: a record of twelve years of collective work

(*El Taller de Gráfica Popular, doce años de obra artística colectiva*)
La Estampa Mexicana
Mexico, 1949
139 x 139 mm (image)
2008,7074.10(1–5)
Presented by the Aldama Foundation

The TGP collated this album which includes photographs of some of their work, short biographies about the artists and information on the history and culture of the workshop. There are also five original signed prints: this one on green paper of a boy waving as he rides on a merry-go-round is by Leopoldo Méndez and appears between pages 144 and 145 of the album.

126 JULIUS FUCIK 1903–1943

Report from the Foot of the Gallows

(*Reportaje al pie de la horca*)
Fondo de Cultura Popular
Mexico City, 1952
196 x 142 mm (cover)
2008,7074.35
Presented by the Aldama Foundation

The book was translated from the Czech into Spanish and is illustrated with half-tone photographs. It is a collection of extracts written by Fucik during his time in Pankrac prison (Czech Republic) and later compiled by his wife, Gusta Fucikova. Fucik was sentenced to death and executed in Berlin on 8 September 1943.

On the front cover, Diego Rivera's print in black, red and white shows a dove flying above a decapitated head dripping with blood. The chopping-block is formed from a broken swastika.

127 ADOLFO BEST MAUGUARD 1891–1964

Methods of Drawing: the tradition, resurgence and evolution of Mexican art

(*Metódo de dibujo, Tradición, resurgimiento y evolución del arte mexicano*)
Editorial Viñeta
Mexico City, 1964
211 x 151 mm (page)
2008,7074.33
Presented by the Aldama Foundation

Containing essays on Mexican art as well as short exercises on drawing techniques, this book by the artist and critic Adolfo Best Mauguard is illustrated with several of his own colour prints. The page shown here (page 67) depicts different types of fruit and a snail interspersed between instructions on how to draw these objects.

GLOSSARY

The main printmaking techniques and terms referred to in this publication are described here. Fuller explanations are given in Antony Griffiths, *Prints and Printmaking: An Introduction to the History and Techniques* (1980), 2nd edn, London, 1996; and Paul Goldman, *Looking at Prints, Drawings and Watercolours: A Guide to Technical Terms* (1988), 2nd edn, London, 2006.

Aquatint
A variety of etching used to create tone, originally to imitate the effect of a watercolour wash. Within a dust-box, fine resin particles are shaken and allowed to fall as a thin layer on to a metal plate; this is then heated until the resin melts and fuses to the surface, forming a porous ground. During immersion in an acid bath, the acid bites into the minute channels around each resin particle. These hold sufficient ink to print as an even tone. Highlights can be obtained by 'stopping out' with an acid-resistant varnish (see under *etching*).

Engraving
Engraving is the oldest and most widespread of the intaglio techniques. The preferred metal for engraving plates is copper, which is relatively soft but strong enough to take the pressure of the printing press. The design for an engraving can be transferred from the drawing to the plate in a number of ways. A popular method was to rub chalk on to the verso of the drawing, coat the plate with wax then use a scribe to retrace the outlines of the drawing, imprinting a transferred line on to the plate. The lines of the design are then cut cleanly and directly into the bare metal plate using a V-shaped tool called a burin.

Etching
A needle is used to draw freely through a hard, waxy, acid-resistant ground covering the metal plate. The exposed metal is then 'bitten' by acid, creating the lines. This is done by immersing the plate in an acid bath; the longer the acid bites, the deeper the lines become and the darker they print. The plate can be bitten to different depths by 'stopping out' the lighter lines with a varnish before returning the plate to the bath. The ground is then cleaned off before printing.

Intaglio printmaking
The traditional hand-drawn techniques of *etching*, *aquatint*, drypoint and *engraving* are all intaglio processes. The methods of printing are the same, but the result of each technique is different. The basic principle is that the line is incised into the metal plate, which is usually copper or zinc. Ink is rubbed with a dabber into the recessed lines and the surface of the plate wiped clean. Printing is achieved by placing a sheet of dampened paper over the inked plate, which is then passed through the press under heavy pressure. Characteristic of intaglio printmaking is the plate mark impressed into the paper.

Letterpress
The term used for all book printing from a relief press. This was the only method of book printing until the nineteenth century, but in the twentieth century made increasingly obsolete by developments in photo-typesetting and offset lithography.

Linocut
The same process as for *woodcut*, except that linoleum is used instead of wood.

Lithography
The technique of printing from stone or specially prepared zinc plates which relies on the antipathy of grease and water. An image is drawn on the printing surface with a greasy medium, such as crayon or a lithographic ink containing grease, known as tusche. The printing surface is then dampened so that when greasy ink is applied it will adhere only to the drawn image and will be repelled by water covering the rest of the stone or plate. The ink is transferred to a sheet of paper by passing paper and printing surface together through a flat-bed scraper press.

Photomechanical printing
Any process by which a printing surface is produced by a method based on photographic technologies rather than human skill.

Proof
An impression outside the edition, usually pulled during the process of working on the plate and sometimes called a trial proof. An artist's proof is one from a small number of impressions reserved for the artist outside the edition.

States
While the artist works on the plate, proofs are taken which record the different stages, or *states*, in the development of the print.

Woodcut
A block, usually of plank wood revealing the grain, is cut with chisels and gouges so that the areas to be inked stand in relief. Ink is then rolled on to the surface of the block, which is printed on to a sheet of paper, either in a press under vertical pressure or by hand-rubbing the back of the paper.

Wood-engraving
A version of *woodcut*, in which a very hard wood, like boxwood, cut across the grain is used. The close grain of the end-block permits the cutting of very fine lines; these are achieved with a graver tool that is similar to the engraver's burin. This enables work of greater detail to be created than in a woodcut. A multiple tool can also be used on the end-block to produce fine, parallel lines.

BIBLIOGRAPHY

Adès, Dawn, *Art in Latin America: The Modern Era, 1820–1980*, New Haven and London, 1989

Ángeles Cajigas, María de los, *Raúl Anguiano: Uno de los cuatro ases del muralismo mexicano*, Mexico City, 1995

Atl, Dr, *Las Artes Populares en México*, Mexico City, 1922

Bardach, Noah, 'Post-Revolutionary Art, Revolutionary Artists: Mexican Political Art Collectives 1921–1960', unpublished Ph.D. thesis, University of Essex, 2008

Benítez, M., *The Special Case of Puerto Rico. The Latin American Spirit: Art and Artists in the United States 1920–1970*, New York, 1988

Brenner, Anita, *The Wind That Swept Mexico*, Austin, TX, 1943

Cabada, Juan de la, *Mary Martín Homenaje*, Mexico City, 1983

Cancel, L.R., et al., *The Latin American Spirit: Art and Artists in the United States, 1920–1970*, New York, 1988

Caplow, Deborah, *Leopoldo Méndez: Revolutionary Art and the Mexican Print*, Austin, Texas, 2007

Charlot, Jean, *The Mexican Mural Renaissance, 1920–1925*, New Haven and London, 1963

Cortés Juárez, Erasto, *El grabado contemporáneo*, Mexico City, 1951

A Courtyard Apart: The Art of Elizabeth Catlett and Francisco Mora, exh. cat., Mississippi Museum of Art, 1990

Covantes, Hugo, *El grabado mexicano en el siglo XX, 1922–1981*, Mexico City, 1982

Craven, David, *Art and Revolution in Latin America, 1910–1990*, New Haven and London, 2002

Duffy, Betty and Douglas, *The Graphic Work of Howard Cook: A Catalogue Raisonné*, Bethesda, MD, 1984

Exposición retrospective de Amador Lugo 1936–1982, exh. cat., Salón de la Plástica Mexicana, INBA/Cultura SEP, Mexico, 1982

Gretton, Thomas, 'Posada's Prints as Photomechanical Artefacts', *Print Quarterly*, vol. 9 (1992)

Haab, Armin, *Mexican Graphic Art*, New York, 1957

Hooks, Margaret, *Tina Modotti: Photographer and Revolutionary*, London, 1993

Ittmann, John, *Mexico and Modern Printmaking: A Revolution in the Graphic Arts, 1920–1950*, New Haven and London, 2006

Jeffrey, Celina, 'Leon Underwood: An Artist Collector', in *Collectors: Expressions of Self and Other*, ed. Anthony Alan Shelton, London, 2001

Joseph, Gilbert M., and Timothy Henderson (eds), *The Mexico Reader: History, Culture, Politics*, Durham, NC, and London, 2002

Keller, Judith, *El Taller de Gráfica Popular*, Austin, TX, 1985

LeFalle Collins, Lizetta, and Shifra M. Goldman, *In the Spirit of Resistance: African American Modernists and the Mexican Muralist School*, New York, 1996

López Casillas, Mercurio, *Manilla, Grabador Mexicano*, 2005

Lozano, Luis-Martín, *Mexican Modern Art*, National Gallery of Canada, 1999

McClean, Alison, 'El Taller de Grafica Popular: Printmaking and Politics in Mexico and Beyond, From the Popular Front to the Cuban Revolution', unpublished Ph.D. thesis, University of Essex, 2000

Mason Hart, John, *Revolutionary Mexico. The Coming and Process of the Mexican Revolution*, Berkeley, CA, 1987

Meyer, Hannes, *El Taller de Gráfica Popular: Doce Anos de Obra Artística Colectiva*, Mexico City, 1949

Meyer, Hannes, 'El Taller de Gráfica Popular', *Graphis*, vol. 6, no. 30 (1950), pp. 156–61

Miliotes, Diane, *José Guadalupe Posada and the Mexican Broadside Art*, Chicago, 2006

Monsiváis, Carlos, 'Leopoldo Méndez: La Radicalización de la Mirada', in *Leopoldo Méndez 1902–2002*, Mexico City, 2002

Morales, Leonor, *Arturo García Bustos y el realismo de la escuela mexicana*, Mexico City, 1992

Morse, Peter, *Jean Charlot: A Catalogue Raisonné*, Hawaii, 1976

Neve, Christopher, with an introduction by John Rothenstein, *Leon Underwood*, London, 1974

Oles, James, *South of the Border, Mexico in the American Imagination, 1914–1947*, Washington and London, 1993

¡Orozco!, exh. cat., Museum of Modern Art, Oxford, 1980

Poniatowska, Elena, and Gilberto Bosques, *Pablo O'Higgins*, Mexico City, 1984

'Posada: Monografía de 406 grabados, con introducción por Diego Rivera', *Mexican Folkways*, 1930

Presencia del Salón de la Plástica Mexicana, Instituto de las Bellas Artes, Mexico, c.1976

Prignitz, Helga, *TGP: Ein Grafiker-Kollektiv in Mexico von 1937–1977*, Berlin, 1981

Prignitz, Helga, *El Taller de Gráfica Popular en México 1937–1977*, Mexico City, 1992

Raúl Anguiano, una vida entregada a la plástica, Guadalajara, 1985

Reyes Palma, Francisco, *Leopoldo Méndez, El oficio de grabar*, Mexico City, 1994

Rochfort, Desmond, *Mexican Muralists: Orozco, Rivera, Siqueiros*, London, 1997

Rothenstein, Julian, (ed.), *Posada: Messenger of Mortality*, London, 1989

Shoemaker, Innis Howe, 'Crossing Borders: The Weyhe Gallery and the Vogue for Mexican Art in the United States, 1926–40', in Ittmann 2006, pp. 23–54

Siqueiros, David Alfaro, 'Three Appeals for a Modern Direction: To the New Generation of American Painters and Sculptors', *Vida Americana*, Barcelona, 1921

Siqueiros, David Alfaro, *Art and Revolution*, London, 1975

Soler, Jaime, and Lorenzo Avila (eds), *Posada y la Prensa Ilustrada: Signos de modernizacion y resistencias*, exh. cat., Museo Nacional de Arte, Mexico, Instituto Nacional de Bellas Artes-Patronato del Museo National de Arte, 1996

Stewart, Virginia, *45 Contemporary Mexican Artists: A Twentieth Century Renaissance*, Stanford, 1951

Stibi, G., 'Soziale Grafik in Mexiko', *Bildende Kunst*, no. 3 (1948), pp. 10–16

TGP, *El taller de gráfica popular, doce años de obra*, Mexico, 1949

Taracena, Bertha, *Alfredo Zalce, Un arte propio*, Mexico City, 1984

Tibol, Raquel, *José Chávez Morado, imágenes de identidad mexicana*, Mexico City, 1980

Tibol, Raquel, *Gráficas y neográficas en México*, Mexico City, 1987

Tibol, Raquel, and Rene Arceo, *Prints of the Mexican Masters: An Exhibition of Eighty Prints by Contemporary Mexican Masters*, exh. cat., Mexican Fine Arts Center Museum, Chicago, 1987

Tibol, Raquel, *Rufino Tamayo, del reflejo al sueño*, Mexico City, 1995

Tyler, Ron, *Posada's Mexico*, exh. cat., Amon Carter Museum of Western Art, 1979

Williams, Reba and Dave, et al., *Mexican Prints from the Collection of Reba and Dave Williams*, New York, 1998

Womack, John, *Zapata and The Mexican Revolution*, Harmondsworth, 1972

Zúñiga, Ariel, *Emilio Amero, un modernista liminal (A Liminal Modernist)*, Mexico City, 2008

INDEX

COPYRIGHT CREDITS